EXHIBITION ROAD

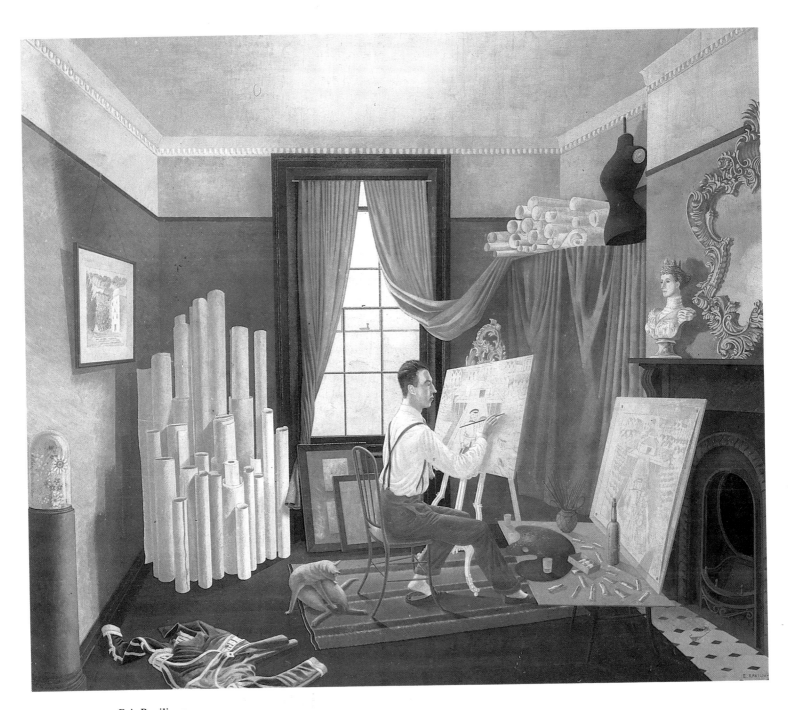

Eric Ravilious
Edward Bawden Working in his Studio,
c.1930
Tempera on board, 76 × 91.5 cm
RCA Collection
Cat. no. 25

EXHIBITION ROAD

Painters at the
ROYAL COLLEGE OF ART

Andrew Brighton
Richard Cork
Christopher Frayling
Marco Livingstone
Lynda Morris
Bryan Robertson

Portrait photographs by
Snowdon

Interviews by
Robert Cumming and Christopher Frayling

Edited by Paul Huxley

Phaidon·Christie's and the Royal College of Art

Published in association with the Royal College of Art
for the exhibition *Exhibition Road, Painters at the Royal
College of Art*, organized by the Painting School as part of
the 150th anniversary celebrations of the College,
March–April 1988.

Exhibition sponsored by:

Christie's Fine Art
Auctioneers and Valuers

and Jaguar Cars

with assistance from:

Global Asset Management
London Weekend Television Ltd.
Wiggins Teape Synthetics Ltd.
MoMart Ltd., exhibition
 transportation and installation
Robert Horne, paper supply
Townsend Hook, paper manufacture
The Sunday Times, Snowdon portraits

The Royal College of Art would like to thank the Museum
and Gallery Commission for helping to arrange indemnity
for this exhibition under the National Heritage Act 1980

Exhibition selectors: Paul Huxley and Susie Allen
Exhibition curator: Susie Allen
Exhibition designer: Terry Robson

Catalogue editors: Marianne Ryan and Judy Spours
Catalogue design: Archetype Graphic Design
Cover design: Phaidon Press

Biographies researched by:
 Monica Bohm-Duchen
 Hilary Cunliffe Charlesworth
 Robert McDonald
 Monica Petzal

First published 1988

Phaidon · Christie's Ltd.
Littlegate House,
St. Ebbe's Street,
Oxford OX1 1SQ

British Library Cataloguing in Publication data
Exhibition Road–Painters at the Royal College of Art
I Royal College of Art–History
II Huxley, Paul III Frayling, Christopher
707 1142132 N333 G75L64

ISBN 0 7148 8056 6
ISBN 0 7148 8059 0 pbk

Typeset in Baskerville and printed in England by
Balding + Mansell UK Limited,
London and Wisbech.

CONTENTS

PREFACE

The occasion for this book and the exhibition which it accompanies is the Royal College of Art's one hundred and fiftieth anniversary.

Over eighty eminent painters who studied in the College's studios on Exhibition Road, South Kensington, are each represented by a painting done as a student and by a later work. This simple theme is extended by the inclusion of a select number of third works to bring a focus on special historic periods, and by paintings by artists who taught at the College. In many cases the student works are the only examples that can be tracked down, and are not always typical of what the artists did as students. The resulting juxtapositions may often be a surprise, and it is hoped that they will provide insight into the learning process during formative years.

In formulating the exhibition, the aim was to reflect the highlights of achievement in painting during the College's history. In spite of its age, these achievements have been largely in this century and particularly in the post-War years. The artists represented are therefore grouped more intensively in the middle of the period covered than at the beginning or in recent years.

This is not to say that great artists were not associated with the College in the last century—they were; nor that there is a petering out of achievement today—there is not. The legend carved in marble in the entrance hall at Exhibition Road reads 'Ars Longa Vita Brevis'. In other words, art takes its own time to unfold despite the fleeting lives of us mortals. The pace at which artists develop is as variable as are individuals, and in most cases it takes many years before a young artist speaks clearly in his or her own voice in a way which can be appreciated. The selection for the recent two decades is therefore sparse and does not extend beyond 1983. It should not be insulting to say that the very youngest artists here are representatives of many more who arguably could have been included.

An exhibition as complex and various in its range of artists as this could hardly be accounted for by a single author. I have therefore asked six writers each to contribute an essay, allowing them the freedom to work their own theme around a given period. Richard Cork, in looking at the pre-War period, chooses just three painters, each in their own way exemplifying the spirit of the early Modernists at work in the 1930s. Lynda Morris and Marco Livingstone follow, bringing their areas of expertise to provide measured and detailed surveys of the famous periods of the 1950s and 1960s when so many gifted young artists progressed up Exhibition Road, later to be labelled the Kitchen Sink school and the Pop Artists. Andrew Brighton takes the later years, from the mid-1960s to the mid-1980s, when painting fell under siege and emerged with a new social awareness and revival of subject-matter. Bryan Robertson, always a champion of that which raises the spirits, is original and enlightened, writing about abstract painting over the years with characteristic breadth of reference. All these essays are preceded by Christopher Frayling's fluent account of the role painting has played in the wider context of the College's long history.

Finally, Christopher Frayling is joined by Robert Cumming in interviewing a selection of artists; in conjunction with Lord Snowdon's masterful portraits they tell a compelling story of student days.

Like many things about painting, this exhibition embodies a paradox. It celebrates the work of artists and the birthday of an institution—yet artists fit uncomfortably into institutions. They are by nature loners, painters perhaps more so than others. Painting and poetry are the only art forms I know of which are embarked on and completed unattended. Without collaboration or interpretation, or assistance or editing, they are performed in solitude and born of reverie. One would be right in discerning a reluctance amongst the artists to be labelled members of a united group. Quite justifiably, their allegiances are elsewhere, in their studios and with the pursuit of their own mysterious alchemy.

This is not to imply that artists are typically social recluses: the larger proportion of those represented here have given a great deal of their time to teaching; many have worked in various fields of design; and some are distinguished writers. In researching this exhibition and its catalogue, a great deal more has been revealed than can be included. In this sense they should be seen as an introduction to the subject rather than the definitive account. Many areas of focus propose themselves: for instance, the great number of RCA painters who became War artists, or the numerous artists who designed for the stage or who illustrated books. Dr Robert Woof's exemplary exhibition, The Artist as Evacuee, which focused on the Painting School in the Lake District during the Second World War, is a lesson on how a small pocket of our past can be revealed as a treasure house of fascinating pictures and social history.

From a personal point of view, this exhibition has been researched to discover just what the tradition is to which I have become caretaker. The link between such disparate artists is sometimes close, but often tenuous. All that is certain is that for a particular period in their lives they inhabited the soaring Victorian studios on Exhibition Road. These days are numbered, as in a few years time we move to a new home close to the rest of the

Royal College of Art, and the studios will be passed to the Victoria and Albert Museum. I believe that buildings influence our behaviour, and so the future of painting at the College is as much in the hands of our architects as it is in my own or those of my successors. We can look forward to being integral once again with the disciplines of design, and that cannot be a bad thing from either point of view.

But whatever the benefits of closer fellowship and cross-influence, it is clear that in the growing climate of economic accountability, fine artists must assert their right to make things which have no practical use whatsoever. For it is these annoying and enigmatic things which, because of their very uselessness, are free to become a real vehicle for the powers of human thought and a true source of spiritual nourishment for our society.

The question repeatedly posed is: 'But can painting be taught?' The answer is yes, and it must be. That people are born with talent is unquestioned, but it should be made clear that, as in the case of writers or composers, dancers or actors, talent must be trained by constant practice, informed by the great achievement of others and challenged with intellectual rigour so as to nurture its continuing development. Painting is not a mere act of physical dexterity; it is first a statement of the intellect, and as such it is perceived and understood. As John Constable remarked in a lecture at the Royal Institute in June 1836: 'A self-taught artist is one taught by a very ignorant person.'

I would like to thank the Rector of the Royal College of Art, Jocelyn Stevens, who has shared in the vision of this ambitious exhibition and from the outset has given his whole-hearted encouragement, and the exhibition's Curator, Susie Allen, whose boundless enthusiasm and selfless ambition for this enterprise have been its inspiration and its driving force.

They both join me to express our gratitude to all the sponsors without whose support this exhibition and its catalogue could not have been made. In particular, we would like to thank Christie's Fine Art, through the friendly offices of Charles Allsopp, whose belief in the aspirations of the College has been a substantial fund of moral, as well as financial, support; Sir John Egan, who leads Jaguar Cars into an adventurous new field of sponsorship; and Gilbert de Botton of Global Asset Management.

We are grateful to the numerous lenders to the exhibition who are listed at the back of this book. They include the staff and trustees of public collections, many of whom went out of their way to help us: in particular, Alan Bowness and the Trustees and staff of the Tate Gallery, who kindly agreed to lend pictures at a very demanding time; the private art galleries who have generously given their time and provided us with photographs free of charge; the many private collectors and artists' families who have been willing to forfeit pictures from their homes; and the artists, many of whom went to a great deal of trouble to unearth student works and provide us with material from their private archives.

We would also like to thank the contributors to this book, especially Lord Snowdon, who has been a model to us all in the care and professionalism with which he made the portraits. All the artists enjoyed their time with him and found in him the understanding of a fellow artist. The authors of the essays and biographies have excelled themselves in writing such informative pieces to the very tight deadlines we imposed on them. In undertaking the daunting task of compiling all this material Marianne Ryan has brought her considerable expertise, coupled with good humour and endless patience. She and her partner, Michael Phillips, who carried out the design of the book, have provided advice, hospitality and friendship extended over many night-long sessions.

Su and John Miller of Colquhoun, Miller & Partners have been tireless in giving advice and support which we hope will eventually lead to the permanent re-structuring of the RCA's Gulbenkian Hall to make new galleries; in the meantime, our exhibition designer, Terry Robson, has created some excellent solutions for the present installation.

In organizing an exhibition of this size and complexity it is impossible at the time of going to press to list everyone who will help in some particular way. Many are listed at the end of this book, but in particular we would like to thank Vivien Duffield, Robin Hambro and Belle Shenkman for agreeing to give their help and advice; Marco Livingstone, Lynda Morris and Robert Woof who helped us track down special paintings; and Frank Thurston of the RCA Photography Department for his highly professional services. Finally, we would like to thank my secretary, Susan Warlow, and the exhibition's assistant, Sophia Citro, for their constant help and loyalty.

To the staff and students of the College's Painting School, I would like to offer my apologies for a winter of neglect. In return I offer them this exhibition as a tribute to their heritage and a challenge to their future.

Paul Huxley, November 1987

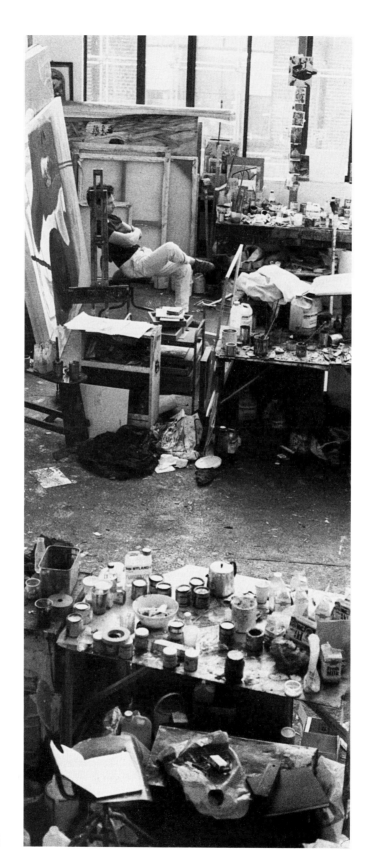

A studio in the Painting School,
1986

INTRODUCTION TO THE PAINTING SCHOOL

Christopher Frayling

The role of painting as a subject taught at the Royal College has been a matter of constant debate ever since the foundation of the College in 1837. The dilemma concerns the value of 'fine art' as opposed to that of 'design'. Tutors and students clearly saw part of the College's role as cultivating the talents of aspiring painters, while successive Government Ministries and Boards, under whose aegis the College came, continually emphasized what they saw as an unquestionable need for the College to train designers for industry, not 'fine artists' who might compete with the Royal Academy Schools. Principals of the College were frequently in the position of needing to placate Governments of the day and reassure them that tuition in painting and drawing was not going to jeopardize the emergence of designers for the 'manufacturing arts' of industry.

In the early years of the College, there were no separate Schools devoted to specific subjects as there are today. Each student was expected to learn a number of disciplines, ranging from the copying of antique and decorative works of art to the production of actual designs, and touching on varying skills and techniques that included painting, alongside illustration, print-making and fabric design. But well before the recognition of the Painting School as distinct from others within the College, the emergence of major painters was to demonstrate the importance of a painting faculty. Emphasis on drawing skills and the copying of artefacts was not able to divert the painterly talent of J. B. Yeats, a student from 1890 to 1893. He began his career as an illustrator, but quickly became a prolific and popular painter, joining the ranks of other ex-College artists such as Luke Fildes (1843–1927), Hubert

von Herkomer (1849–1914), Elizabeth Thompson (Lady Butler) (1846–1933) and George Clausen (1852–1944).

By 1900, there existed in its own right a School of Mural and Decorative Painting, with Gerald Moira as Professor; the argument over its role still persisted. Walter Crane, Principal of the College, promoted the idea that the School should nourish 'the lesser arts' with new visual ideas, but still insisted that each student should study both drawing and architecture in order to understand 'the unity of the arts' in their decorative aspect. His guideline was undermined by Professor Moira, who was criticized for allowing students more time for easel-painting than for other skills.

William Rothenstein, who became Principal in 1920, ran the Painting School himself in 1922 and again in 1930. He took up the Board of Education's advice that 'new blood and new ideas should at once be infused into the staff of the College'—an attempt on their part to bring the College back into the orbit of 'design for industry' but seen by Rothenstein as an opportunity to further blur the distinction between design and fine art. During his periods as acting Professor, he brought into the School (in chronological order) Leon Underwood, Edward Allston, Randolphe Schwabe, Cyril Mahoney, Barnett Freedman, Alan Sorrell, Percy Horton and Gilbert Spencer—all ex-students of the RCA—as well as Allan Gwynne-Jones (of the New English Art Club) and Walter Monnington. For the first time, the fine art Schools could be almost entirely staffed from their own graduates.

The vexed question of life drawing had also been a bone of contention. Considered essential by students and tutors alike, from the earliest years of the College, the subject

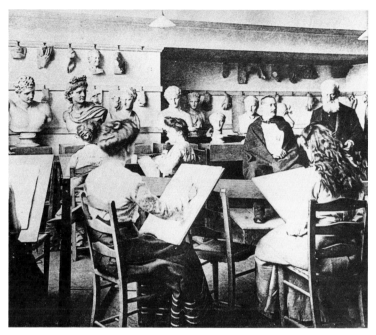

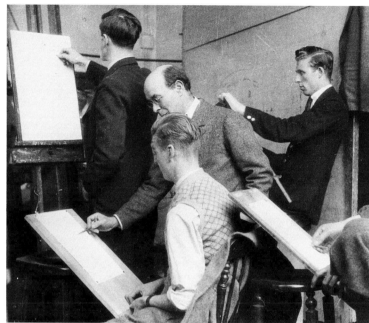

Women's life class in the early 1900s

William Rothenstein teaching in a life class, c.1930

caused concern to the authorities, who tried to insist that students concentrate solely on drawing 'from the flat' or 'from the antique'. Figure drawing seemed to them an unnecessary indulgence. The fine art lobby won, however, and by 1922 life classes were not only at the centre of the curriculum, but also an integral part of the design course. Helen Binyon, a student at the time, recalled the 'rather confusingly different advice' of some of the tutors:

> The door would open and in would come the Principal. Rothenstein's ideal was the pencil drawing of Ingres. He would go round the class, criticizing, advising, and perhaps sharpening the blunt pencil a student was trying to draw with, and then would go out. A little later, the door would open again: heads would turn to see who it was this time. A larger, clumsier man would stand waiting in the doorway. The weaker student felt a little shiver of fear. It was Leon Underwood, the exponent of 'Form', of cylinder and section; drawings would darken, line was out, shading was all important.

The School of Design existed separately from the School of Painting (as it was now known, having dropped the word 'Decorative' from its title in 1920) and the painting students were more than ever concerned to be given credit in their own field. Douglas Percy Bliss, a painting student contemporary of Helen Binyon, wrote:

> We painters who had passed the drawing exam were condemned to a course which consisted of little else but the representation of the naked human body in over-heated and over-ventilated rooms. Those who failed to draw up to the Professor's standards were 'kicked into the Design School'.

Looking back I regret that I had not been banished from the Paradise of Painters (for we felt ourselves to be the Elect) into the purgatory of the Design School. For my best friends were in Design.

The friends in question were Eric Ravilious, Edward Bawden and Helen Binyon, members of that 'outbreak of talent' which Paul Nash associated with the College in the mid-1920s. Rothenstein firmly believed that, instead of spending their final year preparing to become teachers, painting students should be involved in 'public art', as exhibitors, muralists or 'community artists'. He planned a series of public projects for student participation in London, including murals for St Stephen's Hall, India House, the Council Chamber in County Hall, employment bureaux in the docklands and Morley College, a commission carried out by Bawden, Ravilious and Charles Mahoney between 1928 and 1930. Mahoney's enthusiasm for mural painting kept the tradition alive not only within the College, but also in the public arena, where regular commissions were carried out over several years by the students.

The debate about the teaching bias towards the fine arts, divorced from industry, continued throughout the 1930s—the Hambledon *Report* of 1936 said: '. . . notwithstanding the prestige which it has achieved in various directions, it is impossible to feel that all is well with the Royal College'. There was talk of amalgamation with the Central School of Art and Design, or absorption into London University, even of closure. Gilbert Spencer, brother of Stanley, was Professor during these troubled years, having been hand-picked by Rothenstein to succeed him in 1938.

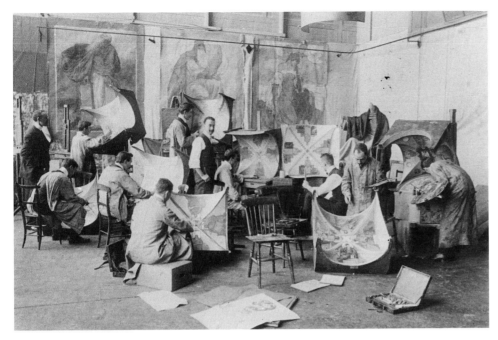

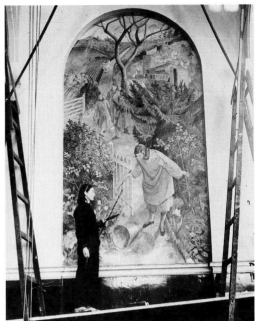

In the event, it was the Second World War—and Professor Spencer's consequent evacuation with the rest of the RCA to two fashionable hotels in Ambleside in the Lake District—which helped to save the College. *Picture Post* noted in 1943 that most of the students seemed to be turning into landscape painters:

> A throne, a model and a clutter of easels, paints and canvases litter a peace-time ballroom. Students design, weave and dye fabrics from experimental formulas in a converted cowshed . . . some have converted old pigeon lofts and garage attics into patched-up, white-washed studios, isolated above rickety ladders. Others may go off into the mountains sketching for several days at a time . . .

After the War, Spencer saw the School safely back to Exhibition Road, but did not stay to witness what became known as the 'Darwin Era'—he handed over the Professorship to Rodrigo Moynihan in 1948.

By the time Robin Darwin became Principal in 1948, he was well aware of the pre-War pressure to realign teaching at the College, and he had agreed with the Ministry of Education that 'to provide a training for the professional easel-painter' was emphatically *not* a priority. So it is paradoxical that the reforms of the Darwin era (1948–71)—all of which implied (as he wrote) that 'only in a fairly *narrow and concentrated* field will a student's interests be sufficiently aroused to evoke his deeper creative instincts'—really made 'Exhibition Road' a force to be reckoned with. Robin Darwin, a painter himself, proved an adept promoter of the College's distinctive contribution to the fine arts at a time when many undergraduate art colleges were offering a broader, more

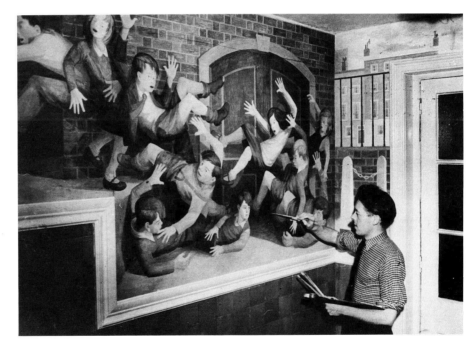

diagnostic approach. If his public statements in the early years were mainly concerned with 'the training of the industrial designer', he equally emphasized (in private or internal documents at first) that studies in painting and sculpture were not merely continuing 'on sufferance or for the sake of tradition', but as an essential adjunct to studies in design. It was unthinkable, he wrote in successive *Annual Reports*, to have an institution devoted to teaching and research in design, in isolation from the plastic arts.

Men's class in the Mural Room, early 1900s

Evelyn Dunbar working on one of the murals at Brockley School, Kent, c.1936

Malcolm Hughes completing a mural for the Children's Section of Chelsea Public Library, 1949–50

11

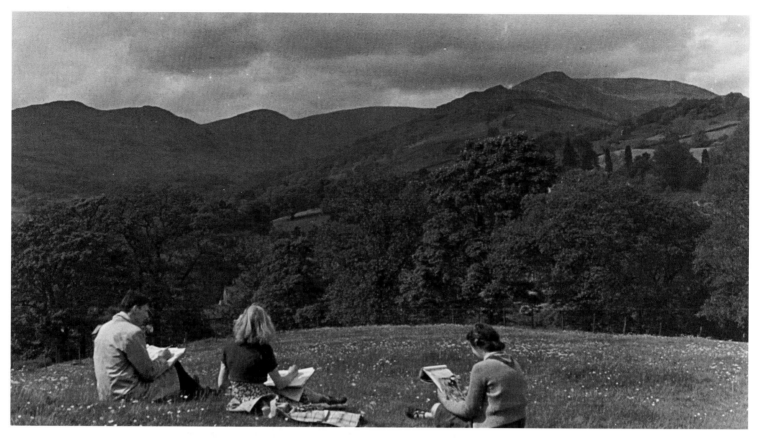

College students, evacuated to the Lake District, 1943

No further justification was necessary, whatever the Ministry might say and whatever had been agreed way back in 1947–48.

If the mind of the College, in the Darwin era, was set on emphasizing the number of design students who went into industry—under the new corporate image of the Phoenix—its heart seemed, in most students' memories, to lie in the Principal's red-damasked office in the Painting School. But when the College's concrete and glass main building was opened at the new site on Kensington Gore in the early 1960s, and when it became clear that there would only be room for the design schools and the central administration—leaving the Painting School behind, in Exhibition Road—Darwin became very concerned that the essential links which bound the institution together might be broken; as he wrote, prophetically in 1959:

> It will only be by the most determined self-discipline and sense of purpose that the Fine Arts will be able to bring their vital influence to bear on the College's other activities. Under these very difficult conditions it may, indeed, be hard to combat that sense of superiority which can only too easily be nurtured by enforced isolation.

Professor Carel Weight, who succeeded Rodrigo Moynihan in 1957, was also keen to point out the interconnectedness of the Painting School with the rest of the institution: 'A lively Fine Art Department sparks off ideas. There is a strong two-way traffic.' He was quoted as saying this in the mid-1960s, a time when Zandra Rhodes was adapting motifs from David Hockney's student paintings. Meanwhile Hockney was photographed by David Bailey as if he was a rock star; Derek Boshier did the lettering for Pauline Fordham's boutique 'Palisades'; the work of the Archigram architectural group referred to the visual language paintings of Peter Phillips and Joe Tilson; Barbara Brown designed her op-art inspired 'Caprice' fabrics; and some students of furniture experimented with throwaway paper furniture which looked like sculpture.

With this two-way traffic in full swing, it was not always easy to disentangle the College's promotion of art in design from its promotion of professionalism in art proper. From the later 1940s onwards, for the first time ever there was a sustained attempt to present the work of successive generations of RCA painters to the exhibition-going public, often through the medium of the annual *Young Contemporaries* show. Over the years, these London exhibitions showed the neo-Bomberg paintings of Frank Auerbach and Leon Kossoff; the Kitchen Sink paintings of John Bratby, Jack Smith and Edward Middleditch; the Abstract Expressionist paintings of Richard Smith, Robyn Denny and William Green; and the work of the so-called 'Pop' generation, heralded by the autobiographical

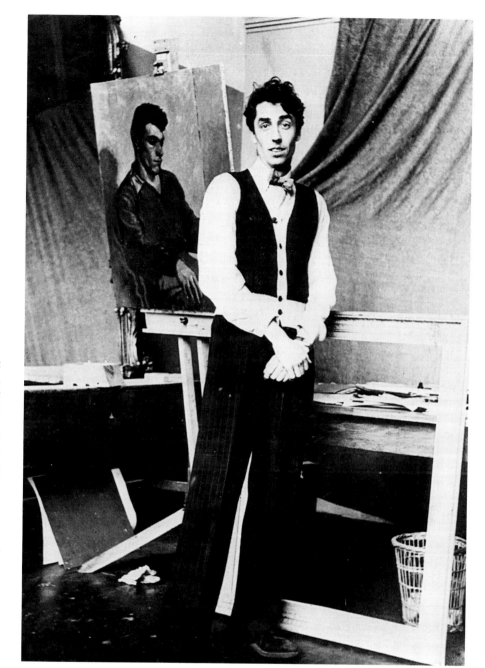

John Minton, c.1950

paintings of Peter Blake and the literary Symbolist paintings of R. B. Kitaj—David Hockney, Peter Phillips, Allen Jones and Derek Boshier, exhibiting at the same time as Patrick Caulfield and 'Billy Apple'. It has been said of the *Young Contemporaries* of this generation:

> Perhaps the traditional College connections with design influenced these particular students, perhaps also they picked up on a new feeling in the air and drew it into their work, adopting a career commitment which underlay all their actions. Patrick Procktor, who was a student at the Slade, identifies the difference between the two colleges. The Slade tradition placed emphasis on painting as research, while the RCA stressed the importance of the display object . . .

The year 1962 has been called 'the high-water mark of the *Young Contemporaries*' and, as if to imply that it represented a full stop, the Arts Council immediately compiled a touring show called *Towards Art?*, which catalogued the contribution of the RCA between 1952 and 1962. Robin Darwin insisted on the title —'I say there *is* to be a question mark'—much to the annoyance of the Painting staff, who felt it was something of a slur on their efforts. In his introduction to the catalogue, Professor Carel Weight pointed out that although in retrospect certain 'styles' had become associated with the RCA, at any given moment there was likely to be 'a great variety of work which reflects the policy which has encouraged every student to develop his art in his own way'. To ignore this, he implied, was to succumb to the new myth of the RCA:

> When Mark Rothko recently visited the College he seemed astonished that students painting in such contrasting styles could work together in such complete harmony, often stimulated and inspired by one another. . . These ten years have been a period in which the influence of the College has had its effect upon the course of art in this country.

In 1952, the students were not *all* spreading it on with a palette knife, just as in 1962 they were not *all* painting packets of Ty-Phoo tea. Weight concluded, again by the gentlest of implications, that the students who managed to avoid being the most dedicated followers of fashion were

13

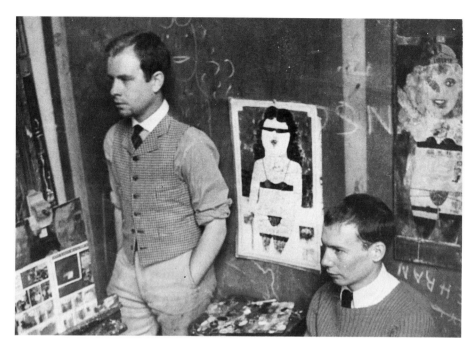

Peter Blake (*left*) and Richard Smith at the College, c.1956 (with *Children Reading a Comic* on Blake's easel)

Robyn Denny (*left*) and Richard Smith in a College studio, 1957

likely to be the ones who really 'assimilated the complex problems of existence in our modern world'.

The student magazine *Ark*, to which a lot of young painters contributed, is a useful barometer of changes in the School at this time, from Joe Tilson's lithographs of calypso singers in London clubs (complete with names and addresses) to Robyn Denny on mosaics and Peter Blake's 'true romance' style strip cartoons. *Ark* eventually went down in the 1970s with a review of the RCA drag-queen contest, which began with the words 'life is decomposing in front of our eyes . . . the first to be corrupted are bound to be the artists because *they* are the ones who are aware and will accept first'. By this time, the College had been granted the status of a university institution, and, under Professor Peter de Francia, the Painting School was beginning seriously to reflect on whether the painters wanted the RCA to be 'with it' when a university's job was usually to stand outside it. 'Under Darwin,' de Francia told the press, 'we were geared up to produce stars. We're not in a period of stardom now. It's far better to work without the illusion of a Bond Street show just around the corner.'

Throughout the 1970s, then, the traditional activities of the painting studios co-existed with a bit of community art and a lot of intense discussion about the social role of the artist, while work in mixed media (performance, video, installations) was banished to the upper floors of the Darwin Building at Kensington Gore. It was a time when the 1960's 'art of success' (as the new newspaper colour supplements had dubbed the pop era) was reassessed, and when apparent breaks in the continuity of recent College history were seen to have been over-sold by those who took

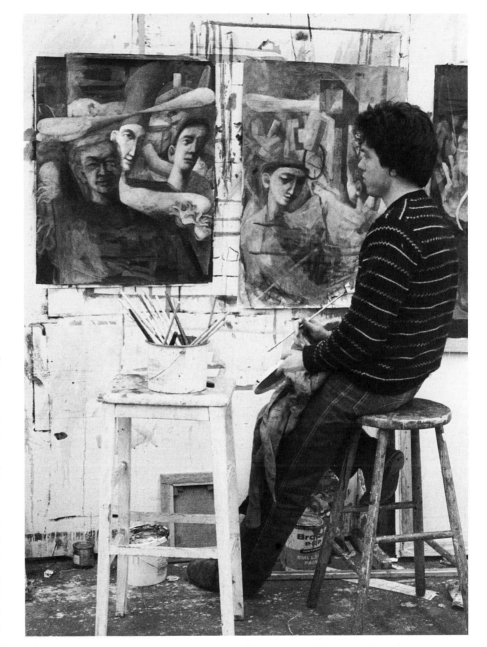

part in them. There were, it now appeared, clear lines of continuity, from the brown realism of Euston Road to the Kitchen Sink paintings of the early 1950s; from Kitchen Sink to the everyday figuration of Peter Blake; and from this to the 'pop' of the throwaway package. The continuity was as much to do with staff as with successive generations of students: painters such as Horton, Moynihan, Weight, Minton, Ruskin Spear, Robert Buhler and Leonard Rosoman. Under their guidance, the politics of the 1930s had steadily given way to the pop imagery of the 1960s. Maybe it was time to bring the politics back.

To some, it looked as though Darwin's prophecy of 1959 was coming true. To others, this kind of radical thinking was exactly what the Painting School needed. The end result was an almighty collision, with the College authorities asking the School in 1980 to 'infuse aesthetic standards and values for the designers', and both staff and students of Painting replying that fine art could not be applied to design in this way—studied for its aesthetic standards and then put to something called practical use. The concept was very out of date where both art and design were concerned.

Throughout all these changes of direction, and changes of philosophy, the studios of Exhibition Road have continued to be the temporary home of a small army of marvellous painters, who, when they have graduated, have often tended to play down the significance of the experience, as if the admission that they might have been influenced in some way could diminish their stature as artists. This is ironic, since the concept of 'originality' is such a relatively recent addition to the purposes of the College. There is another irony as well: although the

College was founded to introduce artists to the joys of 'manufacturing industry', it has always managed to become (and remain) an *art school* as well as a *design school*. And certainly since the turn of the century, Painting (whether 'decorative' or otherwise) has been at the centre of the institution.

Paul Storey, a 1987 graduate, in the Painting School

Frederick Etchells
Composition—Stilts, 1914–15
Gouache, 32 × 23 cm
The British Council
Cat. no. 5

THE EARLY MODERNISTS:
NASH, BURRA AND EVANS

Richard Cork

The most significant painters connected with the Royal College of Art during the first four decades of this century, either as students or teachers, worked at a time of momentous change in British art. Frederick Etchells, one of the first contributors to this exhibition, was so alert to the revolutionary significance of modern French painting that Roger Fry included him in his second seminal Post-Impressionist survey of 1912. Here, at the Grafton Galleries, London was introduced to an extensive range of young artists from France, Russia and England who were united by their zeal for pictorial renewal. Gilbert Spencer, like his more impressive brother Stanley at the Slade, was excited by Gauguin's monumental simplification of form. But Cubism was included in Fry's show, and Futurism had been imported from Italy only a few months before to bombard Britain with its exuberant conviction that modern artists should celebrate the power of the machine age. By 1914, Etchells was so involved with these heady new ideas that he joined forces with Wyndham Lewis and other allies to produce a home-grown avant-garde movement: Vorticism. With explosive energy, it was determined, above all, to prove that British painters and sculptors had an irrepressible part to play in the experimental momentum which transformed Western art during that brief, yet extraordinarily vital period.

The brutal onset of the First World War ensured that the Vorticists' adventure was short-lived. By the time the Armistice arrived, many of them had moved away from their former interest in near-abstraction and begun to explore more representational alternatives. It was a time of temporary exhaustion and uncertainty, when many artists found solace in re-examining their relationship with

tradition. Many members of the emergent generation, however, soon found themselves caught up in the next great wave of Continental innovation. As John Tunnard would discover after he left the College in 1923, the Surrealist movement offered immense possibilities for the exploration of dream images. But Tunnard, like John Piper after him, was also drawn for a while towards the structural severity of the abstractionists. Both these forces—the desire to investigate the irrational impulse of the subconscious and the urge to purify art of everything except its essential form—were enormously influential during the inter-War years. They helped to stimulate the development of the three artists I will concentrate on in this essay, all of whom arrived at a distinctive fusion of Continental Surrealism and a more indigenous fascination with British life and landscape.

Paul Nash, the oldest of them, was the brother of John Nash, who taught in the Design School at the College during the 1930s. Although they shared many concerns, Paul was by far the greater painter, and his relationship with the College began when he was appointed an assistant in the School of Design on 1 September 1924. His arrival there was a manifestation of the policy instituted by the newly appointed head, William Rothenstein, who had overcome substantial obstacles and persuaded his Board to employ artists on a part-time basis. As James King has pointed out, Rothenstein 'was in the process of transforming the RCA from an institution which produced only designers and teachers of art into a fully fledged art school.' His success in attracting artists as outstanding as Nash, whose work Rothenstein had admired for a long time, played a crucial part in the realization of this reform.

Paul Nash
Nocturnal Landscape, 1938
Oil on canvas, 76.5 × 101.5 cm
Manchester City Art Galleries
Cat. no. 11

Cecil Collins
The Voice, 1938
Oil on wood, 122 × 152.4 cm
Peter Nahum Gallery, London
Cat. no. 41

Moreover, Nash's presence in the Design School was doubly significant, for Edward Bawden remembered it as

> the habitat of the lowest of the low. The Royal College of Art in the early twenties was smaller than the smallest Provincial School today: it was divided into four schools, Painting, Sculpture, Engraving, Design & accordingly the first three ranked as Fine Art & the last as Applied Art. This distinction, absurd though it is, is still maintained today by dealers for commercial reasons, but then it was as real as being a child of acknowledged parentage or being an orphan, the offspring of a gentleman & a whore. As a designer I felt it keenly.

Nash was just the right artist to rectify matters, for by the time he began teaching at the College he had succeeded in moving from a marginal position in British art to a place of central importance. His early pictures were limited to small-scale drawings and watercolours—private art executed by a retiring and diffident introvert. Nash's lack of confidence in his ability to graduate to the more ambitious medium of oil painting was matched by an unwillingness to stray beyond the confines of his immediate surroundings. He was, however, prepared to take those surroundings and use them as a springboard for highly symbolic —not to say visionary—interpretations, as is evident in his response to the family garden in Iver Heath, Buckinghamshire, or the distinctive hilltop beechwoods at Wittenham Clumps, Berkshire. The two locations were Nash's umbilical cords, attaching him to powerful feelings which found eerie physical form in his painting of a trio of sinuous elms silhouetted against a blanched moon. The trees cluster together for reassurance, disconcerted perhaps by the shadows which their trunks cast across a stretch of desolate open ground.

Such images are remarkably personal achievements for an artist in his early twenties. But if we remember that they were carried out at a time when England was fiercely debating the impact of Cubism and Futurism, their loyalty to the English landscape watercolour tradition in general, and Samuel Palmer in particular, seems almost archaic. Nash was not yet capable of coming to terms with the European avant-garde that impressed so many of his contemporaries. For better or worse, his art was home-grown in the most literal sense of the word. While the Vorticists were evolving a machine-age abstraction, aggressive enough to presage the onset of the First World War, he was still drawing his Pre-Raphaelite fiancée plucking corn at Iver Heath. Dante Gabriel Rossetti, not Filippo Marinetti, claimed his deepest loyalties, and if Nash had never moved on from this sheltered dingle he would not now be regarded as one of the most important British artists of the twentieth century.

Whether he realized the extent of his dilemma in 1914 is open to question. He had already enjoyed a modicum of critical success, and English collectors were far more predisposed towards an artist who reminded them of tradition than they were towards those who awakened them to present-day change. But Nash never really had to examine the merits of the new priorities which now entered into his work: they were thrust upon him by the unnerving ordeal of active service in the Ypres Salient, and their results were evident at once.

The trees which had previously been thickly foliated and rounded into womb-like groups were now naked and

John Nash
Dorset Landscape, date unknown
Oil on canvas, 50.5 × 60.7 cm
Carlisle Museums and Art Gallery
Cat. no. 12

torn, each standing in forlorn isolation and rising out of gouged mud. The only way to tackle this terrible austerity was to develop an art of equal starkness, with jagged forms and pared-down simplification. At a time when many experimental artists were forced to undergo an agonizing reappraisal of their earlier priorities, Nash took his cue from his friend Christopher Nevinson and made his work take on an urgency that met this bleak destruction on its own terms. He wrote angrily from the battlefield of Passchendaele:

> The rain drives on, the stinking mud becomes more evilly yellow, the shell holes fill up with green-white water, the roads and tracks are covered in inches of slime, the black dying trees ooze and sweat and the shells never cease . . . It is unspeakable, godless, hopeless. I am no longer an artist interested and curious, I am a messenger who will bring back word from the men who are fighting to those who want the war to go on for ever. Feeble, inarticulate, will be my message, but it will have a bitter truth, and may it burn their lousy souls.

There was nothing feeble or inarticulate about the work Nash proceeded to make. He started painting in oils for the first time, encouraged by a War Artists' commission to spread his apocalyptic panorama across picture-surfaces larger than he had ever tackled before. In an extended series of landscapes, he charted with painful compassion and despair the rape of the earth he had once cherished for its inviolate secrecy. Nash, who had always been hypersensitive about places and the primordial emotions they aroused in him, proved tough enough to elegize over a foreign place brutally shorn of its natural identity. It was

an extraordinary transition for him to achieve, and I doubt if anyone who had known his work before the War could have predicted it. But the significant aspect of this conversion from pastoral to militant was that it derived, as had his early works, from a passionate relationship with the countryside. The harshness of the Front Line required him to learn lessons from an experimental form of art which alone could cope with the skeletal travesty of nature confronting him now.

The War amounted to a traumatic watershed for Nash, and he was never able to recapture his earlier style when he returned to civilian life. The most placid and optimistic of the landscapes he painted in the 1920s are also the most tepid and unconvincing, as if he no longer believed in their kind of beneficence. In order to operate at a consistently effective level, Nash had somehow to discover a way of transfusing the landscapes he loved best with the serum of the profound experiences which war had injected into his system. So he cast around for the kind of stylistic models that had spurred him forward in 1917, finding them this time in the disturbing subconscious imagery of Surrealism. Contact with artists like René Magritte and Giorgio de Chirico convinced him of the need for a radical initiative, and in his manifesto of 1933 announcing the formation of the Unit One group he declared: 'Nature we need not deny, but art, we are inclined to feel, should control.' In other words, Nash wanted to suppress the side of his temperament which relied too passively on a straightforward study of the landscapes he loved best.

But it was not a simple transition to achieve. The more self-consciously modernist he became, the more severed his art was from the mainsprings of his inspiration. Even a

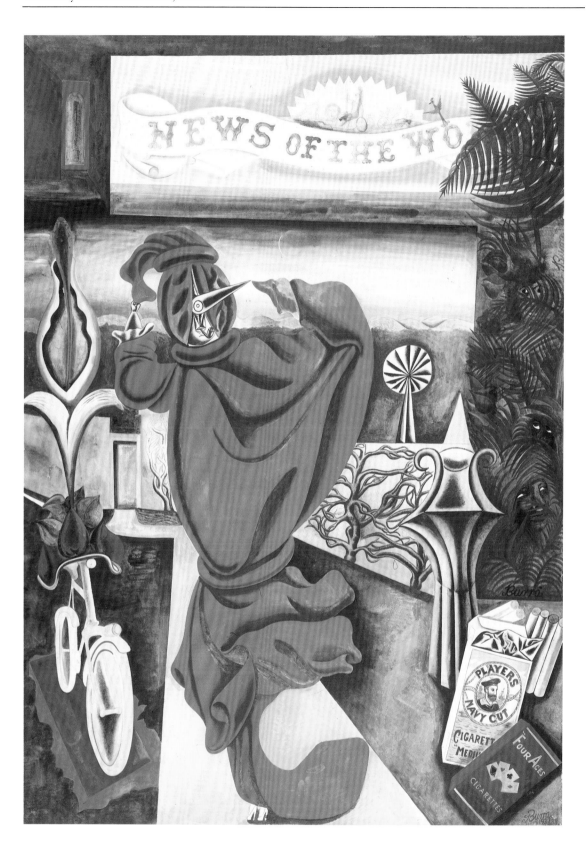

Edward Burra
News of the World, 1933–34
Gouache, 90 × 54.9 cm
Bury Art Gallery and Museum
Cat. no. 20

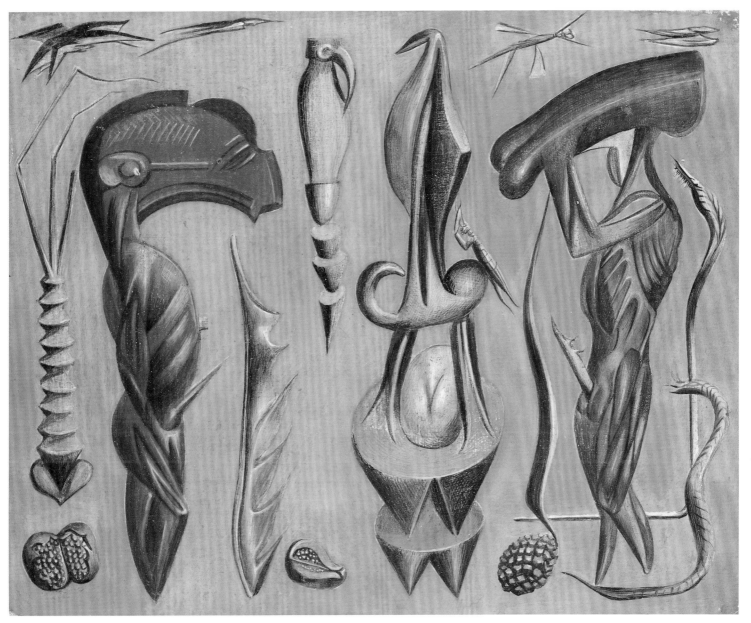

Merlyn Evans
Polynesian Fantasy, 1938
Tempera on panel, 19.5 × 24.5 cm
Leeds City Art Galleries
Cat. no. 51

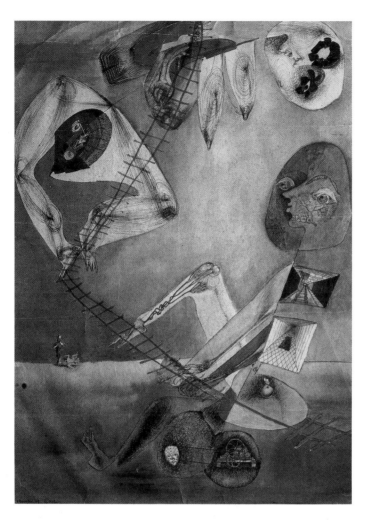

Sam Haile
Couple on a Ladder, 1941–43
Ink, watercolour and collage,
58.4 × 45.7 cm
Private Collection
Cat. no. 55

sensible compromise did not guarantee success: the surreal objects he introduced into his paintings sometimes clash with the naturalistic treatment of the countryside which surrounds them.

All the same, he drew strength from an awareness of belonging to the Romantic tradition in British landscape painting—a movement which was revalued in a 1936 article called 'England's Climate' by Geoffrey Grigson and John Piper, the latter of whom had studied at the College towards the end of the 1920s. The sincerity of Nash's struggle compels respect, and when he did manage to arrive at a genuine synthesis of avant-garde ideas and empirical observation his triumph is memorable. For me, it comes when *Totes Meer* metamorphoses the shattered metal of wrecked German aircraft into the frozen sea which Nash had painted in previous years. The crashed remnants of the machines lie tangled and inert in the heart of a landscape brutally disrupted by their aggression. But the awesome sea-change which these instruments of war are already undergoing in the picture helps to rob them of their former harshness. Rather than painting a

propaganda image, to rejoice over the death of German pilots, Nash's gentle canvas is an elegiac work which mourns the tragic loss of all the young men buried in this chilling nocturnal graveyard.

In Nash's final years, his obsessive involvement with the equinox enabled him to give a wholly nature-based rural view the full symbolic force which eluded his more literal attempts at symbolism. *Landscape of the Summer Solstice* or both versions of *Landscape of the Vernal Equinox* surely represent the summation of Nash's art. They marry the observant eye to the dream-haunted brain so harmoniously that the one is at last indistinguishable from the other.

Although Nash did not teach at the Royal College of Art for long—he had left in 1925, returning for a second spell of teaching from 1938 to 1940—students as outstanding as Eric Ravilious and Edward Bawden were grateful for the stimulus he provided. In 1981 Bawden still remembered very clearly how Nash

> talked to each of us individually in the manner of two artists exchanging their personal experiences. There was no artificial barrier, no talking down as between God and man, teacher and the one who was being taught. Nash brought into the dingy mustiness of the room a draught of fresh air . . . he looked at work most carefully seeking to discover our thoughts, what we were trying to do and never, never did he impose his own point of view.

If Nash had tried to impose his own 'view' on Edward Burra, the brilliant and precocious painter who studied at the College from 1923 to 1925, he would not have met with much success. For Burra, who soon befriended Nash and

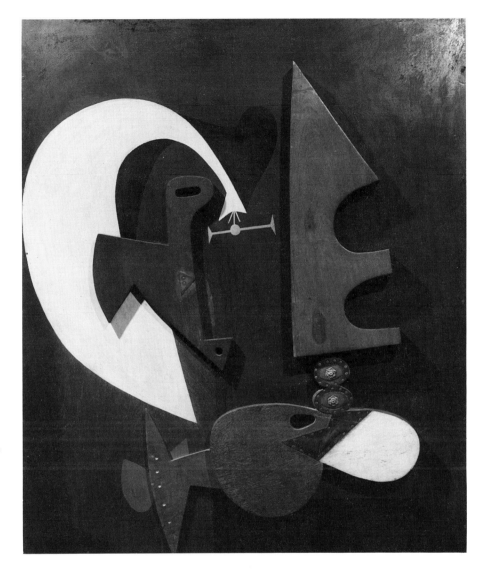

accompanied him on a memorable trip to France early in 1930, knew just how to locate and define his bizarre imaginative world. In 1926, only a year after leaving the College, he produced a watercolour called *Market Day* where 'Burra-land' is already realized in all its raffish yet exotic actuality. The twenty-one year-old artist displays all the swaggering assurance of the more mature work of the following decade. He revels in the two dark-skinned youths weaving an agile path through the crowded Mediterranean port. Dressed to kill in flat caps, freshly-laundered shirts and luminous blue trousers full of suggestive bulges, they are frankly erotic figures. Prostitutes flaunting orchidaceous headgear stare at them expectantly, but they pass by unmoved. Burra prefers these lithe and stylish young men to retain their mystery untouched by the press of people in the street.

At this stage in his career Burra had not travelled very extensively, but he had seen enough of Europe to realize that it offered a beguiling alternative to the England he knew best. His home town of Rye, where Burra Senior was a dignified JP, represented the acme of picturesque bourgeois respectability. So he seized with relish on the multi-racial, working-class, garish and uninhibited spectacle on offer in teeming harbours like Marseilles and Toulon. Although he always regarded Rye as his base, even after his parents had died, Burra needed to escape from its stifling propriety in his art and create a fantasy world where English repressions had no place.

Indeed, his early works take an impish pleasure in subverting the Rye ethos whenever they can. A wicked 1929 gouache takes us into the wood-panelled interior of a Sussex tea-shop. An impeccable lady sits in the foreground imbibing her afternoon beverage with a delicately crooked little finger. But a leering waitress, stark naked except for a cluster of leaves around her loins, pours tea straight on to the lady's hat. She appears to be taking no notice, either of the downpour or of her *louche* companion. The spirit of inter-War Berlin has invaded the tea-shop completely, filling it with high-kicking attendants, art deco lampshades and bowler-hatted customers staring goggle-eyed at the ample breasts dangling over their tables.

Would Burra really have liked Rye to transform itself into a Weimar cabaret? All the evidence suggests that he used his family house as a bolt-hole, where the intoxicating sights he had witnessed abroad could be refined and intensified in tranquillity. A lifelong invalid who staved off loneliness by cultivating a small circle of loyal friends, Burra needed the reassurance which staid old Rye provided. Yet he could not prevent himself from infusing it

Ceri Richards
The Sculptor and his Model, 1936
Relief construction, wood and metal,
103.5 × 85.5 × 15 cm
Ceri Richards Estate
Cat. no. 31

25

with both glamour and sleaziness. In the marvellous *Saturday Market* of 1932, a burly vegetable seller fingers the bulbous peppers on his stand while cats scavenge in the rubbish-choked street. Bold capital letters above a shop front spell out the name of the 'Home & Colonial', a Rye landmark. But the surrounding squalor is more akin to an East End slum, and picking her way fastidiously through the refuse is an ornate Hollywood movie-queen. A slit in her opulent gown lets a shiny leg appear, taunting the vegetable seller, who eyes her with sidelong greed.

She is, however, more like a projection of the man's sexual fantasy than a real market customer. Her brazen, camp allure foreshadows a later watercolour of Burra's favourite actress, Mae West, whose film *Belle of the Nineties* inspired him to rhapsodize about the moment 'when she stands draped in diamonte covered reinforced concrete with a variety of parrots feathers ammerican [*sic*] beauty roses & bats wings at the back and ends up waving an electric ice pudding in a cup as the statue of Liberty.' This unpunctuated paean is typical of many passages in Burra's idiosyncratic letters, reporting on the excitement of cinema-going. His looming close-ups of hands, faces, guns and playing cards are as indebted to cinematic techniques as his plunging perspectives.

In the end, though, their contribution cannot be disentangled from the equally powerful impact of Surrealism, which also affected the development of John Tunnard and two near-contemporaries at the College: Cecil Collins and Ceri Richards. The Surrealist movement confirmed and deepened Burra's involvement with macabre dreams. Judging by the hallucinatory path taken by his work in the 1930s, he may well have been attracted to the drugs smoked by the sprawling inhabitants of his *Opium Den*. For Burra leaves Rye and even Marseilles far behind as he explores an irrational universe, where Player's 'Navy Cut' is juxtaposed with a whirling dervish, and bird-women stalk ruined cities. Although never a politically committed artist, Burra was all too aware of the gathering unrest in Europe during the 1930s. His fascinated preoccupation with decadence and mortality, which produced a rancid masterpiece in *John Deth* as early as 1931, grew with the decade. Smoking pistols and references to masked torturers proliferate by the time he becomes a first-hand witness of the conflict in Spain. The horrors of civil war precipitated Burra into a more thorough-going confrontation with violence, and the scale of his watercolours increased along with his anguished response.

He still held the world at a remove, nevertheless. Far from experimenting with a more documentary approach, Burra conveys his disquiet through an increased involvement with theatricality and artifice. *The Three Fates* are shown, ghoulish beneath their hoods, before a stage-set city where public executions are in progress. Immense diabolic figures wield a ball-and-chain or preside over indiscriminate slaughter. One of them, a scarlet apparition frankly entitled *Beelzebub*, smiles as the killings proceed. He provides a reminder that Burra once described, in a confessional moment, how 'the very sight of peoples faces sickens me. Ive got no pity it realy [*sic*] is terrible sometimes Ime quite frightened at myself I think such awful things I get in such paroxysms of impotent venom I feel it must poison the atmosphere.' It certainly poisons Burra's most vicious Spanish pictures, but there is

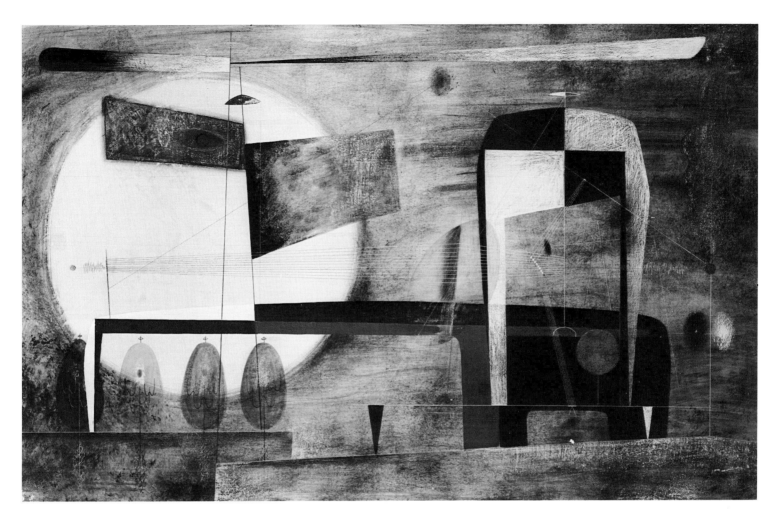

John Tunnard
Installation A, 1939
Oil on canvas, 76.2 × 122 cm
Laing Art Gallery, Newcastle-
upon-Tyne,
Tyne and Wear Museums Service
Cat. no. 15

at the same time a cartoon-like exaggeration about *Beelzebub*'s preening pose which proves that Burra never quite lost his sly humour. Since his roots lay deeply embedded in the great satirical tradition of Hogarth, Rowlandson and Gillray, impish irreverence continually intrudes.

After the War his work became quieter and more directly observant again. Images of England predominate, but the old sense of unease never entirely disappeared. He even found it lingering in a ghostly mound of apple blossom, and a giant sliced melon still transmits a troubled sexuality which Burra may never have finally resolved. His greatest achievements in these later years are the landscapes. Not for a moment content with cosy images of Sussex cottages, Burra took to the motorway in his sister's car and produced some mesmerizing watercolours of Dartmoor and Connemara at their bleakest. Lurid pantechnicons barge up mountainous slopes, while the Forth Bridge is seen from a terrifyingly vertiginous angle. Although the wry comedy is still there, the isolation of these remote settings predominates. And a year before

his death the figures who had once been so extravagantly alive grow limp and transparent, as if aware that the end was near.

One admirer of Burra's war pictures was Wyndham Lewis, who declared: 'I share Burra's emotions regarding war: when I see the purple bottoms of his military ruffians in athletic action, I recognize a brother.' Lewis's work, both as an artist and a writer, had even more in common with the memorable images produced during the War years by Merlyn Evans, who studied at the College from 1932 to 1934. Unlike Nash and many other British painters, Evans was never able to secure government commissions in the Second World War. Isolated in South Africa, where he had settled in 1938 after despairing of London's indifference to his work, he eventually found himself fighting with the Eighth Army in North Africa and Italy. It was a miracle that he managed to complete a significant body of work at this difficult time. His determination, however, was as formidable as his ingenuity. He executed one painting, *Nocturnal Fantasy*, during twenty-four-hour periods of leave in Johannesburg.

27

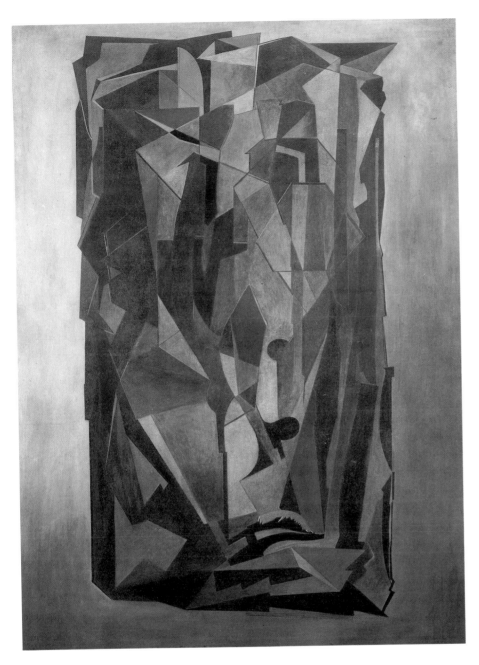

Merlyn Evans
Day and Evening, 1932
Tempera on canvas, 176.5 × 127 cm
Estate of the Artist/Mayor Gallery,
London
Cat. no. 50 student work

Another picture was packed into a shell carton for safety, and several more were painted on a makeshift easel constructed from German artillery equipment. He even completed an intricate tempera *Crucifixion* in some fields near Venice while erecting prison camps for the captured Germans with wooden stakes and barbed wire.

Why was the indefatigable Evans able to paint such deeply considered images in circumstances which would have defeated most artists? The main answer can be found in the character of his pre-War work. He had, in a sense, been preparing himself for such a task throughout the

1930s, when his acute awareness of social unrest and political conflict led him to develop a harsh, uncompromising vision. Even as a student at Glasgow School of Art he witnessed the daily looting and violence which accompanied the General Strike, and by the time the Depression really set in Evans's outlook had been scarred by the perpetual gang warfare on Glasgow streets. A trip to Berlin on a travelling scholarship in 1931 confirmed that the malaise was widespread. 'Berlin was lecherous and poverty ridden,' he wrote later, recalling the sound of gunshots and the wretched futility of the prostitutes parading at night.

Evans's earliest works do not deal in a direct way with this mounting aggression and despair. A canvas called *Vertical Crustacean*, handled with a sophistication quite remarkable in a twenty-year-old, is inspired by plant and marine forms. Precociously interested in abstraction, and yet committed to the painstaking refinement of tempera, Evans creates an image at once mysterious and precise. It seems to imply an involvement with organic growth, curving and twisting up the picture-surface with sinuous elegance. But there is an aridity about *Vertical Crustacean* which signifies pessimism as well. He originally called it 'Bright Sterility', and his desire to give desolation a stark, clinical clarity grew throughout the 1930s.

The sources employed by Evans seem far removed from slump and civil unrest. According to him the starting-point for *The Conquest of Time*, which became the best-known of Evans's early images when Herbert Read reproduced it in his book *Surrealism*, 1936, was a kingfisher 'still beside the moving river'. But by the time he completed this complex interlocking structure, its menacing mood

had become impossible to ignore. More reminiscent of the dockland machines Evans used to admire at Clydeside, this sinister presence extends sharply pointed arms towards an unseen enemy. Although he called his largest pre-War canvas *Time King (Vertical Abstraction)*, this predatory form bristles with bayonet-like weapons. It seems to be preparing, all too prophetically, for the conflict ahead, just as the Vorticists had anticipated the mechanized aggression of the First World War in many of their pre-1914 images.

Evans's debt to the Vorticists is substantial. His interest in abstraction was fortified by illustrations in a book about Lawrence Atkinson, whose rigorous sculpture played a considerable part in determining the spare, angular forms of Evans's carvings. His sculptural experiments were short-lived, however, and they lack the demonic energy he was able to inject into paintings. By February 1938, when he painted *Distressed Area* and thereby heralded his fierce sequence of War pictures, Evans was convinced that the artist had a duty to reveal 'the aggressive instinct for power and destruction'. This remorseless image is set in parched wilderness, where a blood-flecked vulture hangs over a desert incapable even of sustaining a cactus. It is a world occupied exclusively by beasts of prey and humans so hard and fossil-like that they appear to be beyond any redeeming tenderness. Lacking the grotesque humour of Dali's *Autumn Cannibalism*, and the eerie lyricism which Tanguy gave his moonscapes, Evans concentrates on the evil of war with ruthless precision.

When Hitler and Stalin signed their infamous non-aggression pact in August 1939, he lost little time in pillorying them as *The Chess Players*. Their teeth exposed in robot leers, the two dictators lock their arms like pincers and stare down at a chessboard where other nations' pawns stand vulnerable and alone. It is a hellish image, far more alarming and manic than James Gillray's comparable caricature of Pitt and Napoleon carving up the plum-pudding of the globe. For Evans has ensured that no wit alleviates the grim ritual enacted in this claustrophobic chamber. The smiles gleaming on his conspirators' metallic faces are devoid of joy, and as merciless as the grinning features of *The Looters*, who run amok in a painting prompted by the Italian occupation of Abyssinia.

Both these pictures were executed in 1940, when Evans's reaction to the War was at its most savage and indignant. But because Hitler's attempted subjugation of the world went on to fulfil the most pessimistic fears Evans had previously harboured, his subsequent War paintings are no less lacerating. Even the final phase of the conflict did not tempt him to create a more positive art: in 1945 his *Paesaggio Tragico* mourned a European landscape ravaged beyond recall, and a blood-red *Crucifixion* attended by insects is almost as ferocious as the relentless triptych which Francis Bacon first exhibited in the same year— *Three Studies for Figures at the Base of a Crucifixion*. Evans refused to let the War's end soften his anger or lessen his vigilance. The final painting of these years, *The Prisoner*, was triggered off by the Nuremberg trials, and allows a manacled figure to dominate his cell-like surroundings. Captive he may be, but Evans gives his squat body a brutal power which implies an ability to break free and assert the rule of tyranny with renewed venom. The warning retains its pertinence undimmed today.

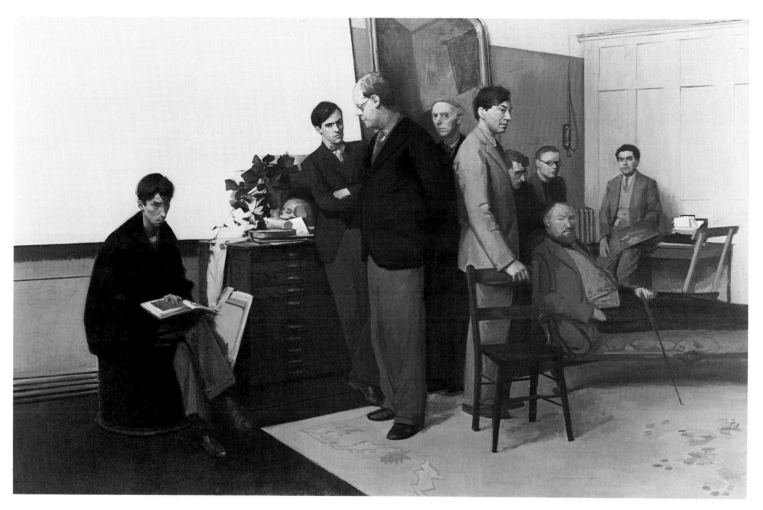

Rodrigo Moynihan
Portrait Group (The Teaching Staff of
the Painting School at the Royal College
of Art, 1949–50), 1951
Oil on canvas, 213.3 × 334.6 cm
The Trustees of the Tate Gallery
Cat. no. 62

From left to right : John Minton, Colin Hayes, Carel Weight, Rodney Burn, Robert
Buhler, Charles Mahoney, Kenneth Rowntree, Ruskin Spear, Rodrigo Moynihan.

THE BEAUX ARTS YEARS, 1948–57

Lynda Morris

The Teaching Staff of the Painting School at the Royal College of Art, 1949–50 by Rodrigo Moynihan is not simply a group portrait of the artist's colleagues. The painting acts as a guide to a period of change in the teaching of drawing and painting, a change that almost brought to an end the assumption that artists represent what they can see. Moynihan was appointed Professor of Painting at the College in 1948, after Gilbert Spencer had been forced to retire. He painted this picture in his studio at the College, which became an unofficial staff club during the months when his colleagues took up their poses.

The romantic figure in the picture seated apart and a little larger than life is John Minton. He was a prolific artist who sometimes painted alongside the students in the life room, showing them how the perspective of a room could be 'tipped up' to create more atmosphere and intensity. Minton's role at the College was as an interpreter of modern French painting, a draughtsman who understood the lessons that could be learnt from a rational approach to the work of Matisse, Braque and Picasso. Large paintings like his *Coriolanus* of 1953 and *The Death of Nelson, after Daniel Maclise*, 1952, were attempts to parallel the historical paintings of Picasso, such as *Massacre in Korea* of 1951. He promoted the idea of students working towards 'a big painting'. It is ironic that he is remembered predominantly as a Neo-Romantic draughtsman and illustrator when his ambition was so grand and he was so naturally talented. Derrick Greaves, a student from 1948 to 1951, recalled watching him paint a twenty-foot mural for a student party in a single day.

The dominant figure turned to face Minton is Carel Weight, who succeeded Moynihan as Professor in 1957. In the 1930s he had been a member of the anti-Fascist group, the Artists International Association (AIA), and his experience in the Army during the Second World War had increased his radicalism. The decade between 1947 and 1957 established the main themes of Weight's painting, an idea of a presence or a tragic drama in a windswept South London landscape. It is also the period when his two marvellous portraits of Orovida Pissarro were painted.

He explained his sense of tragedy in relation to his painting *The Day of Doom* (see p. 54) in the *Painter and Sculptor* of 1958:

> When I was about three years old there was a fire in a wood yard only a few yards from my home . . . I still have a vivid memory of that terror and so when recently I wanted to paint a picture about the fear of atomic explosion it seemed natural that I should choose as its setting the scene of my childish fright.

Ruskin Spear, who is depicted seated in Moynihan's painting of the staff, shared Weight's radical background in the AIA, and like Minton was a Pacifist during the Second World War. He was a student at the College from 1930 to 1934, but his enthusiasm for character and low-life subjects, and his technique as a painter, were learnt from a study of Walter Sickert. Certain techniques and ideas about painting run from Sickert through Spear to the College students of the late 1940s: for instance, a coloured ground to unify a composition, drawing with the paintbrush, and working with a limited palette across the entire surface of a painting, stressing light and shade. Most important of all was Sickert's idea of 'painting from drawings, rather than in front of the movie that is nature' to enable an artist to depict scenes from modern life.

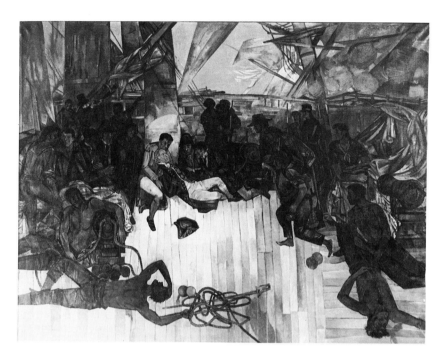

John Minton
The Death of Nelson: after Daniel Maclise, 1952
Oil on canvas, 183 × 244 cm
RCA Collection
Cat. no. 68

Spear's own work shows an interest in Sickert's use in the 1930s of photographs as 'drawings to paint from'.

Moynihan, Minton, Spear and Robert Buhler were all recruited by Robin Darwin, Principal of the RCA from 1948, from the teaching staff at London's Central School of Art and Design. As artists and teachers, Buhler and Colin Hayes (the intellectual of the group, portrayed in a bow tie) were both more concerned with colour as tone, as a means of representing a simplified reality, rather than with draughtsmanship and subject-matter. In an interview with Andrew Brighton in 1972, Weight caricatured the atmosphere at the College in 1947, before the arrival of Robin Darwin and Moynihan, by recalling that the economy of Rembrandt's drawings was considered 'dangerous': 'The actual teaching in the life rooms was extraordinarily narrow ... there was a certain sort of moral obligation to get the painting absolutely finished.'

Derrick Greaves divided the staff into two groups, the 'chatters or gossips' and the 'teachers'. The new staff, like Weight and Spear, taught in a relaxed conversational manner. The 'teachers' taught by demonstration, continuing the traditional practice of sitting in a student's place and examining his drawing in direct reference to the model, and demonstrating corrections on the side of the paper. Jack Smith is said to have taken exception to a teacher painting corrections on top of one of his life paintings.

Moynihan painted Charles Mahoney and Rodney Burn, two of the 'teachers', as half hidden figures at the back of the group in his picture. Burn was one of the most gifted students at London's Slade School of Art in the early 1920s. I interviewed him in 1983 about Professor Tonks

and the teaching of life drawing at the Slade. He talked about the perspective of a model, the angle of the head, a receding wrist, the direction of a thigh and the importance of anatomy in understanding a figure. He continued: 'It can only be taught by instruction, and even then it is only of use to certain students. I was still teaching at the College when Hockney was a student there, and even though one was no longer able to teach much by that time, one recognized his ability to look closely.'

Charles Mahoney ran the Mural Room at the College (where students were taught the technique of mural painting), initially with Percy Horton (who left in 1949 to become Master of the Ruskin School, Oxford), and subsequently with Kenneth Rowntree. Mahoney had himself worked between the Wars on murals at Morley College, London, with Edward Bawden and Eric Ravilious, at Brockley School, London, with Evelyn Dunbar and at Campion Hall, Oxford. Three College students painted murals for the Children's Section of Chelsea Public Library; Horton published an article on this scheme in *The Studio*, 1950. Mahoney was eventually dismissed by Darwin, and he then taught, always by demonstration, at the Byam Shaw and Royal Academy Schools in London. Peter Greenham remembers him as a very good artist and teacher:

> He was the conscience of a generation, and I for my part learnt as much from teaching with him as I did from studying under Ernest Jackson . . . I don't expect Mahoney would have brought out Allen Jones, or even Hockney, though he had a great liking for Auerbach, which was returned.

Malcolm Hughes, a student from 1946 to 1950,

32

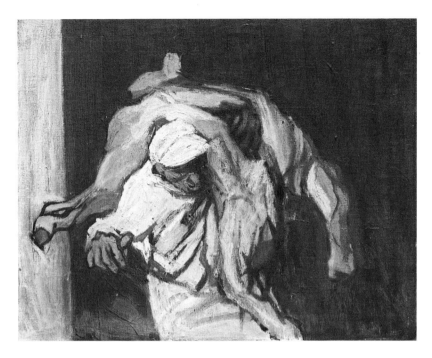

Edward Middleditch
Meat Porter Carrying a Carcass, 1952
Oil on canvas, 39.8 × 49.8 cm
Private Collection
Cat. no. 83 student work

remembers Mahoney as a difficult man but 'a very tough and solid teacher'.

The painting of murals was revived at the College in a conscious effort to gain publicity, and in keeping with plans for the Festival of Britain in 1951. The idea of murals was linked with that of big paintings for public buildings, which the Arts Council wished to encourage for the new housing estates, schools, hospitals and civic buildings of the Welfare State. *60 Paintings for '51*, the Arts Council's Festival exhibition, was intended to promote this idea: Minton, Weight and Spear were all commissioned to paint pictures for it, and Moynihan exhibited his *The Teaching Staff of the Painting School*.

For students at the College, Picasso dominated this period of the late 'forties and 'fifties, not only as a painter but also as a political symbol. He travelled to England in November 1950 to attend the International Peace Congress in Sheffield, which Prime Minister Attlee denounced as 'A Great Red Peace Lie'. Many of its delegates were refused entry to this country, including Pablo Neruda, Louis Aragon, Paul Robeson, Shostakovich and Renato Guttuso. Picasso was allowed in after questioning, but the Congress was postponed. Moynihan and about a dozen Royal College students, including Edward Middleditch and Greaves, turned up to meet Picasso at St Pancras Station. *The Evening Standard* reported that 'Professor Moynihan, who has painted members of the Royal Family said, "There is nothing political about this demonstration but we hate to feel that Picasso may have felt himself snubbed in England."' Picasso did cause political anxiety in the London art world. Henry Moore, Graham Sutherland, Herbert Read, Stephen Spender,

Moynihan, Spear and Roland Penrose wrote to *The New Statesman* deploring the attitude which effectively said: 'Picasso is a Communist. Anyone who wants to meet Picasso must be a Communist sympathiser.'

The period 1945–50 had witnessed the development and use of atomic bombs, the division of Europe between East and West, and the beginnings of the Cold War and the Korean War. It was a period of intense political debate, of austerity and exhaustion. Edward Middleditch went to Stuttgart in 1950 as a delegate from the College to an International Student Congress. He found that the massive rebuilding programme taking place in West Germany, and the food and consumer goods in the shops, contrasted vividly with the bomb sites and rationing in London.

Picasso's modernism provided young political painters with an alternative to Socialist Realism, the official art of the Soviet Union. In one of his first reviews for *The New Statesman*, in January 1952, John Berger claimed a new realism had emerged in the London *Young Contemporaries* exhibition of that year:

> This attitude is based on a deliberate acceptance of the importance of the everyday and the ordinary . . . it is a parallel attitude to that found in the best post-War Italian films . . . the general experience of each work is one that most people can share, because it reaffirms the importance of drawing . . . The impetus behind the new work is the painter's imaginative identification with the thing or person painted so that the result, however usual the subject, is compelling and real.

The review ends with a list of works including Derrick

Derrick Greaves
Sheffield, c.1953
Oil on canvas, 86.2 × 203.3 cm
Sheffield City Art Galleries
Cat. no. 81

Greaves's, 'and most interesting of all, those by Edward Middleditch'.

Berger showed what he meant by realism in the exhibition *Looking Forward* held at the Whitechapel Art Gallery, London, in September 1952. His choice included Royal Academicians L. S. Lowry, Stanley Spencer and William Roberts, *émigré* artists Josef Herman and Peter Peri, AIA members James Boswell and Patrick Carpenter, a group of artists from the Camberwell/Slade Schools of Art: Euan Uglow, Claude Rogers and Patrick George; and a large group from the College of both students and staff: Malcolm Hughes, Bruce Lacey, Alfred Daniels, Minton, Moynihan, Greaves, Spear and Weight. Middleditch showed three student studies of 'Butchers'; Greaves showed a landscape and a portrait of Jack Smith, similar in style to the portrait of *George Pascoe*, the Royal College porter.

An alternative definition of realism was argued by David Sylvester. He lectured at the College and spent time there in 1950 while Francis Bacon was the unofficial artist-in-residence. In May 1952 he organized the exhibition, *Recent Trends in Realist Painting*, at the Institute of Contemporary Arts, London, including works by Bacon, Balthus, Giacometti, Lucian Freud and William Coldstream. It was Sylvester who inadvertently labelled the new movement the 'Kitchen Sink' in an article for *Encounter* of December 1954:

> The post-war generation takes us back from the studio to the kitchen . . . as part of an inventory which included every kind of food and drink, every kind of utensil and implement, the usual plain furniture, and even the baby's nappies on the line.

Everything but the kitchen sink? The kitchen sink too . . .

While they were students, Jack Smith, Derrick Greaves, George Fullard, Leslie Duxbury and Geoffrey Dudley and their families all shared a large, partly War-damaged house at 44 Pembroke Road, Kensington, which had once belonged to Aubrey Beardsley's mother. Smith talked about it in the student magazine *Ark 26* in 1960: 'I just painted the objects around me. I lived in that kind of a house. A house that I suppose many would consider rather squalid, surrounded by social realist objects . . .' All the artists living in the house were from the North, and mainly from working-class families. Middleditch made several visits to Sheffield to stay with Greaves's family, and the city provided him with the sombre industrial magnificence of his pictures of Sheffield Weir.

The seriousness of the period came from the experience of the Second World War. Middleditch won an MC and Bar at the age of twenty-two, and was badly wounded; Fullard was wounded at the Battle of Casino. Duxbury was in the Army, Peter Coker was in the Fleet Air Arm and Malcolm Hughes was in the Navy. Smith, Greaves and John Bratby were of a younger generation who did not see active War service, which perhaps explains Bratby's parody 'Frustrated Painters of a Generation', published in *Prospect* in 1962:

> . . . the art schools . . . suddenly became over-crowded with men who had seen death and sometimes caused it . . . Barrack discipline, and austerity, and philistine army conversation, were replaced by the loosest scholastic freedom, the glamour of nude models . . . instead of the sergeant-major there was

the tired, sloppy art-teacher who lived in philosophically justified adultery . . .

Middleditch and Bratby shared a mutual respect for the importance of drawing. Bratby worked in the Mural Room, which Mahoney claimed was just to make his life impossible. Nevertheless, Bratby's early work contains a lot of good drawing. Most of his chaotic 'table-top' still lifes were made in the summer between leaving the College and his first exhibition at the Beaux Arts Gallery, London, in September 1954. He left the College with an Abbey Minor Scholarship, an Italian Government Scholarship and a Royal College Minor Travelling Award. He became one of the best-known artists in Britain in 1957 when he painted the pictures for Alec Guinness's portrayal of Gully Jimson in the film of Joyce Carey's novel, *The Horse's Mouth*.

John Minton was close to Middleditch, Greaves and Smith, and he wrote about them as a group in *Ark 13* in 1955:

> Doom being in, and Hope being out, the search amongst the cosmic dustbins is on, the atomic theme is unravelled: the existentialist railway station to which there is no more arrival and from which there is no more departure . . . *Is it valid? Does it relate? Is it socially significant?*

The Beaux Arts Gallery, which was taken over by Helen Lessore in 1951 because of the death of her husband, quickly established a serious reputation for showing the work of young figurative and realist artists. Smith was the first of this group to show at the Beaux Arts, in February 1953, while he was a final-year student. Greaves left the College in 1952 and spent a year in Italy on an Abbey Major Scholarship, meeting Italian realist painters, including Renato Guttuso and Emilio Vedova. Helen Lessore offered him an exhibition on her second visit to his studio; he showed paintings of Sheffield and Italy in the small Gallery in November 1953, while Francis Bacon's work occupied the main Gallery. Middleditch first exhibited there two years after leaving the College in March 1954. His exhibition was a critical and commerical success, and included two Sheffield Weir paintings, *Pigeons in Trafalgar Square* and *Sleep*, which Helen Lessore recently praised as 'a picture of the phenomenon of Sleep itself'.

Helen Lessore arranged for the four painters to show together at the gallery at Heffers' bookshop in Cambridge in 1955, and the following year they were selected for the British section at the Venice Biennale exhibition, alongside Ivon Hitchens and Lynn Chadwick, who was awarded the Grand Prix for Sculpture that year. The selection of the four young radical painters for the Venice Biennale was seen as a remarkable development. Alan Bowness (later to become Director of London's Tate Gallery) reviewed the exhibition for *The Observer*, placing the painters in the context of the genre of novelists and poets that included John Wain, Kingsley Amis, Thom Gunn and Philip Larkin. Bowness suggested dropping the 'social realist' description of their work and described them in the following terms: 'Jack Smith seems to possess the writers' brand of humanism to the full; Bratby has done some real 'lucky Jim' paintings; and Middleditch is the poet among the painters, with such remarkable talents that one looks forward to his frequent re-appearance at Venice.'

An art school cannot hope to influence artists to the

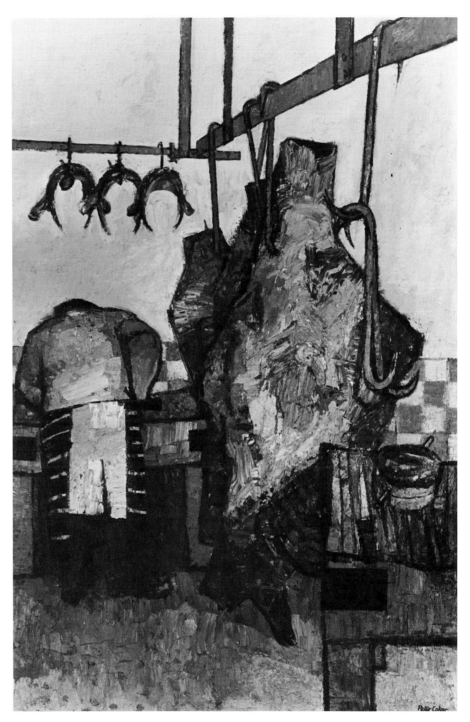

Peter Coker
Butcher's Shop No 1, 1955
Oil on board, 182.8 × 121.9 cm
Sheffield City Art Galleries
Cat. no. 90

John Bratby
*Jean and Still Life in front of
a Window*, 1954
Oil on hardboard, 122 × 108.8 cm
Southampton City Art Gallery
Cat. no. 93

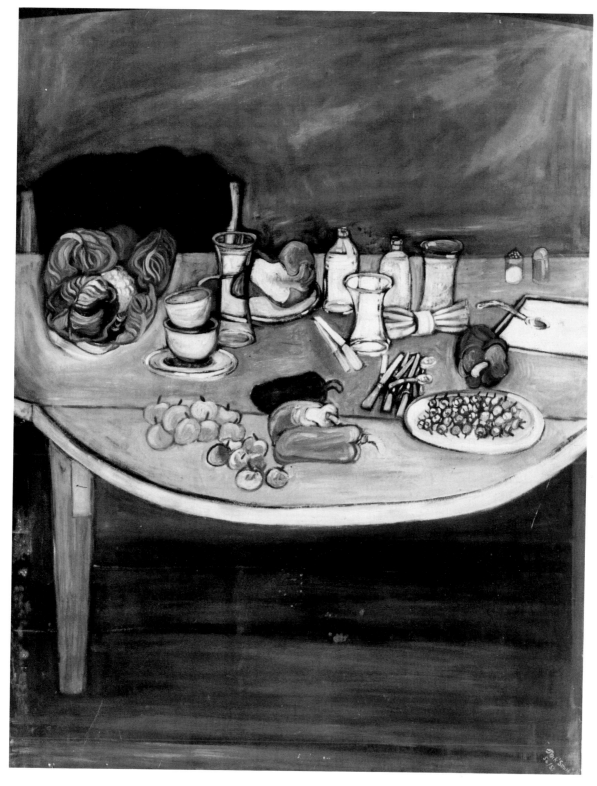

Jack Smith
Still Life with Cherries, 1954–55
Oil on board, 152.4 × 122 cm
Mayor Gallery, London
Cat. no. 87

Leon Kossoff
Seated Woman II, 1961
Oil on board, 134.6 × 88.9 cm
The Artist
Cat. no. 115

extent that a great teacher can. Nothing illustrates this point more clearly than the influence David Bomberg had on his students Frank Auerbach and Leon Kossoff. Bomberg only taught them on Wednesday and Friday evenings at the Borough Polytechnic in South London, in comparison with the seven years they spent as full-time students at St Martin's and the Royal College of Art. Auerbach studied with Bomberg from 1947 until the classes were cut in 1953, and in 1950 encouraged Kossoff, a

fellow student at St Martin's, to join them. Kossoff was four years older than Auerbach, but he was a year behind him in his studies because of military service.

In an interview with Richard Cork in 1981, Kossoff said that 'Coming to Bomberg's class was like coming home.' He went on to describe Bomberg's methods of teaching by demonstration: 'Once I watched him draw over a student's drawing. I saw the flow of form, I saw the likeness to the sitter appear. It seemed an encounter with what was already there and I'll never forget it.' Auerbach also confirmed Bomberg taught by demonstration. In a written reply to a questionnaire by Neil MacGregor, a young painter, he commented that '. . . he would often draw on a student's drawing—not in the margin but redrawing the whole image . . . pointing out the *errors* in their drawings which he did with devastating acuity.'

Through his teaching Bomberg's pupils came into contact with the idea of a great tradition of drawing, which linked his own work with that of Sickert, and through him to Degas, Ingres, and David, right back to Raphael. Drawing regularly from the Old Masters was not taught as an academic exercise, but as a way of learning from Rembrandt or Tintoretto as if they were living teachers.

Auerbach recalls his early days at the College as the turning-point after which his work became his own. He told Judith Bumpus in an interview in *Art & Artists* of June 1986:

> I was doing a life painting . . . for some sittings in a relatively timid way, that is I'd tried to do one part, and save a bit. Then I suddenly found in myself enough courage to repaint the whole thing, from top to bottom, irrationally and instinctively, and I

found I'd got a picture of her. And when I went into the College the first day, I felt so disturbed at entering an institution that I went home at eleven o'clock, and, provoked by this crisis, repainted the painting of the building site that I had been working on at home.

Auerbach and Kossoff's work as students is documented by their first exhibitions at the Beaux Arts Gallery. Auerbach had graduated from the College in 1955 with First Class Honours and a Silver Medal, and showed at the Gallery in January 1956 with his early series of heads of E.O.W. (a sitter who he continued to paint for twenty years), some nudes, pictures of the building site and two portraits of Kossoff. It was an extraordinarily mature and moving body of work to have been painted by the age of twenty-four.

In her book *A Partial Testament*, published in 1986, Helen Lessore describes watching Kossoff in the 1950s as like watching a fire kindling in a vast shadowy fireplace, struggling upwards with difficulty, fighting against something dark and tragic. He graduated from the College in 1956 and held his first exhibition at the Beaux Arts Gallery in February 1957. His subjects were the same as they remain today, portraits of his family and closest friends

and the parts of London he has known since childhood: 'Ever since the age of twelve I have drawn and painted London. I have worked from Bethnal Green, the City, Willesden Junction, York Way and Dalston. I have painted its bomb sites, building sites, excavations, railways . . .' Helen Lessore describes Kossoff's great picture of the mid-late fifties, *City Landscape, Early Morning* as though it were the aftermath of a holocaust: 'A scene in the heart of London, devastated by bombing; the walls stand up like black fortresses, or great battlements, against the ashen sky . . . it is clearly a picture of a great city struck by a disaster, and an ant-like swarm of inhabitants getting to work to rebuild it . . .'

It is impossible to think of this period in the history of the Royal College as anything but the Beaux Arts Years. The significance of Helen Lessore's Gallery overshadows that of both the Royal College and the Slade School of Art during these years. In an interview with Mark Glazebrook in *Studio International* in 1968, she said: '. . . what gives me most pleasure is the feeling of having concentrated into a little knot what I still feel to be the best art of its time and place.'

Frank Auerbach
Railway Arches, Bethnal Green II, 1958–59
Oil on board, 122.5 × 150.5 cm
Saatchi Collection, London
Cat. no. 106

Peter Blake
Girlie Door, 1959
Collage and objects on wood,
122 × 59 cm
Private Collection
Cat. no. 127

PROTOTYPES OF POP

Marco Livingstone

The recent history of the College can have witnessed no more extraordinary event than the arrival at the Painting School in 1959 of a group of students who were to make a unified assault on the conventions of British painting even during their three years at the College. The similarities remarked in the early work of R. B. Kitaj, David Hockney, Allen Jones, Peter Phillips, Derek Boshier and Patrick Caulfield (who joined their ranks in 1960), and which helped to establish them as a movement, were not entirely fortuitous. Aside from the cross-influences, friendly rivalry and joint discoveries that briefly established a strain of Pop Art identified as the 'Royal College style', they were in the fortunate position of being able to present a unified front at the *Young Contemporaries* exhibition of student art in February 1961. With Phillips as president of the organizing committee and Jones as its secretary, they followed the advice of critic Lawrence Alloway and re-hung the show shortly before the opening so that all their work could be seen together.

Alloway, himself one of the jurors of the exhibition, drew further attention to developments at the College in his catalogue introduction, in which he stressed the nourishing influence of the urban environment in their work. He conspicuously avoided using the label 'Pop', a term which he had coined by 1958 with fellow members of the Independent Group (I.G.), a small association of artists, architects and critics that met intermittently at the Institute of Contemporary Arts. For Alloway's generation, 'Pop' identified not an artistic movement but the popular end of the spectrum of visual production, such as Hollywood films, science fiction, magazines, car styling and contemporary ephemera. These were amongst the many categories of material outside the realm of fine art which had served as sources for I.G. artist members such as Eduardo Paolozzi and Richard Hamilton, and which were also being mined as early as the mid-1950s by Peter Blake at the College. By the turn of the decade, they were used not only by the 1959 College intake, but in different ways also by Blake's near-contemporaries Joe Tilson and Richard Smith.

Royal College Pop was born almost in spite of the College itself, with little common ground between these students and their tutors. As Boshier recalled in 1976: 'One of the things I remember about the whole thing getting off the ground in terms of the excitement of it was a fight against the staff.' Robert Melville, in his review of the *Young Contemporaries* exhibition in the *Architectural Review*, May 1961, singled out the vitality and independence of the Royal College group: 'I gather from his remarks made to a Sunday newspaper that the head of the painting school of the College doesn't think much of them, and no doubt the freshness and liveliness of their contributions is due in some measure to the absence of official encouragement'. The situation was confirmed in Hockney's 1976 autobiography:

> The staff said that the students in that year were the worst they'd had for many, many years. They didn't like us; they thought we were a little bolshy, or something, and so they threw out Allen Jones at the end of the first year . . . A lot of students were told that their situation would be reviewed in six months . . .

Hockney's rather tempestuous relationship with the College authorities has been well-documented. Notified in

41

Joe Tilson
A–Z Box of Friends and Family, 1963
Mixed media, 223 × 152.4 cm
The Artist/Waddington Galleries,
London
Cat. no. 98

With paintings and constructions by other artists:
Frank Auerbach [A], Peter Blake [B], Bernard Cohen [C], Clive Barker [C], David Hockney [D], Eduardo Paolozzi [E],
Photographer Robert Freeman [F], Harold Cohen [H], Allen Jones [J], R. B. Kitaj [K], John Latham [L], Tony Messenger
[M], Peter Phillips [P], Richard Hamilton [R], Richard Smith [S], Tony Caro [T], Brian Wall [W], and Brian Young [X
and Y]. Further contributions were made by Tilson's wife Jos [J] and young children Anna and Jake [A and J]. Behind the
Q door is a full list of all the participants.

Allen Jones
Thinking about Women, c.1965
Oil on canvas, 152 × 151.8 cm
Norfolk Contemporary Art Society
Cat. no. 155

David Hockney
I'm in the Mood for Love, 1961
Oil on board, 122 × 91.5 cm
RCA Collection
Cat. no. 160 student work

space, although his presence and example exerted a powerful influence on his fellow students, particularly Hockney. Caulfield, reticent and retiring by nature, began his course in 1960 and remained largely separate from the 1959 group, responding to similar stimuli but consistently following an individual path.

The sense of being under fire proved to be one of the most fruitful aspects of the College experience, useful ammunition for the artists' self-conscious and largely working-class rebellion against received ideas and established conventions. There is no doubt some degree of exaggeration in their sense of the opposition they received, given that it came from the same members of staff who had recognized their potential in accepting them on the course. Their sense of embattlement extended not just to the powers-that-be at the College, but also to their rivalry with other art schools, particularly the Slade School, with whose students, as Boshier recalls, fist-fights were even known to break out.

However strained staff-student relations may have been, the contacts among the student population itself were to have far-reaching consequences. The atmosphere of the College, with its anti-hierarchical division into separate schools, which placed industry and design on a par with fine art, was itself salutary. Friendships developed not just among the painters but with students in other schools, such as Graphic Design (New Zealander Barrie Bates, later known as Billy Apple), Stained Glass (Pauline Boty, also a painter), and above all Fashion Design. Among those in this latter circle were Marion Foale and Sally Tuffin, later instrumental in establishing Carnaby Street, and other trendsetting figures in 1960s fashion such as Ossie Clark (at that time a shoe designer), textile designer Geoffrey Reeves and milliner James Wedge. Fellow painters who were not themselves associated with Pop—a term which, incidentally, Kitaj and Hockney were loath to accept—likewise contributed to the exchange of ideas. Adrian Berg, who studied at the College from 1958 to 1961, had already painted the first of the landscapes which were to become his obsessive subject in later years, but much of his energy was also devoted to life paintings of black male models which were as sensuous and brave a statement as Hockney's contemporaneous series of pictures on overtly homosexual themes.

The wide range of reference characteristic of the work by the 1959 generation sprang to some degree from internal developments within the Painting School during the previous decade. A determination to marry art to everyday life was particularly evident, for example, in the paintings produced by the so-called 'Kitchen Sink' artists, who likewise enjoyed early fame. The development of this concern can be clearly plotted in *Ark*, the student journal produced at the College. The editorial printed in the first issue in October 1950 singled out 'the elusive but necessary relationships between the arts and the social context' as a primary concern. Subsequent issues suggested possible

April 1962 of his failure in the General Studies course, which he had deliberately neglected as an infringement on his painting time, he eventually got his way and was awarded the Gold Medal for his year. Others were not so successful in their ideological battles with the authorities. Jones was expelled at the end of his first year, much to his own surprise, as a bad influence and as an example to the others. Phillips, meanwhile, was berated by staff for painting huge abstract canvases, and was told to reform or else to leave the course at the end of three months. His rather wily solution was to paint the expected nudes and still lifes in his College studio while carrying on with his audacious Pop paintings at home; the scandal with which these were greeted by his tutors when they became aware of them forced him to transfer in his third year to the Television School, while still devoting most of his energies to his painting.

Kitaj, five years older than his colleagues and already sure of his direction on his arrival, enjoyed a far greater degree of independence as an American based at the College under the terms of the GI Bill. The two years that he spent at the College were largely a question of studio

44

ways by which this equivalence could be manifested in painting: for example through Social Realism or by means of a direct involvement with 'the pattern of contemporary life', especially through industrial arts, as a way of 'finding the right relationship between our work and the society in which we live'. As early as 1952, and insistently throughout the mid-1950s, particularly under the editorship of Roger Coleman—part of a closely knit group which included Peter Blake, Richard Smith and Robyn Denny —visual material not usually considered within the domain of art was subjected to a close examination. Victoriana, barge decoration, advertising, the cinema, pulp magazines, comic strips and cartoons all came into their frame of reference.

The example set by Peter Blake, who studied at the College from 1953 to 1956, was paramount both to the development of the Pop vocabulary of artists such as Phillips and Boshier and as a confirmation of Hockney's resolute devotion to drawing. Not only was Blake's work particularly visible in 1960, with exhibitions at the ICA, the New Vision Centre and the Portal Gallery in London, but he also still made visits to the College to see what was going on, and met Hockney and some of the others as early as 1960. In February 1962 he appeared with Boshier, Phillips, and Pauline Boty in a television programme directed for the BBC's Monitor series by Ken Russell.

Blake's *The Preparation for the Entry into Jerusalem* of 1955–56 includes characteristic elements of what one could describe as his proto-Pop style: a hieratically frontal presentation of figures in emulation of the poignant awkwardness of naive and folk art; an absorption in the fantasy world of childhood; a fascination with pictures

within pictures as a means both of incorporating contrasting styles and of suggesting the power of image-making as a catalyst to the imagination; and a loving, almost hallucinatory detailing of the ephemera of everyday life. The willingness to place his own dexterity as a draughtsman at the service of a style associated with the unsung and largely anonymous heroes of visual traditions outside of fine art was to prove an enduring aspect not only of Blake's work, but of Pop in general in its later forms. Other works by Blake during this period celebrate the simple pleasures of children's comics, the circus, and the fun-fair, all aspects of the popular art traditions which he was to study on a Leverhulme Research Award in Holland, Belgium, France and Italy during 1956–57.

Girlie Door, 1959, is one of an influential group of works that marked Blake's emergence as a fully-fledged Pop artist, and was among those shown at the ICA in January 1960. In them he dispensed altogether with his drawing skills, appropriating all the images from ready-made material such as magazine photographs and postcards collaged directly on to the surface of another found object, a fragment of an ordinary door coated in bright, household enamel paint. This series proposed much of the subject-matter that was to characterize 1960s Pop, including the contemporary sex goddesses of Hollywood movies, pin-ups, and the stars of early rock 'n' roll, pop music and other mass entertainments. Formal solutions, too, were to sustain Blake and inspire others, by their boldness of design and in the adoption of an apparently anonymous style that expunged individual brushwork and drawing so as to establish a direct link with the mass-produced imagery of popular culture.

R. B. Kitaj
Kennst du Das Land, 1962
Oil on canvas, 122 × 122 cm
The Artist/Marlborough Fine Art
(London) Ltd.
Cat. no. 158

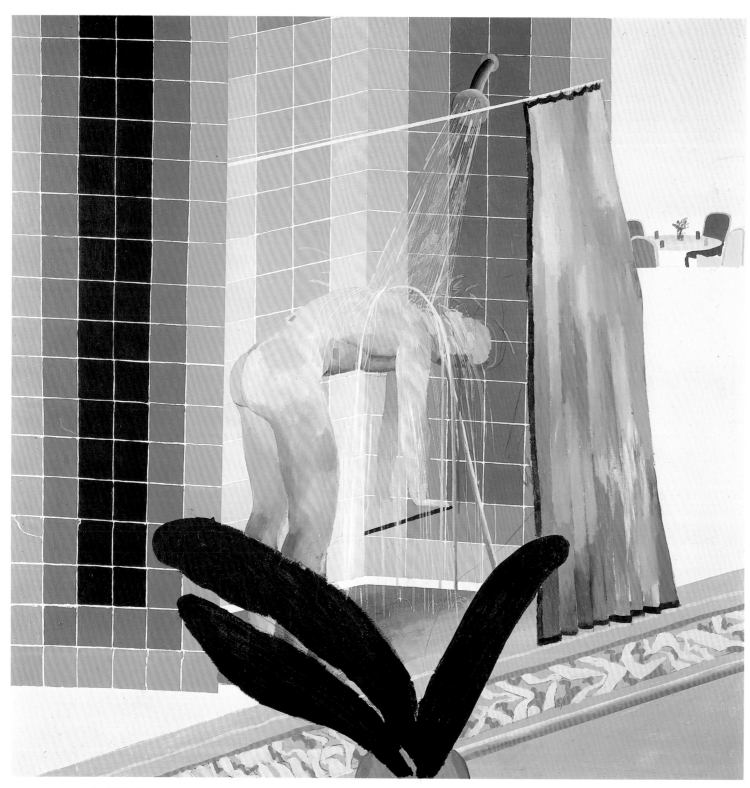

David Hockney
Man Taking Shower in Beverly Hills, 1964
Acrylic on canvas, 167 × 167 cm
The Trustees of the Tate Gallery
Cat. no. 161

46

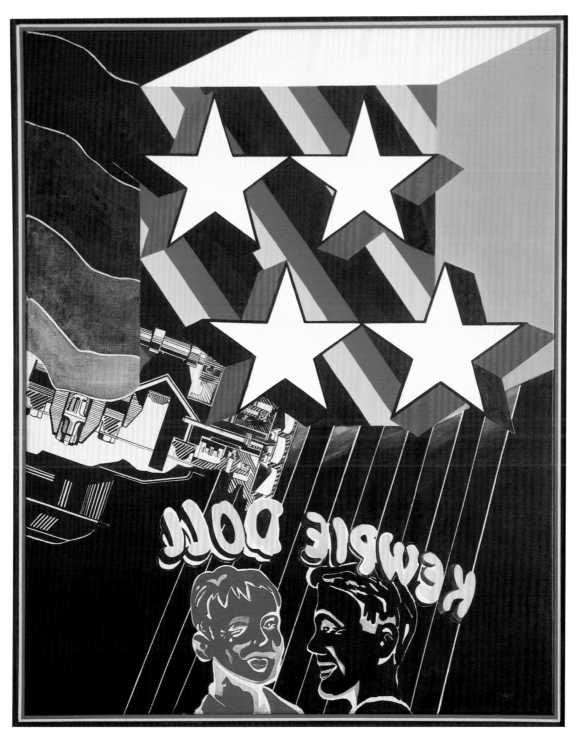

Peter Phillips
Kewpie Doll, 1963–64
Oil on canvas, 132 × 107 cm
Private Collection
Cat. no. 167

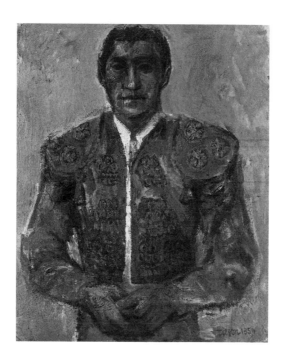

Joe Tilson
Matador, 1954
Oil on board, 77.5 × 64 cm
Private Collection
Cat. no. 97 student work

Also at the College during Blake's time were Joe Tilson and Richard Smith, each of whom was to devise a personal form of Pop in the early 1960s. The student works which represent them here, however, reveal the extent to which both were initially engaged in a straightforward figuration, not as an end in itself but as a discipline within their training. Tilson arrived in 1952, a year before Blake and at the same time as Bridget Riley and Frank Auerbach, with whom he was particularly friendly. Smith began his course in 1954, along with Robyn Denny, with whom he was to remain closely associated.

For both Tilson and Smith, the confrontation with large-scale American abstract painting, first seen in strength in England at the Tate Gallery in 1956, was to exert a more immediate and lasting influence than their shared interest in the artefacts of popular culture. Nevertheless, the gulf which is now often assumed to exist between Pop as a representational style and the colour-field paintings produced during the same period, obscures the motivations common to both. The guide written by Roger Coleman to the *Place* exhibition held at the ICA in October 1959, a collaborative venture by Smith, Denny and Ralph Rumney, opened with an account of the influence of the mass media on their work,

> present but not generally detectable without the aid of outside cues (sometimes the titles of the paintings are sufficient). The mass media . . . is not a source of imagery, as it is for Blake, but a source of ideas that act as stimuli and as orientation in a cultural continuum. They are concerned with the environment—mental and physical—that the mass media makes up and this sense of environment affects their outlook and activity as painters.

Coleman's introduction to the catalogue of the 1960 *Situation* exhibition at the Royal Society of British Artists' Galleries, London, again hints at similarities of intention and reference in the nascent Pop art, particularly in the preoccupation with the painting as a 'real object'. Among the artists showing with Denny on this occasion was Bernard Cohen, whose use of concentric circles in canvases such as *Painting 96*, 1960 (Walker Art Gallery, Liverpool), provides evidence of the currency of the 'target' motif in abstract and Pop work alike: an image traceable to Jasper Johns's paintings of 1955, then known in England only by hearsay and in reproduction.

Smith's transformation into a very particular kind of Pop artist occurred during his prolonged stay in New York from 1959 to 1961 on a Harkness Fellowship. Motivated as much by the atmosphere of the city as by the professionalism of the art community, he discovered in billboards a powerful analogy for the ambitious scale on which he wished to work, and in glossy magazines the sumptuous surfaces of layered colour which he was soon to emulate in paint. Although the imagery was of a generalized nature subservient to abstract concerns—simplicity of form, sensuousness of colour and tactility of surface—the titles of the paintings clearly alluded to their origins in advertising (*Billboards*, 1961), consumer products (*Revlon*, 1961 and *Panatella*, 1961), magazines (*McCalls*, 1960), corporate symbols (*Chase Manhattan*, 1961) and ordinary objects (*Penny*, 1960). Such pictures were exhibited in 1961 at a one-man exhibition in New York at the Green Gallery, where American Pop artists such as Claes Oldenburg and Tom Wesselmann were also shortly to show, but were not seen in England until 1962, when they were displayed in the artist's London studio.

By this time, the latest wave of Pop artists was emerging from the College, and although they appreciated their common bonds with Smith they had already established their own forms of Pop much more explicitly rooted in the imagery of mass culture. In works such as *For Jake and Anna*, 1961, Tilson coincided with the new directions being established by the younger, 1959 arrivals, whom he was then getting to know. His own variety of Pop incorporated ideas current among the abstract painters who had exhibited at the 1960 *Situation* exhibition, notably in the formal austerity of his compositions and in his increasingly overt figurative references to contemporary society. The very medium in which he chose to convey these images— that of handmade and painted wooden construction— alluded to Pop by its direct application of the carpentry skills he had acquired in his teens. Later in the decade, Tilson was to exploit a wide variety of media made possible by the latest innovations in technology, such as screen-printing and vacuum-forming, taking to an extreme Pop's identification with the processes of modern industry.

The *A–Z Box of Friends and Family*, produced by Tilson in 1963 as a collaborative venture with a number of his artistic friends and associates, stands today not only as a monument to the sense of common purpose and mutual support among those artists, but also as a sign of Tilson's essential role in bringing many of them together through informal gatherings, hosted with his wife Jos. Within the separate panels are emblems of Tilson's own work, such as the Ziggurat in the Z box and the question mark in the Q box, and examples of paintings and constructions by other artists and members of his family, identified by the initial letters of their names.

By 1963, all the artists associated with Pop had left the College, and any sense of unity was more professional than stylistic. Between 1960 and 1962, however, the links uniting the work of the 1959 generation were strong, encompassing within single pictures contrasting styles and images plucked from disparate sources (a form of representation at once immediately legible but anti-illusionistic), and an openness to a wide range of sources including, but not limited to, mass-produced objects, diagrams, advertisements, photographs and other material previously considered outside the realm of fine art. Among the appropriated stylistic elements were devices from abstract painting, although admiration for their rigorous design was often tempered by an examination of their potential as agents of communication when used in a more accessible, representational context. Current issues—such as flatness, the painting as object and the shaped canvas—were voiced by equating format with image in Kitaj's tackboard-like, collage-based paintings; in the allusions by Hockney and Boshier to consumer products such as packets of tea or matchboxes; in Phillips's derivations from pinball machines and the fun-fair; in Jones's shaped canvases representing the sides of moving buses; and in Caulfield's early decision to adopt the flat

graphic style of the sign-painter.

Kitaj, although never comfortable with the Pop label, arrived at the College with a clear programme for his own art, and, in the absence of any real sympathy on the part of the staff, became something of a mentor for his slightly younger colleagues. In works such as *Homage to H. Melville*, c.1960 (see p. 128), he had the audacity to use methods of drawing and paint application associated with the

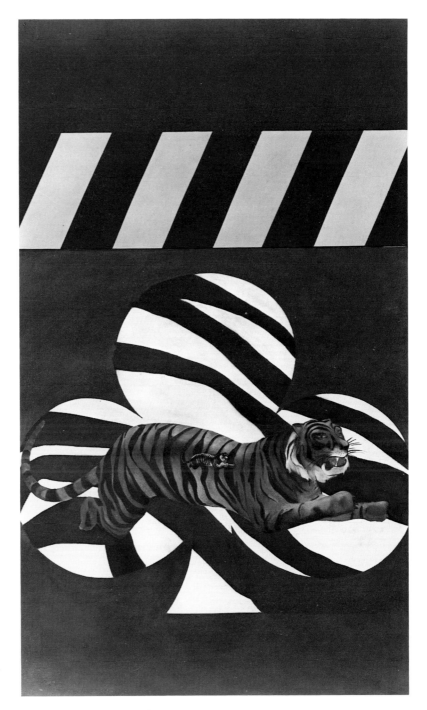

Peter Phillips
Motorpsycho/Club Tiger, 1962
Oil on canvas, 127 × 76.2 cm
Private Collection
Cat. no. 166 student work

Abstract Expressionists, and to define his art as a measure of his own experience and intellectual and emotional life. The allusion here to the author of *Moby Dick* speaks of Kitaj's unabashed literary interests, his sense of identity as an American and the romance of his own past as a merchant seaman. This emphasis on a personal commitment to subject-matter seems simple enough now, but at a time when the art school discipline of representational painting was still dominated by rigid categories of landscape, figure painting and still life, this kind of stream-of-consciousness opened enormous possibilities for individual investigation.

The concept of the picture-puzzle preoccupied Kitaj in early works such as *Kennst Du das Land?*, 1962. This particular canvas is typical of his work in the coexistence of a modified illusionistic space with fragments of images flatly appended to the surface, and in the post-Surrealist conjunctions of apparently random images and co-opted styles. The title of the painting, borrowed from Goethe, alludes to the romantic visions we often have of foreign places. The drawing in the upper register of a woman pulling on her stocking is based on a Goya study of a prostitute for the *Capricho* etchings, and the machine-gunners below have been outlined in a smudged technique reminiscent of Goya's later sepia drawings. There is no simple explanation of the picture as a whole, only an endlessly revolving series of references suggestive of political events from the recent past.

In contrast to Kitaj's scholarly, essentially private and encoded iconography, Hockney and his more Pop-orientated colleagues made a virtue of speaking plainly about familiar things while retaining a formal complexity and a layering of meaning and experience. Within just a year or two of beginning the course, moreover, each artist had found ways of expressing his identity and place in the world through a consistent subject-matter and choice of language.

Hockney, for instance, came into his own in a series of confessional pictures in which he declared his homosexuality. He poignantly voiced the passage from adolescence into adulthood, in an apparently inarticulate style derived from child art and the obsessive scrawlings of the graffiti of public toilets. His incorporation in paintings such as *I'm in the Mood for Love*, 1961, both of written messages and of events in his life, such as his first trip to New York City, allowed him to express, with extraordinary intimacy, shared human experiences. Although he was as resistant as Kitaj to the Pop label, pictures produced after his move to Los Angeles at the end of 1963 make some sense in context of the term, both formally and in their atmosphere. In *Man Taking Shower in Beverly Hills*, 1964, for example, the sexual furtiveness still evident in the earlier 'coming out' paintings has been exchanged for an almost carefree, sun-drenched eroticism, matched by a new boldness of colour and form, by details observed as if from the corner of his eye, and by inventive and visually witty devices for suggesting volume, space and transparency.

Autobiographical concerns emerged in a more stylized form in works by Allen Jones, such as *Thinking About Women*, c.1965, in which a schematic self-portrait is represented in the act of conjuring up an apparition of the opposite sex within a cartoon 'thinks' balloon. The bus paintings of 1962, a series of canvases that were

Allen Jones
You'll have to run to catch this bus, 1961
Oil on canvas, 152.4 × 152.4 cm
Private Collection
Cat. no. 154 student work

eccentrically shaped to express movement, were also muted comments on his experiences of commuting and big city life. Jones's identity as a Pop artist became more overt from the mid-1960s, when he introduced the sexually provocative images of women with which he was to become most closely identified. But his paintings continued to be conceived equally in response to modernist, largely French-based traditions of colour.

Boshier early demonstrated the political concerns and the insatiable hunger for everything new and of-the-minute in paintings based on current events such as the space race, the Bay of Pigs crisis in Cuba, the threat of world Americanization and—in works such as *Drinka Pinta Milka*, 1962 (see p. 130), or the series of 'toothpaste paintings' initiated in 1961—the manipulations of advertising and business. In pictures such as *Swan*, 1962, the human figure is reduced to a mere cipher and in the aptly named *Identi-Kit Man*, 1962 (Tate Gallery, London), to the interlocking pieces of a puzzle beyond one's control.

Phillips's boldly designed, brashly colourful and aggressively large paintings of the early 1960s, perhaps the most uncompromizing of the Pop produced at the College, have often been judged to be straightforward, not to say mindless, celebrations of teenage life and consumer culture. As early as the summer of 1962, however, in an article in *Ark 32* titled 'New Readers start here . . .', Richard Smith observed the anxiety and threatening moods that have continued to characterize Phillips's work, remarking that these

> dark bright hard edged paintings . . . are made with the precision of an exact register, nothing is off-printed. Phillips adds darkness to brightness; there

is no blurring or shading, the paintings push forward for attention with an oppressive, juke-box amplification. There is a dark side of popular art—Ray Charles rather than Bobby Vee . . .

In paintings such as *Kewpie Doll*, 1963–64, the world emerges as a series of random, even violent, assaults on the senses, potentially seductive and awe-inspiring but ultimately beyond comprehension. Phillips's move in 1964 to the United States, where he began using an airbrush, and his return to Europe in 1966, have not diminished but added greater subtlety and precision to this sense of strangeness.

As the latest arrival of the Pop generation at the College, and as a stubborn individualist constitutionally incapable of aligning himself with any group, Caulfield developed a highly idiosyncratic variant of the College style by the time he finished his course in 1963. *Christ at Emmaus*, 1963 (see p. 132), typical of his heraldically flat graphic treatment, was his quirky response to a set subject on an Easter theme. Faced with the choice of two subjects—'Christ at Emmaus' or 'Figures in a High Wind'—he decided with characteristic humour and contrariness to combine the two into 'Christ at Emmaus slightly in the

Derek Boshier
Swan, 1962
Oil on canvas, 183 × 69 cm
Edward Totah Gallery, London
Cat. no. 164

wind'. Deliberately avoiding the blatant contemporaneity associated with Pop, he based his equestrian figure on a painting by Eugène Delacroix, and surrounded this central scene with a decorative border derived from designs on packets of dates, which evidently appealed to him as a suitably debased source of exoticism. Caulfield's paradoxical art, even in his student days, was founded in his appreciation both for the formal rigour and restraint of the Cubism of Juan Gris and Fernand Léger, and for subjects that in other hands would seem impossibly romantic and hackneyed. In subsequent work, such as *Stained Glass Window*, 1967, he continued to pursue a fine line between aloofness and commitment: on the one hand, a wilful blandness and anonymity of technique; on the other, a luscious use of colour and a curiously intense introspection in a borrowed style presented with complete detachment.

The development of British Pop painting as a coherent movement during the 1960s owes much to the various prototypes created by successive waves of students at the College during the 1950s and early 1960s. The intricate network of friendships formed among the artists in their youth likewise created a supportive atmosphere in which each of the painters was able to continue his own investigations, not necessarily within the confines of Pop. Of the first generation, only Blake, after the interlude of his Ruralist period in the late 1970s, has remained faithful to the subject-matter and stylistic concerns of Pop which he was instrumental in establishing. Smith's impulse to abstraction, always a strong element in his art, had by the end of the 1960s almost completely eradicated the references to consumer culture in his paintings. Tilson's move to Wiltshire in 1972 also entailed a conscious exchange of the contemporary subjects and techniques of his 1960s work for traditional hand-worked media and for a more timeless imagery centred on nature, alchemy and, more recently, on pre-classical mythology.

The 1959–60 generation have likewise gone their separate ways, even in the case of close friends such as Kitaj and Hockney, the subject of Kitaj's recent metaphorical portrait of *The Neo-Cubist* 1976–87 (see p. 129). The highly distinct character of the work sustained by each of the artists over nearly three decades is, in fact, one of the most remarkable features of this group brought together by force of circumstance at a critical moment in their development.

Kitaj has remained firm in his devotion from an early age to iconography, to the history of art, and to subjects that convey passionately held beliefs. However, since the mid-1970s he has sought a rediscovery of the basis of modernism in traditions of life drawing exemplified by the Post-Impressionists and by the towering example of Picasso and Matisse. He refuses as ever to abandon his literary leanings, but now directs these as a spur to figure inventions that suggest an imaginative identity as strong as that of the characters of fiction.

The discoveries of the student years have continued to motivate even an artist with as wide a range as Hockney. In spite of the naturalistic style with which he established his ever-growing popular following in the later 1960s, he has in recent years returned to the spontaneous spirit and stylistic devices which characterized paintings now a quarter of a century old. When Boshier returned to painting in 1979 with works such as *The Culture of Narcissism* (see p. 131), after a thirteen-year gap in which he experimented with sculpture, photography, film, collage and assemblage, he took up the thematic threads and sources of his student production almost as if nothing had changed. In recent pictures such as *Fish and Sandwich*, 1984 (see p. 133), Caulfield has introduced contrasting techniques and methods of representation while remaining true to the attributes of all the work he has produced since he was a student: an immaculate surface and rigorous design, a pervasive melancholy and sense of the transience of life, a deployment of flat areas of colour as agents for representing light, and a consuming passion for pictorial conventions derived from the history of European painting.

Of the entire group, Jones and Phillips became the most committed protagonists of Pop from the mid-1960s to the middle of the following decade, but have also since returned to the source and spirit of the work which first established their identity. The subdued eroticism and luscious colour of Jones's recent untitled diptych, for example, has perhaps more in common with his early devotion to twentieth-century French modernism than with his more linear and blatantly sexual images of the intervening years. Phillips, likewise, having exploited the potential of vast airbrushed canvases teeming with precisely rendered contemporary images, has established since the late 1970s a more mysterious but still collage-based idiom of fragments bathed in dream-like atmospheres of colour.

The repercussions of the few Pop-orientated years at the Royal College have not yet died out, either for the original participants or for succeeding generations whose mature work has in some way extended these terms of reference. There are artists, for instance, who were at the College during the same years but whose work developed in similar directions only much later. Such is the case with work since the mid-1970s by Mick Moon, an immediate contemporary and close friend of Caulfield, or the recent object-based sculpture by Bill Culbert, who studied at the College from 1957 to 1960. Also at the College from 1957 to 1960 was Norman Stevens, whom Hockney had known at Bradford, and who later developed a naturalistic but stylized idiom similar in some ways to that briefly practised by Hockney. Victor Burgin, a student in the Painting School from 1962 to 1965, went on to produce conceptual works that married photographs with printed texts, which could be regarded as a more theoretical version of the relationships betweeen words and images

investigated by Kitaj and Hockney.

Parallels can continue to be made with the work produced by those who have studied even more recently at the College: for example, the photo realism practised by Brendan Neiland (1966–67), the free-wheeling investigations of styles and pictorial conventions in the paintings of Graham Crowley (1972–75) and Stephen Farthing (1973–76), and the collages and miniaturized environments by Joe Tilson's son Jake (1980–83). All owe something, no matter how subconscious the influence, to the work of their Pop predecessors. College traditions, it would seem, have their own life, not because of any imposed sense of loyalty or duty, but in part from a spirit of friendly competition, and also out of a consciousness of the achievements and inventions still to be sustained.

Patrick Caulfield
Stained Glass Window, 1967
Oil on canvas, 213.4 × 122 cm
Waddington Galleries, London
Cat. no. 172

Carel Weight
The Day of Doom, c.1955–65
Oil on canvas, 152.5 × 143 cm
Private Collection
Cat. no. 120

SINCE '62: THE LAST TWENTY-FIVE YEARS

Andrew Brighton

The USA has been a constant and formative element in the British art world for the last twenty-five years, and a history of post-War British art must address the rise, and now the decline, of its influence. To fail to understand the importance of the US is to misunderstand the significance of Pop Art to British culture. It represented a parting of the ways. To some it was a betrayal of either (or both) the ethics of high art or national culture; whilst to others it was an escape from the English indifference to contemporary art and the use of culture as a marker of class—it was a liberation. Pop Art established US culture as a shaping and dividing presence in the British art world, and at the RCA.

In 1964 the Whitechapel Gallery put on the exhibition *New Generation*. It included work by such former RCA students as Derek Boshier, David Hockney, Allen Jones, Peter Phillips, Bridget Riley and Patrick Caulfield. (Amongst the non-RCA participants was the Royal Academy Schools graduate Paul Huxley, now the Painting School's Professor). The painter Keith Vaughan wrote of the exhibition in his journal:

> After all one's thought and search and effort to make some sort of image which would embody the life of our time, it turns out that all that was really significant were the toffee wrappers, liquorice allsorts and ton-up bikes . . . I understand now how the stranded dinosaurs felt . . .

Much of the work shown at *New Generation* courted either American commercial graphics or New York School painting. The artists' work was not just (and in some cases not at all) a rejection of what Peter Blake had in 1963 called 'orthodox, so-called cultural things—you know,

Beethoven and D. H. Lawrence, the whole culturemonger concept of foreign films and such-like'. The professional art world they were entering was fundamentally different to their teacher's professional world, and its model was New York.

In 1957 Carel Weight, who had been teaching at the RCA since 1947, was appointed as Head of the School of Painting. It was a year after the pivotal exhibition at London's Tate Gallery, *Modern Art in the United States*, which was created by the Museum of Modern Art (MOMA) in New York. Weight said shortly after his appointment: 'I feel myself a solitary figure with little interest in current art fashions. American Tachist and Hard Edge, as well as most abstract painting, are profoundly boring to me.' For the bulk of Weight's Professorship from 1957 to 1972, the values and ideas of the art receiving the most attention and institutional support were radically different from his own and those of most of his staff.

MOMA was the single most important institution in creating the art New York had to offer. It established the 'Modernist' history of art—a historicist tale of art's autonomous development, of movement after movement which was presented through exhibitions and scholarly catalogues. At MOMA the art of this century was turned into history. For an artist's work to figure in this history was to secure its continuing significance and value. MOMA supplied the exemplar for how twentieth-century art could be institutionalized: it professionalized the culture of modern art.

A New York-style professionalism was added to the British art world during the late 'fifties and 'sixties. One

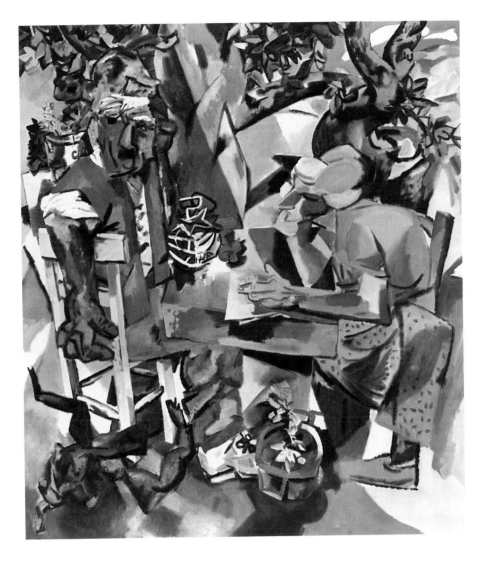

Peter de Francia
Monsieur et Madame Beylac, 1974
Oil on canvas, 170 × 152 cm
Arts Council of Great Britain
Cat. no. 191

crucial example of this change was at the end of the 1950s, when the commercial gallery, Marlborough Fine Art, turned its attention from the Old Master market and instead pioneered marketing modern art as art history. In their presentation, Marlborough's exhibitions and museum-like catalogues implied that the work they showed was worthy of scholarly attention and museum purchase. At a time when most of the College staff were making paintings untouched by pre-War avant-garde art, Marlborough were helping to establish its blue chip status. They were offering relatively luxuriant terms to contemporary British artists and selling their work internationally at international prices. They were creating a new top strata in the British contemporary art world, to which most art students aspired.

From the early 'sixties, other institutions started to follow suit. The Arts Council's catalogues became more like those of MOMA and Marlborough. The Tate

Gallery's new Director, Norman Read, declared he wanted to make the Tate a museum of modern art which, whether he realized it or not, implied a shift in emphasis to historical rather than aesthetic criteria for selection. And, of course, in terms of exhibitions of US artists in this country, what Alan Bowness called 'the American Invasion' was underway. British Gallery directors and critics made distinguished careers from showing and writing about American art, and a new generation of British painters won their attention by efforts much formed by American models.

In 1973, Allen Jones said of the College in 1959: 'The lecturers had a very old-fashioned idea about painting. They felt that a student should spend his first year in the life class, the second year thinking about it and the third year experimenting.' This obviously caricatures the RCA staff and their positions, but clearly it also assumes that such learning methods are self-evidently old fashioned and, therefore, ridiculous. Jones goes on in the interview to say that six months after leaving art school he was contracted to a dealer.

Asked why he had not shown with the Surrealists in the thirties, Carel Weight replied: 'I just thought I'd sooner show my things in a place like the Royal Academy. I don't like the art world very much. I don't like the dealers and I don't like the critics.' At the beginning of the 'seventies, over half the teaching staff at the RCA were full or associate Royal Academicians. For the most part, the commercial galleries in which they showed sold English art to English clients at what were, in terms of the international market, low prices. Their reputations were established through the Royal Academy rather than by sales to museums of modern art.

However, Weight and his colleagues were changing the nature of the Royal Academy. Traditionally, its members supported themselves largely by sales, and a great deal of the work was therefore confined to the limited pictorial sophistication of the English rich and their sentimental lives and vanities. Since the mid-1950s, however, the membership of the Royal Academy has increasingly included art school teachers and, particularly, the staff of the RCA, artists no longer dependent entirely on sales. As a result, different sentimental lives and vanities with wider pictorial sophistication now characterize the Academy. The ethos of the work has moved from the City of London towards Bloomsbury, from board-room portraits and horse racing to tastefully Bohemian interiors and scenes of the Dordogne. In this rather genteel context, pictures with seemingly gracelessly put on paint are to be seen, which are not limited by easy taste: Carel Weight depicts seedy South London as a theatre for the personal tragedies of suburban people.

In modern English literature there is a tradition of intelligent refusal of Modernism: for instance, by Graham Greene, Evelyn Waugh and Phillip Larkin. Similarly, Weight's refusal is not a licence to sentimentality, nor is it

unknowing. Speaking of the days of art historian Roger Fry's dominance in the art world, Weight has said: 'I was brought up at a time when English painting was considered absolutely beyond the pale and anybody who produced humanistic painting which played upon the emotions was absolutely out . . . I really rather like the idea of sending up high-brows.' In an essay about Stanley Spencer, Weight wrote that

> the innovator of an art movement need not necessarily have a great artistic personality; it is the idea which takes possession, not the man . . . But if a man is to succeed as a reactionary artist, as Stanley Spencer undoubtedly was (and I do not mean it in any derogatory way), then he must do so by the sheer force and originality of his personality.

The idea of personality, of a unique vision, is central to Carel Weight's work and to the liberal way in which he ran the Painting School. In his paintings, the apparently ordinary is depicted in a rhetoric of peculiar vision: perspectives are distorted, figures are placed strangely in and at the edges of the canvas, the movement of the brush is recorded in each transparent glaze of paint. In their movements and postures, his figures express fear or hate or loneliness. In defence of his liberal regime at the College, Professor Weight wrote in *Ark 50*, published in 1972, that 'anything we can do is utterly useless without the enthusiasm of the student . . . He must come to realize that he is no longer to be instructed or directed which way to turn. He must take his place in a community of fully fledged artists . . .' He went on to say:

> Movements have happened in the past like Pop and Social Realists and will probably continue to

happen and are very stimulating, but the backbone of a school depends just as much on the completely dedicated artists who seek to find themselves and the way they want to go.

The education art students were receiving in the undergraduate art schools changed after 1962, when degree status courses were introduced. As a consequence, the College itself became a purely post-graduate institution and was given a university charter in 1967; Heads of Department became Professors. The raising of the status of art schools was probably aimed more at designers, who would be involved in the 'arts of manufacture', than fine artists. However, if the artist or designer were to join the professional classes, then his or her education should not simply be in art and design as an artisanal activity. Now students normally had to have 'O' and 'A' levels to enter art school, and as part of their first degree studied art history and wrote dissertations. Ruskin Spear, who taught in the School from 1948 to 1976, described it as

> the Great Purge of the Art Schools. Art Education was to take over, with its 'O' levels, 'A' levels and Art Examinations. Students were dragooned into emulating the latest art styles. They were force-fed; made to 'read all about it'; to know through reading books—painting itself became almost a secondary activity. It was assumed that if you read about it you could do it automatically.

A great deal of what was being read came from the USA. To a large extent, in the late 'fifties and 'sixties British art students—and their staff—got to know about pre-War European as well as post-War avant-garde art via New York. In the USA, modern and contemporary

Ken Kiff
Talking to a Psychoanalyst: Night Sky no. 13, 1973–79
Acrylic on canvas, 81 × 137 cm
Private Collection
Cat. no. 224

Alan Miller
Gifts (for Ruby), 2nd version, 1985
Oil on canvas, 182.9 × 152.4 cm
The Artist
Cat. no. 194

Eileen Cooper
Taking Root and Falling Leaves, 1984–85
Oil on canvas, 212.1 × 151.8 cm
The Artist/Benjamin Rhodes Gallery,
London
Cat. no. 212

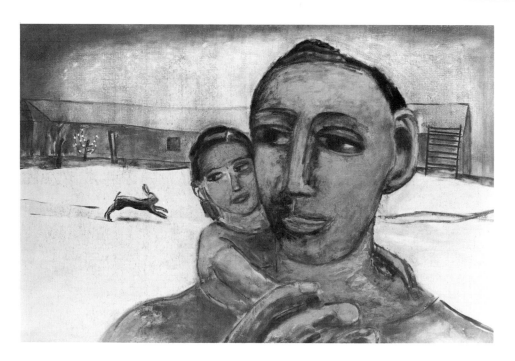

Andrzej Jackowski
Earth Stepper with Running Hare, 1987
Oil on canvas, 152.5 × 233.5 cm
Marlborough Fine Art (London) Ltd.
Cat. no. 208

art were objects of scholarly and serious critical attention to a far greater extent than in this country. The American art magazines were a revelation; the catalogues to major shows unequalled. The classic texts of the pre-War avant-garde were translated and published there, and British publishers contributed virtually nothing to this field. A student in the 1960s who was attending to such material was working within a different world to that of the staff and many of the students at the College. In his recent book *The End of Art Theory*, Victor Burgin, who graduated in 1965 and went on to study in the US, still cites the RCA and its students in the 'sixties to exemplify anachronistic attitudes to painting and image-making in modern society. In an essay published in 1975, Burgin wrote:

> Conceptualism administered a rebuff to the Modernist demand for aesthetic confections and for formal novelty for its own sake. It disregarded the arbitrary and fetishistic restrictions which 'Art' placed on technology—the anachronistic daubing of woven fabrics with coloured mud, the chipping apart of rocks and the sticking together of pipes—all in the name of timeless aesthetic values.

The terminology of Burgin's statement has its origins in US art culture. What is meant by Modernism is Clement Greenberg's interpretation of modern art since Manet, and the art produced and given value in the US in the light of that interpretation. In this account, authentic modern art offers an instant and intuitive experience.

After Carel Weight's retirement in 1972, Peter de Francia was made Professor of Painting, remaining in this post until 1986. In his inaugural lecture, *Mandarins and Luddites*, he approached in very different terms the

arguments Burgin later addressed. For de Francia, art is a matter for intellection—it is there to be thought about. That modern art in general, and Picasso in particular, should be read as offering only experience devoid of concepts was entirely foreign to his teaching. At the centre of de Francia's position is a Marxist view of art and culture. In the context of his teaching in Britain, his Marxism has meant a view of contemporary art in context of the history of European art and high culture, and one that interprets that art in the light of the Marxist strand of Hegelian art history (he was a student and friend of Kurt Badt). De Francia was not only at ideological odds with much of English culture, but also his terms of reference were much wider and his ways of understanding unfamiliar. For some, including myself, his teaching was a bridge into another continent of ideas.

In de Francia's *Mandarins and Luddites*, the Mandarins included 'the important dealers, a horde of cultural entrepeneurs, and the majority of critics'. He accuses them of playing counterpoint to public relations prattle, and of being trapped in 'Taste'. He attacks the ideas of the supposed autonomy of art, and of art itself as the focus of the artist's investigations. Such ideas ignore the relationship between mind and things which are fundamental to visual language. This relationship cannot be understood on the basis of individuality and the individual, 'It can only be understood on a socio-historical basis'. Criticism must be based on a reasoned theory of history.

De Francia is an academic: that is, I take him to believe, like Reynolds, in the power of reason to understand and shape the practice of art. If at the centre of Professor

Weight's regime was the idea of the young artist cultivating his individual talent, in de Francia's was the painter as intellectually well-equipped cultural worker. With a rapid and almost complete change of staff, the School under de Francia offered a much more rigorous experience. He has been described by R. B. Kitaj as 'a great and born teacher from whom I can always expect, and always get, a withering storm of close-order scrutiny of my own pictures, which makes my most savage critics sound like Bo-peep . . .'

De Francia's Professorship began amongst a high tide of what in his lecture he called Luddism, one instance being the Conceptualist attack on painting. He agreed with the contemporary Luddites' rejection of the commodity function of art, but he criticized as absurd their denigration of art as useless. Such denigration, he argued, was based on what he called 'the fag end of Dada', the avant-garde 'myth' of the progressive role of the artist, and crude ideas of historical advance. I understand de Francia as believing in art as offering something other than a symptom or expression of the dominant culture. 'In the Hegelian sense art is a partial system,' he has said, 'depending on the multiple significance given to objects of a privileged nature. These objects act as mediators between all other systems making up society.' Art does not simply reflect the multiple systems of society, it reflects *upon* them, and is in this sense a critical activity. De Francia writes of how in Picasso's lifetime,

> Picasso and a few of his contemporaries were seen as offering a certainty, a guarantee that the very nature of painting, incongruously armed with its rudimentary tools and working methods, was valid

and could triumph in the modern world, and it could also, in some ways, challenge it.

De Francia's work is not predicated on an idea of originality, and he has declared his commitment to the reconstruction of the syntax of pictorial language after the fragmentations of Modernism. His drawings echo Picasso in their line and the way they speak of our world through a fictive Classicism. He has described himself as 'not good at colour', but in *The Forgotten Fifties* exhibition (Sheffield, 1984), the raw absence in his painting, *African Prison*, of a conventional painterly sensibility made it appear the most modern painting in the exhibition—if it was not so well drawn it could have been painted in Hamburg or Düsseldorf in the 1980s.

In the 1960s when Max Beckmann was largely ignored and Picasso was of importance as a stepping stone to Jackson Pollock and the New York School, de Francia was making them central to his teaching. With the rise of European art, and in particular the German art and art market, during the 1970s, Picasso and Beckmann are models for young artists again. Now paintings of or like toffee wrappers and liquorice allsorts seem like the debris left in the wake of a receding culture. I do not presume to know what debt if any, for instance, Graham Crowley, Stephen Farthing, Andrzej Jackowski, Michael Heindorff, Eileen Cooper, Arturo di Stefano, Thérèse Oulton and Tim Jones would accept they owe to de Francia's teaching and professorship, but all of their work is informed by a European imaginative high culture. For the practice of painting so informed there was no more appropriate place to be in Britain as a student between 1972 and 1986 than the College under Peter de Francia.

James Mooney
Invisible Cities, 1987
Oil and wax on canvas,
213.3 × 411.3 cm
The Artist
Cat. no. 213

Thérèse Oulton
Pearl One, 1987
Oil on canvas, 238.8 × 213.4 cm
Marlborough Fine Art (London) Ltd.
Cat. no. 216

Denzil Forrester
Untitled, 1983
Oil on canvas, 240 × 195.5 cm
RCA Collection
Cat. no. 215 student work

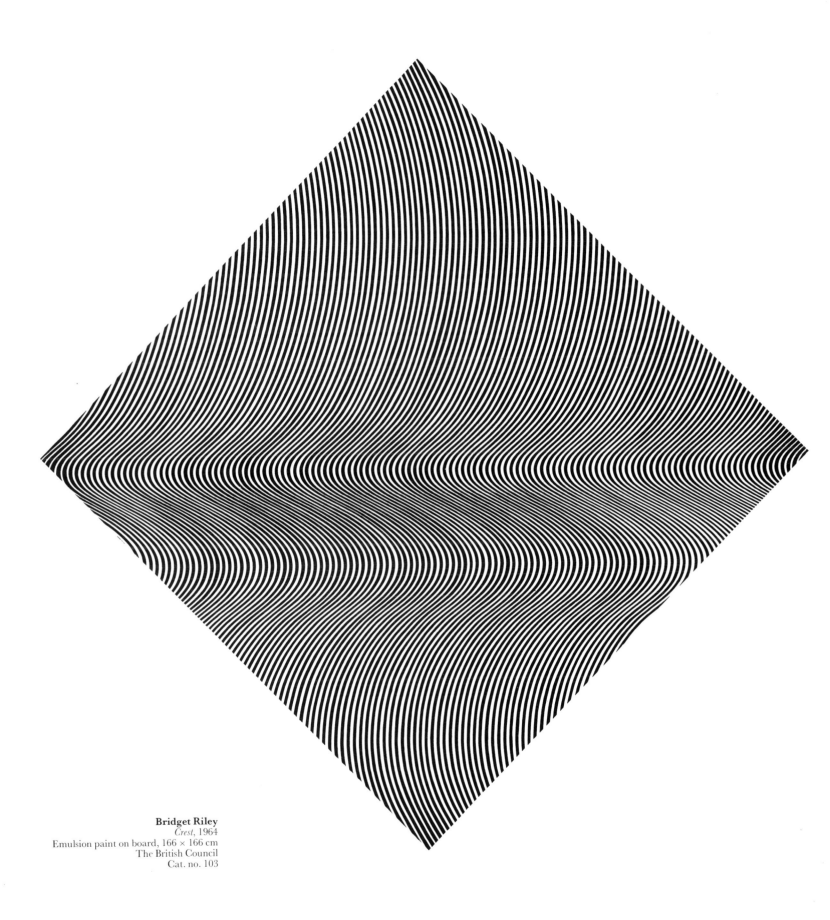

Bridget Riley
Crest, 1964
Emulsion paint on board, 166 × 166 cm
The British Council
Cat. no. 103

ABSTRACT PAINTERS AT THE RCA

Bryan Robertson

When we consider the effect that art schools have upon the development of a young artist, it is salutary to remember that Francis Bacon never attended one. Innate precocity of that order is rare. For lesser mortals, art schools provide indispensable time for evolution, space for technical instruction, access to materials, life class—so crucial in the habitual practice of great artists from Matisse to Moore—the clarifying challenge of differing viewpoints from mature teachers, and a forum for the flow of information.

A broad-based liberal establishment is better for a young artist than a school governed by orthodoxy, however lively and alluring that orthodoxy may seem momentarily. Orthodoxies never last. Imaginatively and intellectually, a liberal establishment will be open, the orthodox school closed. Everyone respects what Frank Martin achieved as Head of the Sculpture School at St Martin's in the 1960s, when Anthony Caro's fresh approach to sculpture as assemblage was the prevailing house style—it was a necessary revolution—but the climate for work created by Bernard Meadows, running the Sculpture School at the RCA in the same period, seemed then and still seems now more productive in the long run for emerging talent. Meadows ran a tight ship, where technical weakness was jumped on, but all kinds of exploratory approach countenanced. Style was not put in a strait-jacket. Orthodoxy is what can go wrong with an idea when it freezes: what begins as an idea is implemented with too rigid an idealism, an inflexible creed which suddenly atrophies as ideology. The freely creative impulse is lost, leaving behind an unyielding, iron-clad totem of fixed belief.

Emerging student talent can be knocked out by this kind of doctrinaire grip, or it can be harder for an original talent to reach daylight. Through the 1950s and 1960s, the painting school at the Slade School of Art was dominated by latter-day followers of the 1937–38 Euston Road principles of figurative painting, in their day a post-Abstraction and Surrealism 'back to Degas' academic revisionism, topped up with a thin veneer of social content. Its lieutenants in the 'fifties supported the equally rigid followers of David Bomberg, viewing their work as an Expressionist extension of Euston Road painting. John Berger supported this academic work in his criticism, and an almost moral element was built into the use of tonality: the use of pure primary colour was seen in this context as something immoral, or at least irresponsible and 'decorative'.

Young talent can also be set back by another form of disruptive dogma: politicization. Following the world-wide student unrest of 1968, centred in Paris, and the notorious lock-out at Hornsey School of Art, there was an anti-authoritarian phase at the RCA, extending into the 1970s, which saw the rejection and closure of the life class and locks placed by students on the lithographic and printing presses to ensure 'freedom' from traditional disciplines.

If the idea that an art school that is creatively open seems healthiest, it is also salutary to recall that Caro, John Hoyland and Paul Huxley, three of our best and most radical artists in recent years, all graduated from the Royal Academy Schools, an institution then not only free of restrictive doctrine but notably lacking in any particular cachet or atmosphere as a centre of instruction. The truth is that 'talent will out' from any school, but the

John Piper
Forms on a Green Ground, 1936
Oil on canvas, 152.4 × 182.9 cm
The Artist
Cat. no. 38

Richard Smith
First Fifth, 1962
Oil on canvas, 172.7 × 182.9 cm
Knoedler Kasmin Ltd./Mayor Gallery,
London
Cat. no. 135

Merlyn Evans
Composition No. 3, 1962
Oil on canvas, 199 × 110 cm
Estate of the Artist/Mayor Gallery,
London
Cat. no. 52

process may take longer if it has to climb out from beneath the shadow of doctrine.

Apart from the troubled phase of polarization in 1968–72, the Painting School at the RCA seems to have been comparatively free from dogma in its outlook. For the past thirty years it has been staffed by men and women of basically conservative allegiance, artistically speaking, but open to abstraction or abstractly figurative work. Since the 1950s, both the Painting and Sculpture Schools have kept a warily amused eye on that particular element of faintly old-fashioned smartness within the College corporate style which hovers halfway between Heals and the old Faber and Faber house style (when Barnett Freedman designed charming dust-jackets for Walter de la Mare anthologies).

More crucially, the Painting and Sculpture Schools for years now have had to fight their corners against an almost constant threat of cuts. In an inter-disciplinary college of art and design, the need for interaction between pure art and applied art must surely guarantee the continuing

strength of painting and sculpture. There is no good applied design without the influence and direct involvement of pure art. William Johnston established this conclusively forty years ago at the Central School of Art and Design when he engaged artists like Alan Davie and Mary Kessell to teach in the jewellery and silversmith departments, with dramatic improvements in the resultant quality of design. Those who seek to promote design, because of its practical usage, at the expense of fine art, reveal a dangerously abortive ignorance. The greatest fabric designer of the twentieth century, Raoul Dufy, made thousands of designs for furnishing and dress fabrics as a spill over from his great gifts as an artist, not as a central pursuit. Streamlining, the dominant element in early modern style, did not come from a designer, but directly from Modigliani and, above all, from Brancusi, the true creator of the Festival of Britain Skylon.

The progression of Professors of Painting from Rodrigo Moynihan (1948–57) through Carel Weight (1957–72) to Peter de Francia (1972–86) sums up the essentially figurative thrust of the College for the past forty-odd years. Weight was conspicuous for his liberality and kindness. De Francia, a Francophile and a Léger scholar, kept the great premises of modern European art alive for students when trips to New York or Los Angeles were the summit of student ambition. His role was re-inforced by John Golding (tutor 1971–86) as a conspicuously brilliant scholar of modern art with commensurate awareness as a practising abstract painter. As a student from 1950 to 1953, Jack Smith does not remember even meeting the amiable and elegant Moynihan. Smith worked in a studio away from the College, and remembers with affection the

ungrudging visits of his tutor, John Minton—his intelligence, idealism and consolingly shared view that art was something marvellous to devote one's life to. Minton seemed not at all disillusioned to Smith, and his suicide came as a shock.

Smith's first one-man show was held in 1953 at the Beaux Arts Gallery while he was still in his last year at the College, and his work then was figurative, although strongly Expressionist from the outset and with an evident drive towards abstraction. The Kitchen Sink label was first spelled out at this time, but it never fitted Smith's work. The journalistic phrase seemed at first to parallel the 'angry young man' epithet for John Osborne's outspoken work for the theatre, but it really only applied accurately to John Bratby, who actually did paint a few pictures with sinks in them. Helen Lessore was intolerant of any art which departed from representation, and what she saw, sometimes mistakenly, as smart gallery art. She asked Smith to leave the Beaux Arts when his work grew wholly abstract in 1957–58. Derrick Greaves was also asked to leave the Gallery when he suggested that the brownish canvas-covered premises might be painted white.

The work by Smith that I saw in 1957–58, before his Whitechapel show in 1959, was abstract, in his 'sea rise and fall' series, like abstract graphs of movement and almost obsessive in its visionary intensity. His painting has evolved independently from anything acquired at art school. He remains a magnificently inventive abstract artist, perfecting an idiom akin to music in its freedom, intelligence and precision.

Arriving at the College a year after Jack Smith, Bridget Riley, 1952–55, also remembers Minton with gratitude for

his evident concern for students, fresh spirit and love of art. Otherwise, she found ignorance of the real aspirations as well as recent developments in modern art in the teaching of art history at the College, the scope of lectures terminating at Cubism. Like Smith, Riley worked mainly away from the RCA: her phase of drawing in black and white for two years with Sam Rabin at Goldsmiths' was over, and at the College she still used the life class extensively and painted portraits at home. Her friendship with Maurice de Sausmarez from 1958 on, rediscovery of Seurat, and her first abstract work in black and white came after her departure from the College. Riley's mature work in black and white since 1959 and colour since 1967, consistently avoiding easy exits, has added decisively to the history of abstract art in the past quarter of a century, and continues to develop. Her exploration of colour has passed through some notably spectacular climaxes, and her work retains still its suggestion of power in reserve.

Malcolm Hughes
Six Unit Relief/painting, 1973–74
Wood, hardboard, pva and oil,
167 × 111 cm
The British Council
Cat. no. 73

Mary Martin
Perspex Group on Dark Blue (c), 1968
Perspex on wood, 61 × 61 × 20.3 cm
Annely Juda Fine Art, London
Cat. no. 46

Jennifer Durrant
Little Deaths Series—Descent, 1985
Acrylic and metallic paint on canvas,
260 × 278 cm
The Artist
Cat. no. 225

Paul Huxley
Surrogate, 1982
Acrylic on canvas, 195.5 × 195.5 cm
The Artist/Mayor Rowan Gallery, London
Cat. no. 222

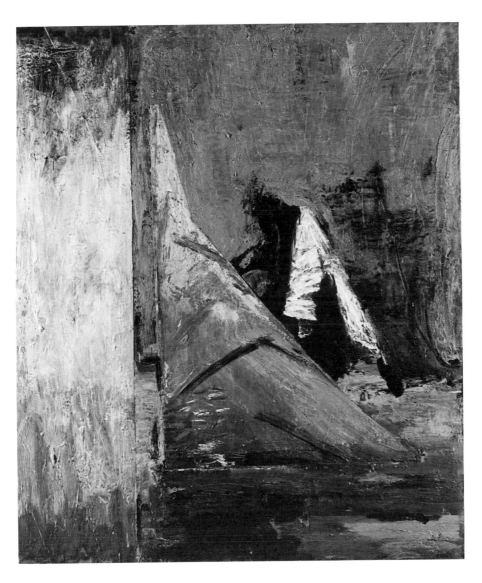

John Walker
The Shape and the Disgruntled Oxford Philosopher, 1979–80
Oil and acrylic on canvas,
211 × 184 cm
Whitworth Art Gallery,
University of Manchester
Cat. no. 196

The early 1950s was a drab time for any practising artist, particularly for those searching for a valid abstraction. England was still provincial after its war-time isolation. The war-time romantic artists, Robert Colquhoun, Robert Macbryde, John Minton, John Craxton and Keith Vaughan still flourished as figurative artists; a Degas pasticheur, Geoffrey Tibble, was a dominant name; Tristram Hillier and Stanley Spencer showed regularly, working through ideas that still seemed tinged by academicism. It was the beginnings of the period of RCA-dominated Kitchen Sink figurative painting. The socially committed figurative painting of Renato Guttuso, Francis Gruber and Paul Reyberole was the aspect of foreign art most publicized in England. The counter-blast of Jean Dubuffet, Nicolas de Staël and Antoni Tàpies made its mark in England only from the mid-1950s.

The climate was marginally livelier for Richard Smith,

a contemporary at the College, 1954–57, with Robyn Denny, Brian Fielding and with Alan Green. All four painters have consistently worked abstractly. Fielding, who died prematurely in 1987, left a complex body of work which has never received the attention it deserves. A decent retrospective in London is badly needed.

With his contemporaries, Richard Smith was stimulated by the early waves of American painting, and he rapidly evolved from serene beginnings as a figurative painter of singular refinement into an extraordinarily detached commentator on aspects of American style in the late 1950s. The commentary swiftly turned into an act of original creation. His first mature abstract canvases in 1957–58 were painted in a 'cool' variation of Abstract Expressionism, as if in slow motion, thin and delicate in paint but vivacious in colour. Smith's subsequent explorations of shape, surface and colour repeatedly set 'style' in inverted commas and focus attention on form and structure in a fresh way. Cosmetic colour, like lipstick and eye-shadow tints, was investigated, and one long phase projected the kind of synthetic colour associated with commercial flavouring and colouring: melon, peach, tangerine, lemon.

Smith never became a Pop artist, but he was fascinated by the abstract aspects of commercial packaging and, more than anything, commercial presentation. He is one of the most distinguished abstract artists to emerge from an English context—and a born designer, with a restaurant and a bank to his credit in the US. A brilliant floating décor of kites and related backdrop for a ballet, *Wildlife* (choreographed by Richard Alston for Ballets Rambert in 1984 with music by Nigel Osborne) is Smith's only English

John Golding
Splintered Light—Toledo Blue, 1985
Acrylic and mixed media on canvas,
152 × 208 cm
Mayor Rowan Gallery, London
Cat. no. 195

work for many years since his residence in the US, which is a shameful reflection on his native country.

Jack Smith and Bridget Riley have also designed memorably for ballet. Riley created seven resplendent backcloths and costumes for Robert North's *Colour Moves*, also made for Ballets Rambert, in 1983. Jack Smith has recently designed two outstanding works: the sets and costumes for *Carmen Arcadiae*, 1986, choreographed for Ballets Rambert by Ashley Page for the Harrison Birtwhistle score; and the stunning sets and costumes for Page's work for the Royal Ballet, *Pursuit*, 1987, with music by Colin Matthews.

John Piper's stage designs for Benjamin Britten's operas, *The Rape of Lucrece*, 1946, and, most recently, *Death in Venice* in 1973, are among the great visual achievements for the stage in this country. Piper has experimented and explored more than is generally realized. He has perhaps removed himself from proper critical attention through his enterprise and resilience, since the slump period of unemployment in the 1930s, in securing all kinds of commercial work for himself. But designing posters and books, illustrating poems and travel guides, creating décor for stage and designs for fabrics has always seemed to me a perfect means of survival for any artist capable of working in these ways—and perhaps preferable to the debilitations of regular teaching. We mistrust, foolishly in my view, artists who work commercially, and impose a snobbish and ignorant stigma over the word 'decoration', forgetting Rubens, Delacroix, Picasso, Matisse, Chagall, Léger, Dufy, Calder and Noguchi.

Piper's abstract phase of the late 1930s—he was at the RCA 1926–28—is less well known. Formally astringent in

Gillian Ayres
Wells, 1982
Oil on canvas, 213.4 cm (diam.)
Knoedler Kasmin Ltd., London
Cat. no. 226

its interplay between flat, overlapping planes of colour, it plays also with the conventions of synthetic or decorative late Cubism of the 1920s, and acknowledges the advent of the more classically composed abstractions of Jean Hélion in the 1930s. Piper and his wife, Myfanwy Evans, were both friendly with Hélion in Paris at this juncture.

The most powerful abstract artist to emerge from the College in the 'thirties was Merlyn Evans, 1931–33. His earliest work was astonishingly mature, as we see in the lyrical abstract painting of *Day and Evening*, 1932 (see p. 28), and his strong gifts and intellect combined to create some of the most memorable pre-War abstract Surrealist images. His immediately post-War paintings of 'The Refugees', and other abstract fantasies fired by social concern, are among his richest and most glowing compositions. Evans has never fitted conveniently into any tight stylistic category: too Surrealist for the purely abstract groups before the War, his work became paradoxically more abstract through the 1960s when Pop Art

took the limelight. His work in painting and engraving largely still remains as uncharted territory to be seen and assessed as a whole.

Another fine artist, Elisabeth Vellacott, a historic survivor at the age of eighty-two from the Will Rothenstein period at the College—she was a student from 1925–29—has described conditions which must have been still relevant for Evans and Piper only a few years later and have applied to John Tunnard in an earlier phase (he was a student from 1919 to 1923); Tunnard's consistently Cornish landscape-based abstract work reached its inventive peak in the late 1930s and 1940s. Rothenstein was felt by students to belong to the 1890s, Vellacott recalls, without contact with modern art, and, though kind, was resented by working-class students. There was no official awareness or encouragement of abstract art. The Diaghilev Ballet, in its last London season in 1928–29, was seen by most students as the best source of reference for modern art. The College was not purely academic in its thinking,

Stephen Buckley
Splash 2, 1975–77
Oil on canvas, 122 × 122 cm
J. Kasmin Collection
Cat. no. 220

but geared more towards the classical discipline of Ingres. The young Tom Monnington was the liveliest teacher. Will Rothenstein, by contrast, gave one annual lecture, and twice a year demonstrated drawing, to the fury of students, by altering their own work directly on the sheet.

Given this extensively figurative bias directing the Painting School ever since Rothenstein, it is surprising that any abstract art has managed to emerge from the College. It is amazing to me that it has managed to exist in England at all. My first steps inside the art world in 1943–44, when I was eighteen, were dogged by everyone exclaiming at the merciful arrival of Geoffrey Grigson, Samuel Palmer and the Romantic figurative art of the war-time period, whilst the abstract art of Ben Nicolson and Barbara Hepworth was remote and unseen in Cornwall. After the War, figurative art continued to dominate the art world, culminating in the Kitchen Sink painters. No sooner had Abstract Expressionism arrived, and American innovations been barely digested, than the new figuration of Pop Art was on the scene. With David Hockney's arrival, when still a college student, critics happily trumpeted 'the return of the figure'. With so many boys splashing about in the showers, Patrick Procktor thought the movement might be better named 'son of figure'.

Anthony Caro and Phillip King, John Hoyland, Bridget Riley, Paul Huxley, and both Jack Smith and Richard Smith were all quickly obscured, not only by Pop Art, but also in the ensuing waves of art and language, video art, performance art and conceptual art as a whole. More recently, the revival of belief in painting has been quickly confined to 'the new spirit', which can only be placated, it appears, by figurative painting. In England, figurative art has never been allowed off stage for more than five minutes. It is our national, established taste—although oddly enough it contrived to ignore the dazzlingly original, powerful and sophisticated work of our best figurative artist, Edward Burra (a student from 1923 to 1925), for his entire lifetime.

As the new Professor of Painting, Paul Huxley will have to move mountains in a time, following his appointment, when figurative art is still in the ascendant. Huxley will succeed in opening the Painting School again to fresh thinking because, as one of our most original and consistent abstract painters, he has clear soundings in the vital issues and achievements of modern painting, as well as a judicious sense of creative balance. Among his colleagues distinguished for their abstract work, John Golding, Jennifer Durrant and John Walker have played a strong part as well as, less centrally, Gillian Ayres, Howard Hodgkin, Bernard Cohen and Stephen Buckley. All this implies a healthy diversity inside the frontiers of abstraction—it is up to the students to extend them.

PORTRAIT PHOTOGRAPHS

By Snowdon

INTERVIEWS

By Robert Cumming
and Christopher Frayling
November 1987

Cecil Collins
Ruskin Spear
Jack Smith
Bridget Riley
Peter Blake
Adrian Berg
R. B. Kitaj
John Bellany
Lucy Jones

CECIL COLLINS

Student 1927–31

It's a long time ago. Sixty years. William Rothenstein was the Professor, as well as the Principal. The atmosphere was very rich, more innocent than it is now, full of an inherited richness—much more 'bohemian', in the nineteenth-century sense of the word. One had a great sense of the nineteenth-century masters. And what clinched the whole thing was the fact that the Principal was a distinguished artist and *knew* Degas, Verlaine, the poet, and others. That, for me at least, was a very, very exciting and stimulating thing. Here was a time in which the residue of an inherited, transmitted culture was present.

The impact of modernity hadn't really been felt then—hence I can talk about a certain 'innocence'. I discovered the Surrealists only really after I had left the College. What the RCA provided for us was this wonderful sense of belonging, which you haven't quite got today—there is an estrangement about now. But during the last year I've come up to College and done a bit of teaching, and I can't tell you how happy I felt. The corridors in Exhibition Road are arranged in exactly the same way as when I rushed down them as a young man, and the whole atmosphere of continuity still remains—the life room which I drew so excitedly in is the same, except the clock has gone. Even the lockers appear to be there.

One of the great influences as far as I was concerned was the presence of the Victoria and Albert Museum. The statues and the sculpture were such an education. In those days, we didn't have a very fat scholarship—we had a very lean one indeed—and often we were rather scarce of food, to be absolutely honest. (We were, after all, not so far off the First World War, or the Great Strike of 1926.) So the milk-bar in the William Morris Room, with its hot milk, was the great thing on cold mornings. And wandering through the V and A actually excited my creative faculty and enabled me to dream. I think the conjunction of the Museum and the College was one of the great things about the RCA.

We were being taught by artists. What I want to stress very much is that it was an artist's epoch—the teaching bureaucrats hadn't yet arrived. Composition was taught very well, on the geometrical principles of the Renaissance. It was something we had to do; they did insist on the *craft*. I had the advantage of the School I'd been to at Plymouth, where I drew from casts (which I absolutely approve of) for several weeks. You learn the discipline of being able to read tonality, which is very useful for any kind of painting, and you learn stamina, how to develop. Since then, there's been more of an emphasis on originality. In that sense, all we're doing is moving towards amateur status—it's not a profession anymore. How many students today can't do anything, and call it 'self-expression'? In the College in those days you were quite severely criticized: there was self-expression, but of a formal registration.

I once painted a picture which caused quite a disturbance, a painting of 'maternity'. There was going to be a great student exhibition in the V and A, which was the crux of the matter, because my picture was reckoned to be totally unsuitable. They objected to my 'maternity', a figure with a huge stomach, but it was beautifully painted, like a Rembrandt, with a wealth of impasto. Well, I was called up and I think I was interviewed by the Principal himself. He didn't condemn the painting at all, he was too much of an artist for that, but he thought it would cause an embarrassment and disturbance to the visitors. And I respected him so much that I had no trouble withdrawing it, but there was quite a lot of spirited talk about it.

It was a four-year course, and for the show at the end we were locked up, literally, in cubicles in Exhibition Road. It was very strictly organized, with printed directions and four subjects we could choose from. You weren't allowed to consult with the others. The subject they gave us was scenes from the Bible: I chose 'Ruth among the Alien Corn'. And then you pinned up all your work around the cubicle. The Diploma Day was quite a thing, in the courtyard of the V and A, among the cherry trees.

I think probably the painters thought of themselves as an elite. The ones that were able to relate to design, and there were quite a number of them, got on happily in both disciplines. I mean there is this great tradition in the College of the decorative arts, but I can't remember that there was any split. The human figure was the key to the whole thing—art and design—and I believe it still is. And the importance of fine art was that the students did *think*—that is what new generations are now coming to realize.　CF

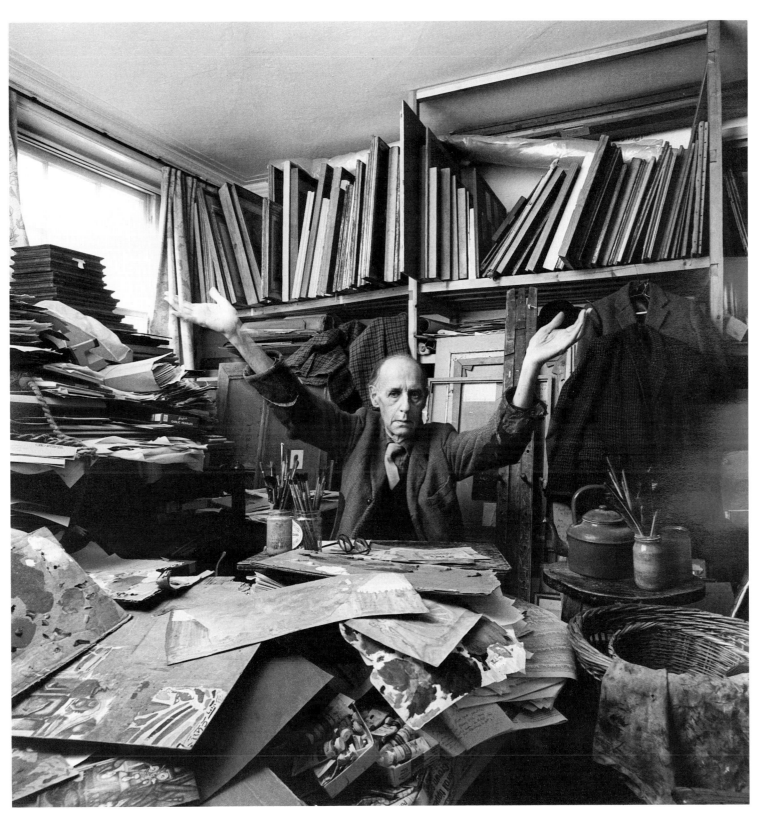

Cecil Collins in his Chelsea Studio, November 1987.

RUSKIN SPEAR

Student 1931–35 Tutor 1948–75

I won a scholarship from Hammersmith School of Art, where I was getting £9 a year. When I went to the College, the next scholarship I got was £121 from the LCC—one of the best in England. And I went up to this wonderful place, which I'd always had my eye on. With a lot of other scholarships, the chaps had to pay them back at the end of their time, and it was really tough on them. You could almost tell by the way they ate their food in the mornings in the Common Room that they knew they would have to pay it back one day.

I went up that opening day, up the stairs to the Royal College, and at the top was the room where the Principal was, and he was going to see us all. We were all in a queue, like going for the dole: I went in, and there was a little man and a very fine-looking man, both sitting there. And I thought, 'Gosh that must be the head!' So I talked to this wonderful man, but it wasn't him: Rothenstein was the little monkey-man by his side. Rothenstein said, 'Why are we giving places to all these people; we can't take them on you know.' I thought, 'Oh Christ, we've had it.' But it worked out all right.

Rothenstein was both Principal and ran the Painting School, which was very unusual. It showed the importance with which Painting was regarded then. We were allotted studios to go in at certain times, not individually but in groups. About twenty-four of us would be booked in to do life drawing in the evenings, and we all went. The teaching was slightly terrifying. Two staff would come in at the door of the life room, and there'd be about thirty students drawing, trying to make a success of themselves. It was terrible: you thought, 'Ooh, I can't draw, I can't draw.'

I had the disadvantage of being a day-boy, coming from Hammersmith. Others who had arrived from different parts of England went to the Common Room, where you got a different lot of people and different radical ideas. There were two big shows in an old house which they decorated and painted over with whitewash, and put all their drawings up to make money for the Spanish Civil War Republicans.

There was a bit of formal teaching, principles of Renaissance painting, the golden section. And we had to do architecture, of course—the biggest waste of time, but the only way Rothenstein could get rid of a lot of us (because there wasn't enough room) was to shove us into architecture. I did a design for a concert hall, which was terribly funny, as I'd never before done anything like it. I think I forgot the roof.

I had a pal who came from Yorkshire, and when he sat down in the life room he sat on the floor. One day Rothenstein looked down at this guy and said to Halliwell, 'And what are you doing there?' He had this marvellous voice: 'And what do you think you are?' 'I'm a primitive!' 'And how did you get to college this morning?' 'By bus,' he said in his Yorkshire accent. And that's how we all did it, primitives all going by bus.

Rothenstein was a good man, and looking back on it we all loved to sneer at what he'd do—he'd come down and show us how to do a painting in one of the rooms, and with great solemnity he'd do this painting of a head or something else and it'd be put up with absolute derision on the side by the window—'He's been down today,' we'd moan. He didn't come round a lot, but left most of it to Gilbert Spencer, who, thank God, would stop Rothenstein tearing the guts out of you. Rothy could be very deep and thoughtful, but you weren't old enough to know, you see. Merlyn Evans was once next to me in the life room. He was a Surrealist and he didn't like painting Impressionist or Expressionist pictures. He was doing the toes of the model with a marl-stick and a brush. And Rothy came round, and I was standing by the side of the painting. So he turns to poor old Merlyn and says, 'Look at your comrades here, painting from the shoulder. What are you doing down there on your knees?' Very little else was said. Out he went. So did Merlyn—he never came in the life room again.

I got a couple of days' teaching in 1948. We had a student called Jerry, who was painting away in the life room and I came in and said, 'It's terribly wrong, the background's absolutely wrong there, mix the whole lot up again.' And Jerry said, 'Thank you sir.' So I went out of the room. And then Robert Buhler came in about an hour later, went over to him and said, 'That colour is all terribly wrong, terribly wrong.' And he put green all over it. And Jerry said, 'I'm never painting in colour again after that, only in black and white.' The students were very different to my day. For example, I went in one room, looked down and there was a chap scrabbling about on his knees on the floor, making a terrible mess, and I said, 'What are you doing there?' He looked up and said, 'I don't know but it's paying off.' Well, that is another attitude, and that man is called Stuart Brisley . . . You see, I don't know, maybe it's right. CF

Ruskin Spear in the Cross Keys pub, Hammersmith, November 1987.

JACK SMITH

Student 1950–53

I wanted to be an artist at the age of fourteen, and one of the crucial things that happened at that time was reading Wilenski's book on Modern French Painting. There I was introduced to the world of Modigliani and Picasso and Braque. It really gave me a direction. There was the world of Modern Art for me at a very early age, and I had no interest in Old Master painting at all. I went to Sheffield Art School for a short time and then I did military service. After that I went to St Martin's for one year and was then immediately accepted by the Royal College.

I felt for the first time in my life that I was among people who also wished to be artists. After the first year I worked away from College, in a studio in Kensington. My personal tutor, John Minton, signed a chit for me to be away from College for six weeks, and this was renewed for two years. I liked this because I hated painting in crowded studios full of other people. The only direct contact I had with the College was coming in to sign and to have a cup of coffee and talk to other students. It was a very self-contained world, quiet and lonely, but it got one ready for what it was going to be like when one left college. I produced two paintings a week—a great deal of work.

My first year was not happy. I was doing what were then considered to be rather extreme pictures, and the College was rather academic and traditional, except for a man like Minton, who was different and open to modern art. He was very alive and without bitterness, and he made you feel that being an artist was very worthwhile. I found some of the other tutors a bit cynical and sarcastic, and dealer- and gallery-orientated. I was spending too much time arguing about what I was doing and why, so I removed myself. At the end of the three years, the tutors who were opposed to what I was doing were so no longer, and in a way welcomed it with open arms.

I had my first exhibition in my final year. That was a bit unusual, as people didn't do that kind of thing. Rodrigo Moynihan, who was Head of Painting then, came to see me to ask about the exhibition, but that was the first time I saw him in three years. He painted in his studio and left the teaching to the rest of them. Occasionally Carel Weight came, and was very kind and always concerned with one's welfare. We had a friendly relationship, and he was completely without bias in that he didn't try and make one paint in any particular way. There was little contact with other departments, except Prints, who were on the floor above. I have no idea what sculpture was being done or even who taught there, although later on I did go back to teach in the Sculpture department.

There was a funny thing with Alan Reynolds. Before he came to College, he was already a well-known artist. He only stayed a year, because he had already decided what he wanted to paint and he just refused to do any life painting or drawing. It had no meaning for him. So Darwin eventually called him in and said: 'You have to do it. I will give you to the end of term to do it.' During the next few months he had an exhibition in which he sold every painting, and at the end of term he went back to see Darwin, whose attitude was totally different. When Reynolds asked him about his strictures over life painting, Darwin replied: 'Forget about it; it's of no importance whatsoever.' Reynolds said: 'Well, it is to me. I intend to leave anyway.'

My realist period lasted from 1952 to 1956, quite a short period, and looking back it seems most important as a stepping-stone. Very few artists do any mature work before the age of forty. It can take twenty years to learn a language by which you can operate without thinking, 'How am I doing this?' So I feel my mature work started in about 1965, when I had managed to find a language which could deal with my needs of that time, and which has continued up till now. Maybe all the College pictures were still concerned with transitoriness, in which everything is moving—snowstorms or seastorms or people moving in rooms, or light moving across a table. Between 1956 and 1960 I gave it a more Classical format.

The show I had as a student was at the Beaux Arts Gallery. It was an extraordinary thing, although I didn't think so at the time. Painting a picture four feet square was considered extraordinary. I went to the Leicester Galleries first and saw Mr Brown (who was Henry Moore's dealer), who said: 'Yes well, I suppose they are all right but this is a homely gallery. Perhaps you would like to do some homely paintings.' Then I went to Lefevre, which was *the* modern art gallery, but they said they weren't interested in the work of younger painters. Then I went to the Archer gallery, who said: 'We only show realist painting, try the Beaux Arts for what you are doing.' And that is how it came about.

Barr's book *Picasso: 50 years of his Art* was very important to me. In a way, when you read about what Picasso said it made you realize that you must follow the imaginative arrow that tells you where to go, irrespective of what you might believe or not believe, and so really walk upon the razor's edge. I found that very important: to know that intuition is of extreme importance and that one must follow it irrespective of history, tradition or fashion. Whatever you do, whatever language you use, you have to take it to an extreme, and that maybe places an artist in an uncomfortable position in relation to the rest of society. RC

Jack Smith in his studio in Hove, Sussex, November 1987.

BRIDGET RILEY

Student 1952–55

Going to the Royal College seemed to me the next step. I had already been a student at Goldsmiths' College for four years (1949–52), and I wanted to study painting in more depth. Acceptance by the Royal College, aside from being an achievement and an enormous encouragement in itself, meant that one would receive a grant and be able to continue painting for the next three years free from financial worry. The alternative was to start there and then as a practising artist, which I felt I was not ready for, or to take a course in teacher-training which I did not want to do.

I went with high expectations. The first problem was that one hadn't realized that it is very hard to go on being a student unless one is going to be addicted to the art school system as a permanent way of life. I had been very thoroughly taught at Goldsmiths', with disciplined and informed teaching, particularly in the area of drawing. Sam Rabin had taught me fundamental principles: to see the thing as a whole; to be objective about what you do; to order your working method, so that, for example, if the model is standing, the first thing your drawing must do is to give the sense of standing and the distribution of weight, long before you pay any attention to a single aspect.

I expected a parallel approach to painting from the College, but of course there are many different ways of teaching. The College philosophy was stated to me by one member of staff as: 'It's going to be very tough outside so you might as well have it tough in here.' So we were left to work it out for ourselves. We were abandoned, when what we needed (and hoped for) was help *towards* independence rather than having independence thrust down our throats. We could ask questions, but the trouble is that you don't necessarily know when you have a problem, and students can be either too proud or too diffident to ask for help. Advanced teaching ought to help a student to discover his or her problems. We were anxious to find out as much as we could but this was ignored—a certain fundamental bargain was not kept. There was an overpowering sense of vacuum in the College. There were exceptions, of course. Among the tutors, Colin Hayes was a good friend, and the warmth and heart of the school was John Minton whose compassion, sophistication and wit were immensely reassuring. You realized at once that he was aware that the problems he faced were in essence common ones. He was much loved by the students.

We were an immensely varied group. There were some fifty of us, with a wide range of backgrounds, interests and aspirations. That, I am sure, was very significant; and some had served in the War, so there was a wide range of experience and maturity. We were not ambitious in the way students are today. We did not expect attention from the commercial galleries, or to command the interest of a wide public. We didn't think far ahead, and that was excellent. We were, of course, woefully ill-informed. English provincialism stared us in the face. The art history lectures we received ended chronologically after one perilous excursion into Cubism. But we were aware that there was a whole body of experience and achievement in painting based on criteria and motivation which we did not sufficiently know or understand, virtually from Cubism onwards.

Dick Smith was a fellow student, and I remember that he spent his £25 government allowance to go one summer to the USA. When he came back, word of what he had seen was passed around. He was a rare bird, and rather exotic, and he came back from America wearing a pair of sneakers which were much envied. His space in the Royal College studios was large and bare with big canvases, and all of this was completely new to us.

I remember painting next to Frank Auerbach during a three week life-model pose. By the end of the first week only the two of us were left: Frank worked by walking to and fro more than several yards to his easel and back, and the path became a kind of metronome through which the work gradually accrued on his canvas. He beat it into place. I had an offshore position and had my own area of concentration, although I didn't move about so much.

Peter Blake had a corner in one of the studios, but it was something more than a corner. One always had the feeling of an event, in that what one saw there was constantly being added to by tiny, unexpected and yet familiar nuggets. John Bratby was the most self-confident of us all. My abiding memory of him is his arriving in the corridor where we queued for cups of tea with his clothes and glasses properly bespattered with paint. He always jumped the queue and always asked for extra sugar.

Bruce Lacey, who later became part of Spike Milligan's Goon Show, took part in the 'Running Jumping & Standing Still' film, in which he wears a raincoat and puts a record on a tree stump and runs around the record (the grooves on the record matching the growth rings on the tree stump) to make it play. It was very exciting and provocative then, and Surrealism had just not been this specific for us. Bruce was indispensable to any party.

There were many others. I was lucky to have people like that as fellow students—they made up for a lot. RC

Bridget Riley in her Holland Park studio, 1984.

PETER BLAKE

Student 1953–56 Tutor 1964–76

The time when I was a student at the College was almost a kind of limbo between the Kitchen Sink school and the Pop Art movement, the main body of which came later. John Bratby was still there, Joe Tilson and Frank Auerbach were in their second year, and in my year were David Troostwyk, the conceptual artist, and Leon Kossoff. Then there were lots of girls like Pamela Lloyd, Betty Cameron and Julia Wolstenholme. I was part of the generation that really started immediately after the War and was extremely grateful to be there: we were getting grants and were the first generation of working-class students who had that sort of privilege. I used all the hours and I loved being a student.

I wanted to be a painter, but was advised that it was unlikely that I'd do very well at it, so I ought to be a graphic designer. I tried for the College as a graphic designer, but sent one painting and got in as a painter. I remember the interview very well, because the whole staff was lined up. Johnny Minton sat at one end, as your ally: the other staff would ask you difficult questions and he'd be on your side. And the odd thing is that just before then I'd had rather a bad cycling accident—lost my front teeth and cut my face up really badly—and I sometimes wonder if that was why I got in . . .

The best thing about my three years there was that you were actually taught. You sat at the donkey and there would be two or three staff and they would say, 'May I sit down', and they'd draw either on your drawing or beside it and would have no hesitation in rubbing out your drawing and adjusting it. When I was teaching there later you just wouldn't have done it—the students would probably all have walked out. Johnny Minton would sit down and show you how to use the paint, which was very good.

It was all more or less life rooms then—except for a still-life room and the composition room—so it was very much in the Victorian tradition. The still-life room had a cupboard with skulls and 'VAT 69' bottles and trumpets, things like that, so you could set up a still life. The composition room really became the studio, and it was my generation that broke down the old system. What you were supposed to do there was have an idea for a composition, like four men digging up a road or whatever it might be. But what we started to do was to set up our own space and to just paint pictures, which hadn't really happened before. I moved into a corner of the composition room and worked there, with a settee on one side of my space, and a carpet.

The whole tradition of models was still going when I was at the College. You'd still get Italian families who'd arrive with the child and the equipment to dress up for 'costume life'. They'd put on the 'Spanish outfit' and the 'Roman outfit', and they loved to do the more difficult poses as a challenge. It was fascinating. And we'd avoid standing next to Frank Auerbach or Leon Kossoff because we'd get showered with charcoal, from an area of three feet around where they were working. The students would be three deep sometimes—if you didn't get there early, you'd have to stand behind a student in front, set up your easel and look through.

I was contemporary with the Independent Group of Pop artists—Eduardo Paolozzi, Richard Hamilton, people like that. I wasn't a member of the IG, but was at the College painting the things that were my own environment: little boys with badges on, and wrestlers and strippers and things like that, and that became my branch of Pop Art. One thing that you just didn't do, which is now common practice, was work with photographs. So if I was working from a photograph when staff came round, I'd hide it, I'd sit on it and pretend I was making it up.

In my first year I did a whole group of self-portraits and still lifes which got lost, because my locker was cleared, and I never saw them again. So I really started in 1954, at the same time as Dick Smith and Robyn Denny; in the following year Bill Green was riding a bicycle across his pictures, so they weren't that worried about me. I was just quietly working away. There was a certain amount of laughter at what I was doing. Ruskin Spear would come round and guffaw at it. But of course their attention was much more on the young abstract painters, Smith and Denny. When Dick Smith came, we shared a flat, so my closest friends were Abstract Expressionists. I think they took me as a rather comical, Stanley Spencerish sort of figure.

For me there was always a connection between the Painting School and the graphic side, because I was always involved in both worlds—but I think there was an enormous snobbery from both camps. The graphic designers were always very pretty girls or very stylish boys who thought the painters were smelly and scruffy and horrible. The painters thought they were really the only serious ones. Certainly there was the snobbery of the 'Painters Table' in the Common Room, where the staff always sat, and if anyone else sat there it was a very frosty atmosphere.

In your final exhibition you showed a selection. I didn't have that much, of course, because I'd lost a whole year's worth. I seem to remember I put down a carpet and a little seat I'd found, and made it like a sort of salon; and I had a showcase, with things like a box I'd made of 'how to make a collage'. So it was quite a quirky show. You were given a space in those days, and you did exactly what you wanted to do in it. They were one-man exhibitions. CF

Peter Blake in his Chiswick garden, 1963.

ADRIAN BERG

Student 1958–61 Senior Tutor 1987–88

From a very early age, no one was in any doubt I was going to be a painter. I got a place at Cambridge to read Medicine before I did my National Service at eighteen. The Army was an extension of Charterhouse and prep. school, and it taught me you didn't need to work for a living. I thought, 'I don't need to be a doctor, I'll manage, somehow,' so at Cambridge I changed to read English. An artist can manage without an art education, but can he manage without an education? I assumed I would have to teach, as it seemed to be what artists did for a living. I did a Higher Diploma in Education at Dublin, and then I taught at a Secondary Modern school for one year. It was in at the deep end, but I managed. Then I went to a private school (Highgate Junior)—I could have had a career in teaching, if I had wanted it.

I needed only two years of earning my own living to qualify for a grant to go to art school. I had spent six weeks at the Chelsea Art School under Ceri Richards during the vacation when I was at Cambridge, so I had had a taste. I didn't get the grant the first year. I went to St Martin's, and my father financed me, and then to Chelsea. I applied to the Royal College and sent in a portfolio, as was requested. I am sure I owe my place to Robin Darwin. There was an interview with Darwin and most of the staff and, as I remember, Darwin practically took you into the room and sat you down. I sat between Carel Weight, who was the Professor, and Darwin who was conveying to me, 'don't worry, I have all these people behind me, just concentrate on the paintings.' I think he had decided before one walked in the door, but I still thought I had ploughed it.

The College was the superior school, but I had no special expectations. I had been regarded as one of the best students at Chelsea, but Jack Smith told me that when I went to the RCA I would meet people who were better. In my second year, Kitaj and Hockney arrived. I was twenty-nine; Kitaj was twenty-six; Hockney, nineteen or twenty. That sobered me up a bit. In the first six weeks at College you alternated between the life room and still-life room so that the staff could get to know you. They were launching a pioneer project, which was history of art and liberal studies, but I had done all that and I wanted to get on with painting. The people teaching on the history of art side, with exceptions like Basil Taylor, didn't know enough. For example, we were told to read Aristotle's *Poetics*, so I read it again and attended the seminar to discuss it. I argued and made mincemeat of the tutor and so gained the reputation of a Bolshie intellectual and trouble-maker.

Towards the end of the first year they wrote out a list of people who were in danger of being put on probation. There were ten names, and mine was top of the list. Probation meant you would be thrown out. Of all the people interviewed, I was the only one

who got away with it and wasn't put on probation, because I showed drawings which were approved of. But so out of touch were they, that they failed to notice that to have leaves on the trees in these drawings they would have to have been done before I started at the College. They threw out Allen Jones, who was doing his best work. I think they were jealous of anyone who was in competition with them—there was a strong feeling of us and them. These things were life and death at the time, and we were in an insecure position.

After that first horrific year everything was better. Ceri Richards came along to teach on one day a week. At the end of term he said to me, 'I'm having to leave your school. I can't stand your staff.' It convinced me it wasn't just me who was at fault. The moment Ron Kitaj and David Hockney came I was no longer in the firing line. It was the *annus mirabilis*, and there were also Derek Boshier, Peter Phillips and Allen Jones. What changed was that from finding the staff a problem, one found one's fellow students a problem! It could have been the sheer lack of input from the staff that made the students so good. The best thing about the College was what Jack Smith said, that for the first time you were with people who were better. What you learned you learned by watching them. Hockney was there all hours and taught me etching, and both he and Kitaj were marvellous conversationalists.

My painting *The Flight of Icarus* was a summer task. You were given a subject to paint, which would then be hung up and criticized by Carel Weight. Kitaj got the accolade. He was working in the basement of the Ashmolean and did a square painting which could be seen different ways up. Carel Weight was very impressed by this—but it's not in the *way* you do things that you are original, but in what you are doing *with* originality. It's the actual seeing alone that can be new.

I don't regret going to the College for one moment, I enjoyed it. There is a scene in the film *Mash* when an appalling fellow arrives in the unit and they give him a gin. He looks at it and he says, 'Where is the olive?' And they think, 'Doesn't he know where he is? How grateful he should be!' And when he gets nothing from them, he takes a jar of olives out of his pocket and helps himself to one. Of course, he's going to survive.

Thomas Hardy said the sole reason to write was to protest. The same goes for painting. It's not always obvious that one is protesting any more than Hardy is. What happens in the arts is that the 'eternal verities', in the form they're given, are quickly plagiarized, hi-jacked, emasculated. The protest the Classical writer/artist has to make is that the beautiful really is beautiful, the worth-looking-at worth looking at, the exceptional exceptional. It's been said before (and painted) but it has to be said (and painted) again. And will be. It's all in Eliot's *Four Quartets*. RC

Adrian Berg in Kensington Gardens, November 1987.

R. B. KITAJ

Student 1959–61

My painting *Homage to Herman Melville* was one of the earliest pictures I made at the College. Melville had been part of my youth, and fired my resolve to leave art school in New York and go to sea as an ordinary seaman, thus instigating at the age of seventeen an expatriate life as a kind of double Diasporist. I began the portrait of Hockney in the 'seventies. I didn't care much for it, and it lay in storage for many years. In the later 'eighties, David described to me the death of his friend Isherwood in California. I took up the old portrait again and drew a kind of alter-figure across the original full-frontal one, with Chris Isherwood in mind. Like Hockney, and unlike me, he had been a very optimistic and sublime personality, so I made of them a sort of Cubist *doppelgänger*, representing both life and death in the particular, widely perspectival California setting they made their own in exile and, I hope, in some harmony with David's recent neo-Cubist theory for pictures.

Hockney and I arrived the same day at the Royal College, I think in 1960. The first week he drew the skeleton twice. I had never seen such wonderful drawing in an art school, and I bought the first one from him for £5. The students thought I was a rich American. I had $150 a month as an ex-soldier and one of those old Ford Populars I paid £90 for. I used to transport paintings by other students on the roof-rack to exhibitions like the *Young Contemporaries*. David's second skeleton eluded me for twenty years, when I got it at a much higher price from a private dealer. The students I was closest to were Hockney and Adrian Berg, with whom I shared a small studio space. Adrian was the only student with a University education (Dublin and Cambridge). He was a marvel, spouting Yeats and G. M. Hopkins and always cheerful and full of sense and sensibility. He became one of England's best landscape painters, a brilliant painter of London's flora.

I envied the other students because they lived in and enjoyed central London, which seemed to me a special, gritty, post-War London still. It was like the movies I used to see in New York, a London seen through a romantic fog with Vivian Leigh in a tight silk dress waiting in a doorway in Soho for a customer. But each day I would put down my brushes and go to Victoria to get the train to Dulwich. I lived in a little semi-detached house in Dulwich Village which I bought for £1800 I had saved in the American Army. My young family and I lived a quiet, sober English life outside Swinging London.

At the College, our tutor represented the liberal wing of the Royal Academy, who left us largely alone to our various arrogant, youthful rebellions. Carel Weight was and is a very fine painter, and was Professor during my time there. Hockney and I often thought later we could have learned more about painting if we got to know the tutors better, but they respected our strange ways. It was a peaceful time for me, devoted to raising my family and delving deeper into an art of iconographic passions which would pull me away from the dominant New York trends and toward an unknowable, confessional, too obscure painting of my own. I could see that I was having some effect on my colleagues, for better or worse. They were a particularly vivid, talented bunch, at first devoted to the latest abstraction wafting across the Atlantic from Eighth Street and Tenth Street, where the six or ten masters of Action Painting were in their prime. Of course, a reaction would soon become pervasive both in America and England. Rauschenberg and Johns had already begun to show not abstract paintings, and the Modernist wheels would turn again. At the Royal College, I was surprised to see students pouring over copies of *It Is*, an in-house journal of the high movement of Abstract Expressionism. For myself, I had other fish to fry.

I have only fond memories of the RCA—of drawing in the life rooms, of my very gifted colleagues, of the *Young Contemporaries* and a certain excitement in the air, of much time spent in the V and A through a secret door, of Mrs Buckett and her tea-trolley, of a taste of another England. I regret never speaking with my grandparents about their life in Russia. In a similar way, I regret not engaging the teachers like Weight and Spear more than I did for their painting expertise, and for another London milieu going back to Sickert and Spencer.

RC

R. B. Kitaj outside his Dulwich home, 1962.

JOHN BELLANY

Student 1965–68 Tutor 1969–73

I think my time at the RCA was probably one of the most important patches in my whole life, in terms of development. The strange thing about my situation was that they hadn't had a Scottish student in the Painting School for about ten years. When I came down I didn't know *anybody* in London at all. My wife was about six or seven months pregnant, and we were really like a couple of lost souls, suddenly dumped in the middle of this big city.

I was definitely the country bumpkin from north of Hadrian's Wall—it was the swinging 'sixties, and there was this guy with heather coming out of his ears. I had been painting these huge pictures on hardboard, twelve foot or ten foot by eight foot, which were very much rooted in where I came from in Scotland, the Firth of Forth. They were also in a Northern European figurative tradition, and my heroes were Brueghel, Bosch, Rembrandt, people like that. When I arrived in the Painting School, all those other people were painting targets and stripes, and in the middle of it you'd got this raw Scotsman painting his homage to the human race. And no-one could understand a word I was saying, because the dialect was much broader in those days. After the first couple of weeks, the staff came round and said: 'We don't think this is going to work.' Apart from anything else, they couldn't understand how I would do a ten by eight in a space about six feet square—I had to do the things in sections.

Eventually they said: 'Maybe it'd be better if you could come down to Cromwell Road—there's an old room that used to be used for cooking for the students' canteen: you can work in there, there'll not be any other students about.' So I worked there for the whole of the first year, and the staff used occasionally to come down and see me. Carel Weight came down and Peter Blake and Cyril Reason, and they couldn't find me, because it was right in the basement part. There was hardly any daylight, so I had to work with the wee light bulb on all the time, on those enormous paintings. There was no heating in the place, and I had this old overcoat that I got in the Portobello Road, and those gloves with no fingers on them—that's what I had to wear while I was painting. And of course it was a stone floor, so I had big boots on. I remember Peter Blake coming in one day, and I could see that his teeth were chattering, poor soul, so the tutorial lasted all of a minute and a half before him getting away to somewhere warmer.

There were no formal sort of tutorials, like the things they have now, it was just more or less a one-to-one chat. Carel Weight was one incredible guy, he was kind to everybody. But the old guys as well, Ruskin Spear, Robert Buhler, they were all very kind to me.

Leonard Rosoman, he was another guy that was very good to me, an excellent teacher. All these people who used to teach me are still very good friends. Everyone talks about the College and design. I wonder about that, because I think really the creative bee-hive has always been the Painting School, and the honey was spread. I think Exhibition Road was where most of it came from, but that's me being prejudiced, as a painter.

We had to live on £100 a year—and that was for my wife and myself and the wee baby. I don't know how we got by. You met lots of different people—John Berger, a great encourager, playwrights like Arnold Wesker, and poets. London was the capital of the world as far as I was concerned. I did quite a lot of paintings about the claustrophobia of London—so many people, especially with things like escalators on the tube. It was so different from what I'd been used to, like a traumatic shock, and that came out in the work, in paintings with just crowds of faces in them. The important thing was that you wanted to be the best painter in the world. And you were meeting some great painters: I met Francis Bacon in some drinking dive in Soho. But there'd be people that you'd just read about in books, and you suddenly found they came and saw your work, and then you'd go and have a few pints with them.

I was very fortunate because I got into the *Young Contemporaries* exhibition in my first year, and showed every year for about five years. And that's where people start seeing your work outside. One year they had the *Young Contemporaries* at the Tate, and that was quite nice to have a ten foot by eight foot hanging in the Tate when you were twenty-one or something. I was nae thinking about anything like showing in galleries. I was just trying to do big paintings. I mean sometimes they'd bring someone around and you'd sell a wee picture and that would pay the rent for a month, but it would just be ten quid or a fiver or something. There was always the Mr Micawber philosophy—and something always did turn up!

In those days the Diploma shows were different. Nowadays it's just like walking into a West End gallery. Then you just had your studio space (you were given a can of emulsion to paint the walls), and you hung up as much as you could of the best stuff you had. And then you had all your drawings and sketch-books all around, on the table, and everybody was able to look through the work, which was a much healthier way of doing it. I think some people run too fast, to get a posh frame around everything. It was the meat on the bone we were after, not the peripheral things. CF

John Bellany at his Clapham home, November 1987.

LUCY JONES

Student 1979–82

I desperately wanted to go to the College—it was the only thing I wanted to do. I suppose it was a hunch, but Mario Dubsky, whom I knew well, had just started teaching there, and he said it would be good for me. I applied late and was called for an interview. I didn't know any students who were there, and I'm ashamed to say I hadn't been to a Royal College degree show. I had hardly poked my nose outside Camberwell. The interview was very exciting and I remember thinking, 'these people know something about art'. It seemed much more dynamic than Camberwell.

You could feel the intellectual flavour of the College—it was as if I was terribly thirsty, especially for the first two years. For me it was the right thing at the right time. It was hard work (and I chose to work hard). Also, it was quite formal, which suited me a lot, as I like things to be well organized. For example, you would get a note from a tutor telling you to be available at a certain time and place: Andrzej Jackowski was one of the guest tutors, and I had a very worthwhile talk with him. I felt I could use the place, and I think I did. The fact that it was a three-year course was important to me, as I like to have time.

We were quite free to do what work we wanted, but there was an emphasis on explaining what you were doing. Of course you cannot justify or verbalize painting, but I felt it was very good for me to have to attempt it. It was a time when I was trying to establish my personality and find out what I wanted, and that seemed quite difficult, although I was firm about my objectives. For example, when I got to the College, I decided I wanted to work more with colour, and I gradually did so.

Once a year you had a major tutorial, and the big chief, Peter de Francia, would be there with four tutors. Everyone threw in their ideas and criticisms, and it was meant to be a constructive discussion of your work. Some people found it extremely traumatic—I did, too, but it was helpful. Most of my year, I think, got quite a lot out of the College. A couple found it difficult, but there was a good atmosphere, and there was great support for Peter to stay when he was asked to resign.

One thing I definitely regret is not talking to tutors who were not allotted to me. You did have access to everyone, but I was too nervous or slow. I always wanted to talk to Ken Kiff, and suddenly I realized I had left the College without doing so. Peter was fairly keen on tutors being out there on the studio floor: he had abolished the staff-room, so that there was nowhere else for them to go. I don't think there were enough women tutors, although we did have Jennifer Durrant and Carole Hodgson, who worked very hard.

For the first two years I was in an end studio with a spiral staircase. I liked that studio a lot and found it very exciting. Carol Taylor worked next to me, making constructions, banging them together and putting them up on a wall. I hadn't seen anything like it before: at Camberwell everyone had painted pictures in a traditional way. Other students there with me were Tina Brown, Sandra Crawford, Ed Durdey, Mark Harris, Jim Mooney and Steve Smith.

I was less pleased with my last year, and I ought to have reorganized it. I didn't get the right studio space, although I had been extremely lucky until then. I used to work from nine in the morning until nine at night, and I also used to go in at weekends and in the summer holidays, when there weren't other people there. That was heaven—there were no interruptions from tutors, or anyone to hassle you. Because you were constantly asked questions during term-time, you were putting up barriers, and it was quite a relief to get on with it without feeling exposed. One of the nicest things was that the College lived up to my preconceptions of it.

I looked at reproductions of Giotto and early Italian paintings and the way they used shapes and balances. I was different from other students at the College in that I painted directly from the object. Most used imaginary images, but I couldn't do that, and I was always doing drawings on the spot. One of the problems was remaking the drawings into paintings.

Galleries and dealers didn't play much part during my time at the College. I felt it was terribly important to go for three years and just paint, and not worry about that side of things for as long as possible. To get anywhere in painting takes years and years. In retrospect, I think they could have provided some hints about the commercial side. At the time you always had the thought you would get a part-time job as an art tutor, but that is very difficult now. When I left the College I went to Italy on the Rome Scholarship, and when I got back I was clueless as to where to begin with this gigantic problem of setting up and trying to sell. Maybe there is no real advice you can give to people.

My painting is currently based on the South Bank. I still use the bridges and the River Thames theme as I did when I was at the College. I use receding spaces, but the colour brings the surface back, I hope. The image of the bridge is quite protective and you can look through it. I have gone on using the same image, a bit like Auerbach or Kossoff using the same places and people again and again. RC

Lucy Jones on London's South Bank, November 1987.

STUDENT

AND LATER WORKS

COMPARED

Jack B. Yeats
Gilbert Spencer
Edward Burra
Ceri Richards
Kenneth Martin
Sam Haile
Jack Smith
Bridget Riley
Frank Auerbach
Leon Kossoff
Peter Blake
Brian Fielding
Malcolm Morley
Robyn Denny
Sonia Lawson
Adrian Berg
R. B. Kitaj
Derek Boshier
Patrick Caulfield
Bill Jacklin
John Bellany
Stephen Farthing
Michael Heindorff

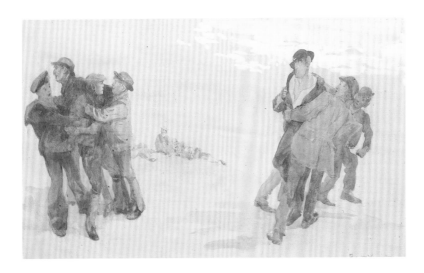

Jack B. Yeats
The Combat, 1897
Watercolour, 29.8 × 48.2 cm
Waddington Galleries, London
Cat. no. 1 early work

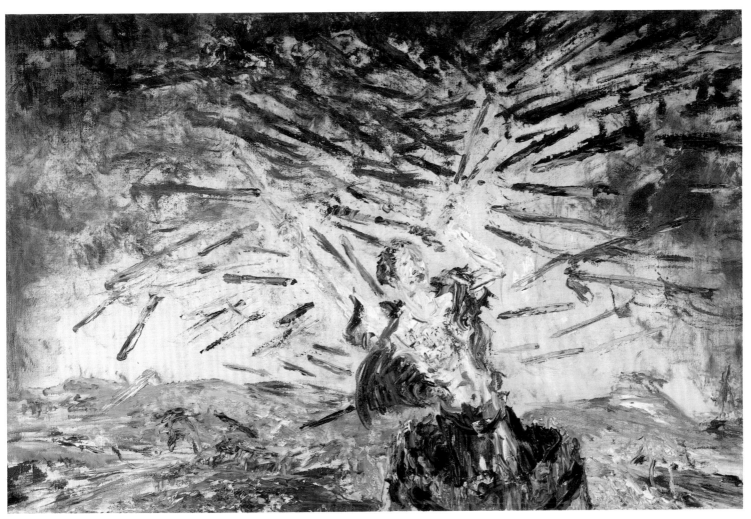

Jack B. Yeats
Humanities Alibi, 1947
Oil on canvas, 61 × 94.3 cm
City of Bristol Museum and
Art Gallery
Cat. no. 2

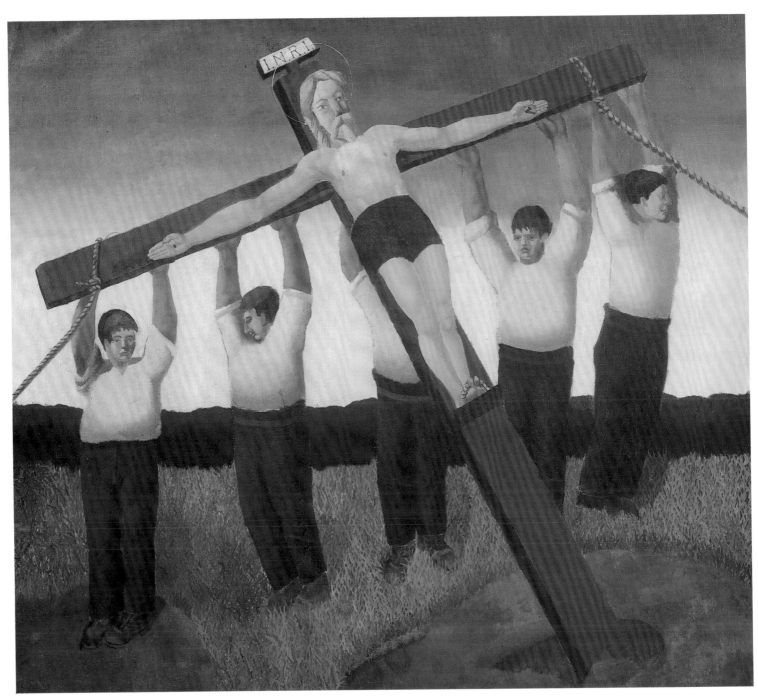

Gilbert Spencer
The Crucifixion, 1915
Oil on canvas, 99 × 86.3 cm
The Trustees of the Tate Gallery
Cat. no. 6 student work

98

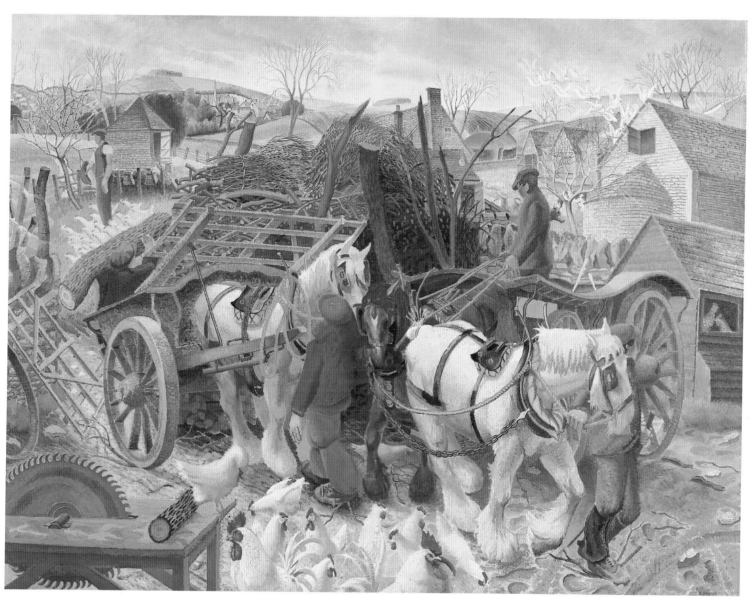

Gilbert Spencer
A Cotswold Farm, 1930–31
Oil on canvas, 141 × 183 cm
The Trustees of the Tate Gallery
Cat. no. 7

Edward Burra
The Three Graces, 1922–23
Pencil and watercolour, 33 × 23 cm
Private Collection
Cat. no. 19 student work

Edward Burra
Winter, 1964
Watercolour on cardboard,
134.6 × 80 cm
Arts Council of Great Britain
Cat. no. 21

Ceri Richards
Nude—Back View, 1926
Red chalk on paper, 41.5 × 34.5 cm
Ceri Richards Estate
Cat. no. 30 student work

Ceri Richards
The Rape of the Sabines, 1948
Oil on canvas, 96.5 × 142.5 cm
Ceri Richards Estate
Cat. no. 32

Kenneth Martin
After Rubens: *The Judgement
of Paris*, c.1929
Oil on canvas, 65.2 × 76 cm
John and Paul Martin
Cat. no. 43 student work

Kenneth Martin
Chance Order Change 13, 'Milton Park A', 1980
Oil on canvas, 91.5 × 91.5 cm
Annely Juda Fine Art, London
Cat. no. 44

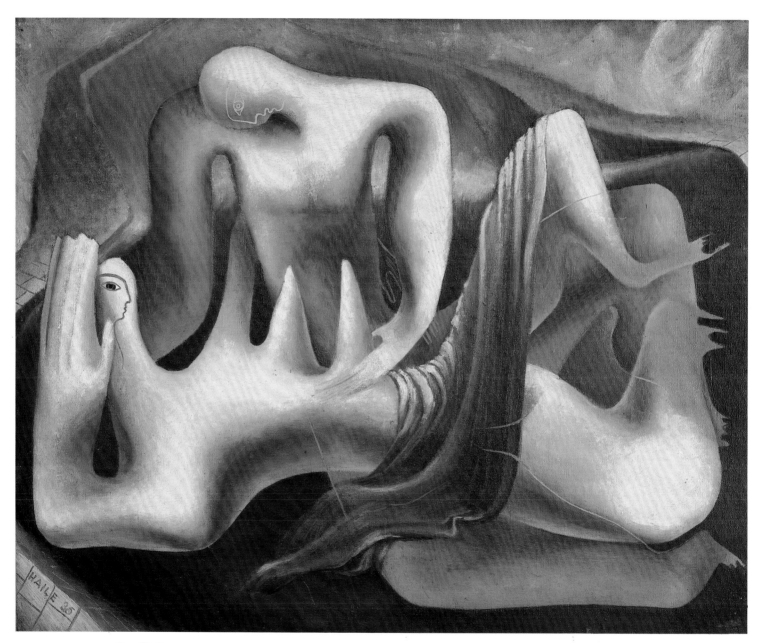

Sam Haile
Reclining Figures, 1935
Oil on canvas, 63.5 × 76.2 cm
Private Collection
Cat. no. 53 student work

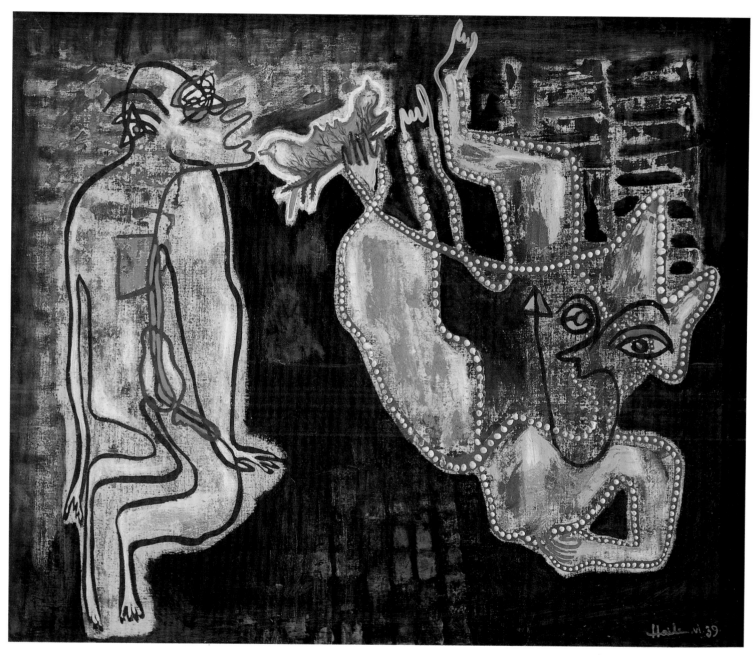

Sam Haile
Man and Falling Woman, 1939
Oil on canvas, 63.5 × 76.2 cm
Private Collection
Cat. no. 54

Jack Smith
Interior with Child, 1953
Oil on hardboard, 122 × 122 cm
RCA Collection
Cat. no. 86 student work

108

Jack Smith
Celebration Sounds and Silences, 1984
Oil on canvas 91.5 × 91.5 cm
The Artist
Cat. no. 88

109

Bridget Riley
Little Nude, c.1955
Oil on canvas, 90 × 70 cm
Private Collection
Cat. no. 102 student work

Bridget Riley
Bloom, 1987
Oil on canvas, 164.8 × 159.4 cm
Mayor Rowan Gallery, London
Cat. no. 104

Frank Auerbach
Primrose Hill, 1954–55
Oil on board, 86.3 × 117 cm
Saatchi Collection, London
Cat. no. 105 student work

Frank Auerbach
*Looking Towards Mornington Crescent
Station, Night*, 1972–73
Oil on board, 127 × 127 cm
Saatchi Collection, London
Cat. no. 107

Leon Kossoff
City Building Site, 1953
Oil on canvas, 76.2 × 67.5 cm
RCA Collection
Cat. no. 114 student work

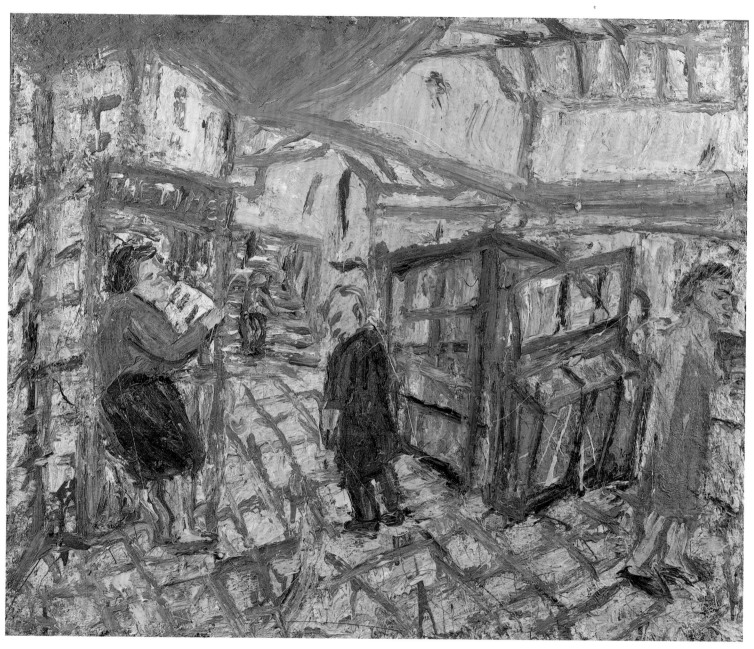

Leon Kossoff
Inside Kilburn Underground,
Summer 1983, 1983
Oil on board, 137.8 × 168.3 cm
Saatchi Collection, London
Cat. no. 116

Peter Blake
The Preparation for the Entry into
Jerusalem, 1955–56
Oil on hardboard, 127 × 101.6 cm
RCA Collection
Cat. no. 126 student work

116

117

Brian Fielding
Antique Room, 1957
Oil on canvas, 129.5 × 91.5 cm
RCA Collection
Cat. no. 129 student work

118

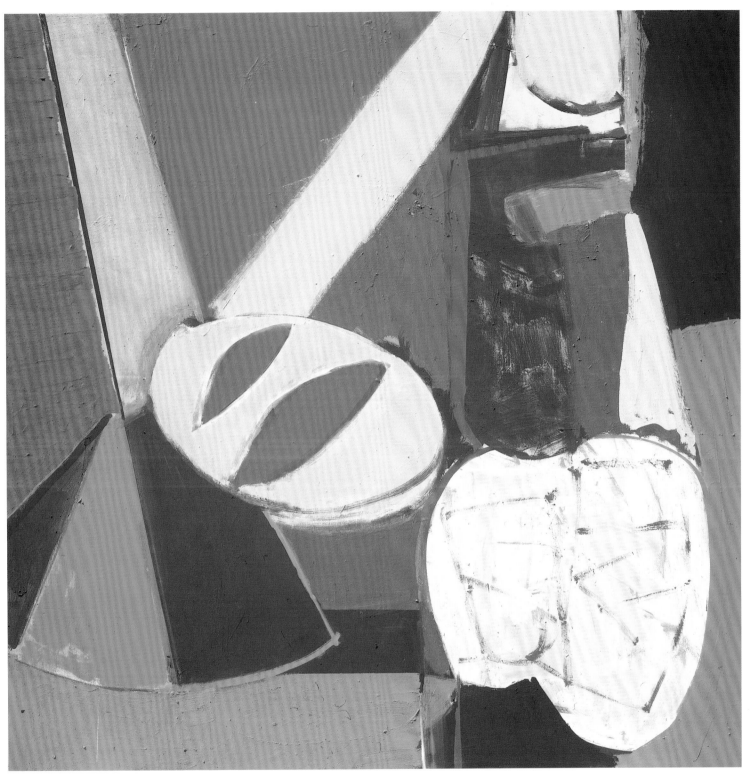

Brian Fielding
Chapel Cake, 1984
Oil on canvas, 152.4 × 152.4 cm
Estate of the Artist
Cat. no. 130

Malcolm Morley
The Richmond Hill below the Wick, 1954
Oil on canvas, 68 × 90 cm
Private Collection
Cat. no. 131 student work

Malcolm Morley
SS France, 1974
Oil and mixed media on canvas with
objects, 182.9 × 162.6 cm
Saatchi Collection, London
Cat. no. 132

Robyn Denny
Eden Come Home, 1957
Oil and gold size on board-burnt,
120 × 240 cm
The Artist
Cat. no. 139 student work

Robyn Denny
Sunset Blue, 1985–87
Acrylic on canvas, 243.8 × 199.4 cm
The Artist
Cat. no. 141

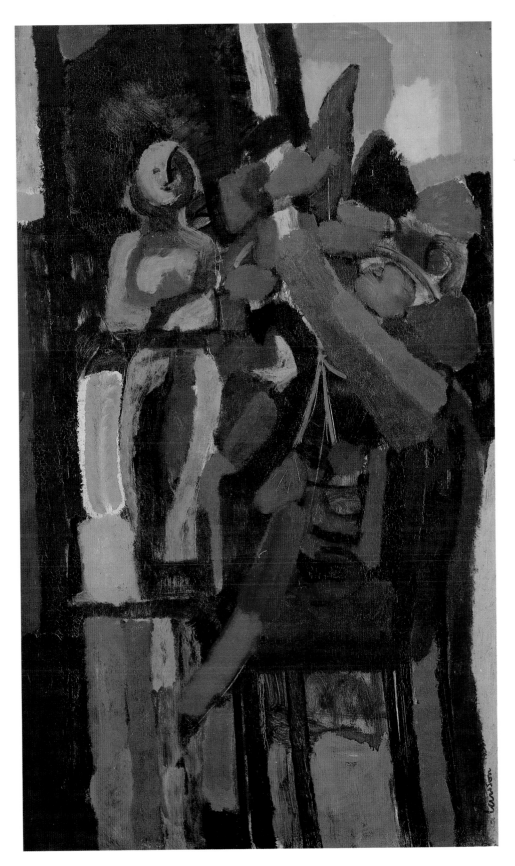

Sonia Lawson
Still Life, 1958
Oil on board, 122 × 76.2 cm
RCA Collection
Cat. no. 142 student work

124

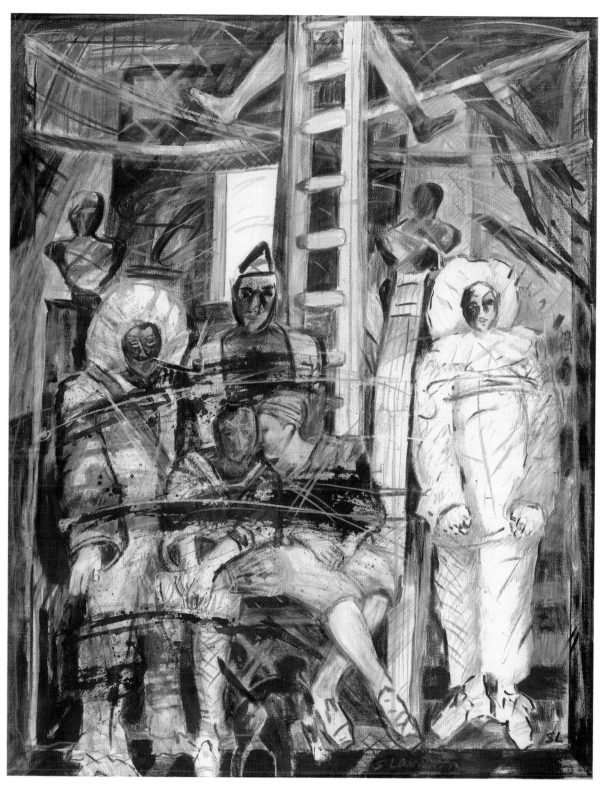

Sonia Lawson
Homage to Molière and Watteau, 1981
Chalk on canvas, 126.6 × 101.5 cm
Arts Council of Great Britain
Cat. no. 143

Adrian Berg
The Flight of Icarus, 1960
Oil on hardboard, 101.6 × 122 cm
RCA Collection
Cat. no. 150 student work

Adrian Berg
Gloucester Gate, Regent's Park, June, 1982
Oil on canvas, 177.8 × 177.8 cm
Arts Council of Great Britain
Cat. no. 151

R. B. Kitaj
Homage to H. Melville, c.1960
Oil on canvas, 137.2 × 90.8 cm
RCA Collection
Cat. no. 157 student work

128

R. B. Kitaj
The Neo-Cubist, 1976–87
Oil on canvas, 177.8 × 132.1 cm
Saatchi Collection, London
Cat. no. 159

Derek Boshier
Drinka Pinta Milka, 1962
Oil on canvas, 155 × 124.5 cm
RCA Collection
Cat. no. 163 student work

Derek Boshier
The Culture of Narcissism, 1979
Oil on canvas, 171 × 125 cm
Angela Flowers Gallery, London
Cat. no. 165

Patrick Caulfield
Christ at Emmaus, 1963
Oil on board, 101.1 × 127 cm
RCA Collection
Cat. no. 171 student work

Patrick Caulfield
Fish and Sandwich, 1984
Acrylic on canvas, 76.2 × 111.8 cm
Saatchi Collection, London
Cat. no. 173

Bill Jacklin
The Invitation Card, 1962–64
Mixed media, 128.3 × 95.3 × 25.4 cm
The Artist/Marlborough Fine Art
(London) Ltd
Cat. no. 180 student work

Bill Jacklin
Washington Square at Night, 1986
Oil on canvas, 198.1 × 198.1 cm
Marlborough Fine Art (London) Ltd
Cat. no. 181

John Bellany
Bethel, 1967
Oil on hardboard, 248 × 319.7 cm
Southampton City Art Gallery
Cat. no. 182 student work

John Bellany
Celtic Feast, 1974
Oil on hardboard, 193.5 × 343.7 cm
Sheffield City Art Galleries
Cat. no. 183

Stephen Farthing
Flat Pack, *Rothmans*, 1975
Screenprint and acrylic on canvas,
213.3 × 109.2 cm
RCA Collection
Cat. no. 203 student work

Stephen Farthing
Siberian Crows, 1987
Oil on canvas, 175 × 207 cm
Edward Totah Gallery, London
Cat. no. 204

Michael Heindorff
15 Deckchairs; a Fragment Contra Repetition, 1976
Tempera on board, each 34 × 23 cm
Bernard Jacobson Gallery, London
and New York
Cat. no. 209 student work

Michael Heindorff
Cave Dance, 1987
Oil on paper on canvas,
78.7 × 144.8 cm
Bernard Jacobson Gallery, London
and New York
Cat. no. 210

CATALOGUE OF THE EXHIBITION
AND ARTISTS' BIOGRAPHIES

AIA The Artists International Association
ARA Associate of the Royal Academy
Camberwell Camberwell School of Arts and Crafts
Chelsea Chelsea School of Art
MOMA Museum of Modern Art
RA Royal Academician
RA Schools Royal Academy Schools
RCA Royal College of Art
RWS The Royal Watercolour Society
St Martin's Saint Martin's School of Art
Slade The Slade School of Fine Art

Where paintings are illustrated earlier in the book, page numbers are given in square brackets.

Jack B. Yeats 1871–1957
Student 1887

Son of painter John Butler Yeats, brother of poet W. B. Yeats. South Kensington School of Art (RCA), Chiswick School of Art, Westminster School of Art, 1887 onwards. Associate, Royal Hibernian Academy (ARHA), 1904; re-elected 1914; RHA, 1915; Chevalier de la Légion d'Honneur, 1950. Retrospectives: Arts Council, London, 1948; centenary exhibition, National Gallery of Ireland, Dublin, 1971; Waddington Galleries, 1987.

Until the mid-1890s, Yeats worked mainly as a graphic artist and illustrator. Between c.1895 and 1906, he painted largely in watercolour, thereafter mainly in oils. His initial inspiration, in terms both of style and subject-matter, seems to have been French Impressionism and the work of Manet, Degas and Toulouse-Lautrec in particular. Profoundly affected by the Irish Troubles, the people and countryside of Ireland came to form his primary subject-matter (in later years treated in a poetically Symbolist manner), while his handling of paint became increasingly rich and expressionistic. Yeats was also a prolific writer. MB-D

H. Pyle, *Jack B. Yeats: A Biography*, Routledge & Kegan Paul, London, 1970.

1 *The Combat*, 1897 [p. 97]
Watercolour, 29.8 × 48.2 cm
Waddington Galleries, London

2 *Humanities Alibi*, 1947 [p. 97]
Oil on canvas, 61 × 94.3 cm
City of Bristol Museum and Art Gallery

Frederick Etchells 1886–1973
Student c.1908–11

RCA, c.1908–11; then rented studio in Paris. Exhibited in *Second Post-Impressionist Exhibition*, 1912–13 and *Post-Impressionist and Futurist Exhibition*, London, 1913. Joined Omega Workshops, 1913; Rebel Art Centre, 1914. Founder-member, London Group, 1914. Contributed illustrations to *Blast*, 1914–15; Vorticist Exhibitions, London, 1915 and New York, 1917; *Group X* exhibition, London, 1920. Designed pioneering Crawford Building, Holborn.

Etchells' early work shows the marked influence of French Post-Impressionism as mediated through the ideas of Roger Fry and the Bloomsbury Group. By 1913, under the impact of Analytical Cubism and Futurism, his forms had become increasingly geometricized, and he soon switched allegiances to become an active member of the Vorticist group. He took up architecture in the mid-1920s, and translated le Corbusier's *Towards a New Architecture*. MB-D

Richard Cork, *Vorticism and Abstract Art in the First Machine Age*, Gordon Fraser, London, 1976.

3 *The Hip Bath*, c.1911
Tempera on canvas, 60.3 × 50.2 cm
Courtauld Institute Galleries, London (Fry Collection)

4 *Woman at a Mirror*, 1914
Oil on canvas, 115.2 × 76.9 cm
Manchester City Art Galleries

5 *Composition—Stilts*, 1914–15 [p. 16]
Gouache, 32 × 23 cm
The British Council

3

4

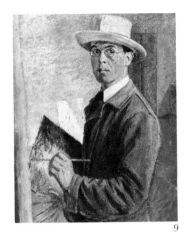

8

9

Gilbert Spencer 1892–1979
Student c.1912–14 Assistant Tutor
1930–32 Professor 1933–48

Ruskin School, Maidenhead,
1909–10; Camberwell, 1910–11;
School of Art, Wood Carving, South
Kensington (later RCA), c.1912–14.
Part-time: Slade, 1913–20. British
Army, 1915–18. Assistant, RCA,
1930–32; Professor, 1933–48. Head of
Painting, Glasgow School of Art,
1948–50; ARA, 1950; Head of
Painting at Camberwell, 1950–57;
RA, 1960.

The talented younger brother of
Stanley Spencer; both worked in a
similar style. As RCA tutor and
Professor, he proved to be of
independent thought yet in touch with
students and fellow staff. Under
Spencer's charge the Painting School
was evacuated to Ambleside during
the Second World War, but he left his
professorship in 1948 soon after the
new Principal Robin Darwin was
appointed. His murals and paintings
of the 1930s are strong in composition,
the figures heavy and exaggerated in
gesture. Gradually the compositions
became more complex, the presence of
movement in figures, birds or sky less
obvious. Paintwork became more
delicate, though his early underlying
stylistic form remained. HCC

Gilbert Spencer, *Memoirs of a Painter*,
Chatto and Windus, London, 1974.

6 *The Crucifixion*, 1915 [p. 98]
Oil on canvas, 99 × 86.3 cm
The Trustees of the Tate Gallery

7 *A Cotswold Farm*, 1930–31 [p. 99]
Oil on canvas, 141 × 183 cm
The Trustees of the Tate Gallery

Sir William Rothenstein
1872–1945
Principal 1920–35

Slade, 1888–89; Academie Julian,
Paris, 1889–93. Official War Artist,
1917–18. Principal, RCA and for
periods Professor of Painting,
1920–35. Trustee, Tate Gallery,
1927–33; Knighted, 1931. Unofficial
War Artist (with RAF), 1939–43.
Memorial exhibition, Tate Gallery,
London, 1950; centenary exhibition,
Bradford City Art Gallery and
Museums, 1972.

Henry Moore recalled: 'The college
was pretty much in the doldrums . . .
[Rothenstein] brought this air of a
wider, more international outlook into
the college'. In 1938, Wyndham
Lewis wrote: 'Sir William
Rothenstein has retained, after fifty
years of study, the humility . . . of the
apprentice. There is no doubt why he
has proved such an inspiring teacher'.
As Principal of the RCA he
particularly encouraged the revival of
mural painting as a public art. His
own—relatively conservative—
painting comprised mainly
landscapes, domestic interiors, and
portraits of the artists and intellectuals
of his day. MB-D

Robert Speaight, *William Rothenstein*, Eyre
and Spottiswoode, London, 1962.

8 *Self Portrait*, c.1892
Oil on canvas, 27.9 × 24 cm
Sheffield City Art Galleries

9 *Self Portrait*, 1917
Oil on canvas, 76.5 × 63.2 cm
Carlisle Museums and Art Gallery

10 *Self Portrait*, c.1930
Oil on canvas, 76 × 61 cm
RCA Collection

10

Paul Nash 1889–1946
Tutor 1924–25 and 1938–40

Slade, 1910–11. Official War Artist, 1917–19; 1940. Tutor, RCA, 1924–25; 1938–40. Founder-member, Unit One group, 1933. Exhibited in *International Surrealist* exhibition, 1936; memorial exhibition, Tate Gallery, London, 1948; retrospective, Tate Gallery, London, 1975.

In 1910 Nash went to the Slade, where he met Ben Nicholson, and by 1914 he had already established a reputation as a landscapist of talent and originality. The countryside continued to be a primary inspiration throughout his life. His images of the ravages wrought by the First World War developed into the 'metaphysical' landscapes of the 1920s. His work of the 1930s became more geometricized and surreal, and led to the mystical 'sunflower' works of the 1940s, inspired by Sir James Frazer's *The Golden Bough*. As a writer and critic he kept in close contact with the European avant-garde. As a painter Nash was highly influential in the British art world. MB-D

Andrew Causey, *Paul Nash*, Clarendon Press, Oxford, 1980.

11 *Nocturnal Landscape*, 1938 [p. 18]
Oil on canvas, 76.5 × 101.5 cm
Manchester City Art Galleries

John Nash 1898–1977
Tutor 1934–40 and 1948–58

No formal training. Took up career as artist on elder brother Paul's advice. Official War Artist, 1918; 1940. Tutor, RCA (Design), 1934–40, 1948–58. ARA, 1940; RA, 1951. Major exhibition: Leicester Galleries, 1954.

John Nash's reputation rests chiefly on his landscape images and, above all, his watercolours, which sympathetically combine vivid observations of the natural world with poetic insights. He was also a prolific book illustrator. Many of the forty-seven or so texts he illustrated (with pen drawings, wood engravings or lithographs) were botanical works: the best known of these include R. Gathorne-Hardy's *Wild Flowers in Britain* (1938); *English Garden Flowers* (1948) and Gilbert White's *The Natural History of Selborne* (1951). MB-D

Sir John Rothenstein, *John Nash*, Macdonald, London, 1983.

12 *Dorset Landscape*, date unknown [p. 21]
Oil on canvas, 50.5 × 60.7 cm
Carlisle Museums and Art Gallery

Barnett Freedman 1901–1958
Student 1922–25 Tutor 1930–40

Worked as a signwriter, stonemason's and architect's assistant; evening classes, St Martin's, 1916–22. LCC scholarship to RCA, 1922–25. Instructor in still life RCA, 1930–40. Exhibition, Literary Bookshop, Bloomsbury, 1929. Official War Artist, 1940–46. CBE, 1946. Arts Council Memorial Exhibition, 1958.

Freedman produced a number of ambitious street scene paintings, but he is best known as a pioneer in the revival of colour lithography, for his illustrations of literary works (among them Sassoon's *Memoirs of an Infantry Officer*, *War and Peace*, *Jane Eyre*, *Oliver Twist* and Walter de la Mare's *Love*). He designed the George V Jubilee postage stamp and posters for Shell-Mex and London Transport. He frequently challenged his students thus: 'What do you mean by commercial art? There is only good art and bad art.' MB-D

13 *Street Scene*, 1930
Oil on canvas, 68 × 183 cm
Salford Art Gallery

John Tunnard 1900–71
Student 1919–23

Studied textile design, RCA, 1919–23; drummer in London Students Jazz Band (played jazz on semi-professional basis throughout 1920s). Designer in textile industry, 1923–29. Started painting, 1929. Exhibited in Surrealist section, AIA exhibition, 1937. Retrospective: RA, London, 1977. ARA, 1967. Gallery: Gillian Jason, London.

Tunnard's work of the early 1930s consisted mainly of relatively naturalistic Cornish landscapes. From c.1935, under the influence of Surrealism, it became less representational, although the natural world remained a major inspiration. Music and mathematics were also important sources, although geometry in Tunnard's work is always infused with a sense of mystery, organic growth and infinite space. His paintings of the late 1940s and 50s, in which landscape motifs reappear, are more readily legible than his pre-War work. MB-D

John Tunnard, Arts Council Catalogue, London, 1977.

14 *Harbour*, c. 1923
Watercolour, 38 × 56 cm
Tunnard Estate/Gillian Jason Gallery

15 *Installation A*, 1939 [p. 27]
Oil on canvas, 76.2 × 122 cm
Laing Art Gallery, Newcastle-upon-Tyne, Tyne and Wear Museums Service

16 *Messenger*, 1969
Oil on panel, 120.3 × 181.4 cm
Tunnard Estate/Gillian Jason Gallery

13

14

16

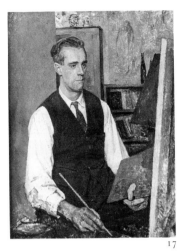

17

18

23

22

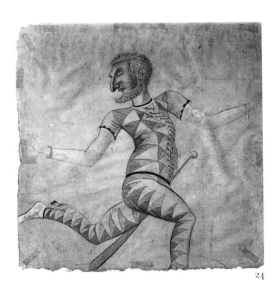

24

Percy Horton 1897–1970
Student 1922–24 Tutor 1930–49

Scholarship, Brighton School of Art, 1912–16. As absolute conscientious objector, served two years hard labour in Carlton Prison, Edinburgh, 1916–18. Central School of Art and Design, London, 1918–20. Royal Exhibition, RCA, 1922–25. Tutor, RCA, 1930–49. Major exhibition: Sheffield City Art Galleries, 1982.

Cézanne was a key influence for Horton, who produced conservative work, although his politics were radical. An early member of the Artists International Association, he taught voluntarily at the Working Men's College, St Pancras, becoming concerned with the humanity of the unemployed in his subject-matter, and imploring artists to become socially committed in *New Left Review*, 1938. An influential teacher, he taught at Ambleside, where the RCA was evacuated during the War. HCC

Janet Barnes, *Percy Horton: Artist and Absolutist*, Sheffield City Art Galleries, 1982.

17 *Portrait of an Unknown Artist*, c.1924
Oil on board, 61 × 45.7 cm
Katharine Horton

18 *Unemployed Man*, 1936
Oil on wood panel, 44.5 × 36.2 cm
Sheffield City Art Galleries

Edward Burra 1905–1976
Student 1923–25

Chelsea Polytechnic, 1921–23; RCA, 1923–25. First one-man exhibition, Leicester Galleries, 1929. *Unit One* exhibition, Mayor Gallery, London, 1934; *International Surrealist* exhibition, London, 1936; *Fantastic Art, Dada and Surrealism*, New York, 1936. Retrospectives: Tate Gallery, London, 1973; Hayward Gallery, London, 1985. Gallery: Alex Reid and Lefevre, London.

At the RCA, Burra revealed a penchant for popular illustration and the bizarre aspects of everyday existence. Cinema, dance and music halls were constant sources of inspiration. Much of his work of the 1930s celebrated the popular culture of Harlem and Mexico, and later reflected his distress at the Spanish Civil War and Second World War. He then began producing book illustrations and ballet costumes and décor. From the late 1950s onwards, he became increasingly interested in landscape and still life. MB-D

Andrew Causey, *Edward Burra: Complete Catalogue*, Phaidon Press, Oxford, 1985.

19 *The Three Graces*, 1922–23 [p. 100]
Pencil and watercolour, 33 × 23 cm
Private Collection

20 *News of the World*, 1933–34 [p. 22]
Gouache, 90 × 54.9 cm
Bury Art Gallery and Museum

21 *Winter*, 1964 [p. 101]
Watercolour on cardboard, 134.6 × 80 cm
Arts Council of Great Britain

Edward Bawden b.1903
Student 1922–26. Tutor 1930–40, 1948–53

Cambridge School of Art, 1918–22; RCA Design School, 1922–25. Travelling scholarship to Italy, 1925. Official War Artist, 1940–45. Tutor, RCA, 1930–40, 1948–53. Major exhibition: Fine Art Society, London, 1987. Lives in Essex. Gallery: Fine Art Society, London.

Influenced by his tutor Paul Nash, notably in his watercolour technique, Bawden was soon recognized for his talents as an illustrator and designer, particularly in his use of wood blocks. The murals done for Morley College, London, 1928–30, were painted by Bawden together with Eric Ravilious and Cyril Mahoney. A strong underlying concern with line is evident throughout all his work, though his skilled virtuosity as a watercolourist shows concern with texture and perspective. HCC

Douglas Percy Bliss, *Edward Bawden*, Pendomer Press, London, 1979.

22 *Cornish Moors*, c.1924
Watercolour, 39 × 46.7 and 38 × 47 cm
The Artist

23 *Mount Carsaig—Isle of Mull*, c.1950
Watercolour, 55.5 × 74 cm
The Artist

Eric Ravilious 1903–1942
Student 1922–25 Design Tutor 1930–38

Eastbourne School of Art, 1919–22; RCA Design School, 1922–25. Travelling Scholarship to Italy, 1924. Instructor in Design, RCA, 1930–38. Observer Corps, 1939; Official War Artist attached to Royal Marines, 1940. Killed in action, 1942. Major exhibition: Crafts Council, London, 1986.

Ravilious was highly influenced by his tutor Paul Nash together with his fellow students, Edward Bawden and Douglas Percy Bliss, with whom he exhibited in 1926. His watercolours place him in a tradition of English landscape art, but he was also a skilled wood engraver and book illustrator with several commercial advertising commissions to his name. Jointly with Edward Bawden and Cyril Mahoney, he painted murals for Morley College, London, 1928–30. His decorative designs for furniture, textiles, glass and especially ceramics illustrate his concern with line. HCC

Helen Binyon, *Eric Ravilious, Memoir of an Artist*, Lutterworth Press, London, 1983.

24 *Jester, Design for Morley College Mural*, c.1925–26
Watercolour, 50.8 × 50.8 cm
Private Collection

25 *Edward Bawden Working in his Studio*, c.1930 [Frontispiece]
Tempera on board, 76 × 91.5 cm
RCA Collection

Douglas Percy Bliss 1900–84
Student 1922–25

English Literature, Edinburgh University; RCA, 1922–25. Head of Art Teaching, Hornsey College of Art, 1929–39; Director of School of Art, Glasgow, 1946–65.

Together with fellow students Eric Ravilious, Edward Bawden and Helen Binyon, Bliss regenerated the RCA student magazine, using Common Room canteen profits; in his final year he edited a new student magazine, *Gallimaufry*. He also produced a book of wood engravings, *Border Ballads*, while still at College; he wrote a history of wood-engraving, published in 1928. He was art critic for *The Scotsman* and *The Print Collectors' Quarterly*, and is best known for his biography of Edward Bawden, 1979. HCC

26 *Self Portrait*, 1923
Tempera poilite on panel, 24.7 × 20.3 cm
Rosalind Bliss

27 *Carson's Cows*, 1946
Oil on canvas, 76.2 × 101.6 cm
Rosalind Bliss

R. Vivian Pitchforth 1895–1982
Student 1922–25 Tutor 1937–39

Leeds School of Art, 1914–15 and 1919–21; RCA, 1922–25. Wakefield Battery Royal Garrison Artillery, 1915–19. Tutor, RCA, 1937–39. Official War Artist, 1940. Retrospective: Wakefield Art Gallery, 1984.

The Principal noted Pitchforth as one of the RCA's most gifted students. Influenced by Cézanne, his style was close to that of his contemporary Ravilious. He concentrated in later years on the effects of atmosphere on land and seascapes. He said that 'a pure translucent watercolour is a *oncer* or one wash, which means putting down 90% of your subject in one go.' He proved a gifted teacher, kind and encouraging, with a genius for explanation through brilliant analytical drawings. HCC

Adrian Bury, *R. Vivian Pitchforth, RA*, RWS Old Watercolour Society; 43rd Annual Vol., 1968.

28 *Old Stone Waller*, 1925
Oil on canvas, 45.6 × 36 cm
Manchester City Art Galleries

29 *The Removal, Spring Cleaning*, c.1952
Oil on canvas, 86 × 112 cm
Laing Art Gallery, Newcastle-upon-Tyne, Tyne and Wear Museums Service

Ceri Richards 1903–1971
Student 1924–27 Tutor 1956–61

Swansea School of Art, 1921–24; RCA, 1924–27 (on scholarship). Worked as commercial artist, 1927–37. Married Frances Clayton, fellow RCA student, 1929. Taught RCA, 1956–61. Represented Britain, Venice Biennale, 1962. Trustee, Tate Gallery, London, 1958–65. CBE, 1960; Honorary Fellow, RCA, 1961. Retrospective: Tate Gallery, 1981.

At the RCA, where Henry Moore described Richards as 'the finest draughtsman of his generation', he was introduced to Apollinaire's *Les Peintres Cubistes* and Kandinsky's *Concerning the Spiritual in Art*, as well as the work of Picasso and Matisse, all of which affected him deeply. In the later 1930s he produced relief constructions and assemblages of a Surrealist nature. His mature work reveals a lifelong love of music and poetry, and is characterized by a tendency to allusive biomorphic imagery. As well as paintings, reliefs and graphic work, Richards produced a number of opera sets and costumes, murals and images for churches. MB-D

Ceri Richards, Tate Gallery Catalogue, London, 1981

30 *Nude—Back View*, 1926 [p. 102]
Red chalk on paper, 41.5 × 34.5 cm
Ceri Richards Estate

31 *The Sculptor and his Model*, 1936 [p. 25]
Relief construction, wood and metal, 103.5 × 85.5 × 15 cm
Ceri Richards Estate

32 *The Rape of the Sabines*, 1948 [p. 103]
Oil on canvas, 96.5 × 142.5 cm
Ceri Richards Estate

Elisabeth Vellacott b.1905
Student 1925–29

Willesden School of Art, 1922–25; RCA, 1925–29. Studio destroyed, 1942, with loss of all work. Retrospectives: *Paintings and Drawings 1942–81*, Kettle's Yard, Cambridge; Warwick Arts Trust, London, 1981. Lives in Cambridge. Gallery: New Art Centre, London.

While at the RCA Elisabeth Vellacott reacted against the academic style in evidence there at the time, and found stimulus in the decorative art of the Victoria and Albert Museum. After a successful career designing theatre sets, decorative frescoes and fabrics, she concentrated, after the War, on painting. Bryan Robertson has drawn a parallel between her figurative and imaginative scenes and aspects of Iris Murdoch's novels. RMcD

Elisabeth Vellacott, Warwick Arts Trust Catalogue, London, 1981.

33 *Portrait of Althea Willoughby*, 1929
Oil on canvas, 40.5 × 30.5 cm
Private Collection

34 *Adam and Eve—after Ucello*, 1985–86
Oil on wood, 81.2 × 83.8 cm
Eva Kolouchova

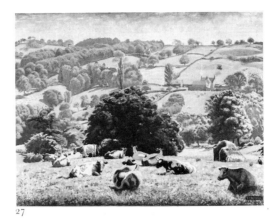
27

28

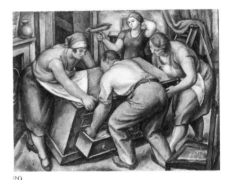
29

33

34

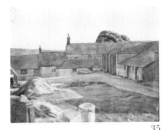

35

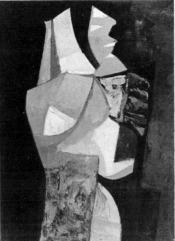

36

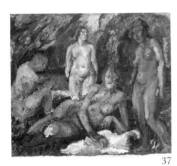

37

39

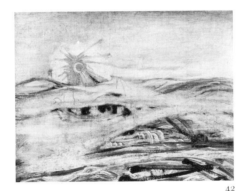

40

42

Morris Kestleman b.1905
Student 1926–29

Central School of Art and Design, London, 1922–25; RCA, 1926–29. Head of Fine Art Department, Central School of Art and Design until 1973. Guggenheim International Prize for Painting, New York, 1958. Abbey Major Award Prize, 1983. Major exhibitions: *Cork Street Gallery*, London, 1968; Sally Hunter Fine Art, London, 1987. Lives in London.

An early interest and commissions in stage design led to an involvement with mural painting and two large murals for the *Britain Can Make It* exhibition at the Victoria and Albert Museum, 1946. Morris Kestleman's work evolved from a figurative to a non-figurative approach from the late 'fifties onwards. RM·D

Bryan Robertson, *Morris Kestleman*, Cork Street Gallery Catalogue, London, 1969.

35 *Sussex Farm*, 1929
Oil on canvas, 48.7 × 81 cm
The Artist

36 *Composition in Greys*, 1970
Oil on canvas, 122 × 91.5 cm
The Artist

John Piper b.1903
Student 1928–29

Studied law, 1921–26. Richmond College of Art, 1926–28; RCA, 1928–29. Secretary, Seven and Five Society, 1933–38. With his wife, Myfanwy Evans, published *Axis* review of abstract art, 1935–37. Included in *Abstract and Concrete* exhibition, 1936. Official War Artist, 1940–45. Trustee, Tate Gallery, 1944–53 and 1954–61. Commission for Coventry Cathedral stained glass window, 1957–62. Retrospectives: MOMA, Oxford, 1979; Tate Gallery, London, 1983. Companion of Honour, 1972. Lives in Oxfordshire. Galleries: Waddington Galleries, London; James Kirkman, London.

Piper started producing paintings in a radical abstract Constructivist tradition in 1934. By the late 1930s, his earlier interest in topography and architecture resurfaced. An early collaboration with John Betjeman, *Shell Guide*, 1937, led to Romantically picturesque landscapes and historic buildings. A versatile designer as well, he created many stage sets during his twenty-five year association with Benjamin Britten. MB-D

John Piper, Tate Gallery Catalogue, London, 1983.

37 *Figure Composition*, c.1928
Oil on canvas, 50.8 × 61.2 cm
The Artist/James Kirkman/
Waddington Galleries, London

38 *Forms on a Green Ground*, 1936 [p. 66]
Oil on canvas, 152.4 × 182.9 cm
The Artist

39 *Wester Braikie*, 1983
Oil on canvas, 106.7 × 106.7 cm
Marlborough Fine Art (London) Ltd.

Cecil Collins b.1908
Student 1927–31

Scholarships, Plymouth School of Art, 1923–27; RCA, 1927–31. Included in *International Surrealist* exhibition, London, 1936. Began first series of images on theme of *The Vision of the fool*, 1940; began writing verbal meditation on same subject, 1943 (published 1947). Designed first tapestry, 1949. Retrospectives: Ashmolean Museum, Oxford, 1953; Whitechapel Art Gallery, London, 1959. Commissioned to paint altarpiece for Chichester Cathedral, 1973. Arts Council film, *The Eye of the Heart* made about his work, 1978. Lives in London. Gallery: Anthony d'Offay, London.

The paintings Collins produced at the RCA were essentially naturalistic. In the 1930s, however, he began to be influenced by Klee, Picasso and (briefly) European Surrealism. A meeting with Mark Tobey (1938) encouraged an interest in the art and philosophy of the Far East. Often labelled a Neo-Romantic, Collins has consistently been concerned with (in his own words) 'art as a metaphysical experience . . . with exploring the mystery of consciousness'. Much of his imagery deals with visionary experience and the notion of a spiritual quest. MB-D

Tribute to Cecil Collins, Plymouth Arts Centre Catalogue, 1983.

40 *Maternity*, 1929
Oil on board, 122 × 91.5 cm
Private Collection

41 *The Voice*, 1938 [p.19]
Oil on wood, 122 × 152.4 cm
Peter Nahum Gallery, London

42 *Landscape of the Unknown God*, 1960
Oil on hardboard, 91.5 × 122 cm
Manchester City Art Galleries

Kenneth Martin 1905–1984
Student 1929–32

Sheffield School of Art, 1921–23, 1927–29. Freelance graphic artist, 1923–29. RCA, 1929–32. Included in *This is Tomorrow* exhibition, Whitechapel Art Gallery, London, 1956. OBE, 1971. Retrospectives: Tate Gallery, London, 1975; Serpentine Gallery, London, 1985; Arts Council touring exhibition (with Mary Martin), Annely Juda Fine Art, 1987. Honorary Doctorate, RCA, 1976. Gallery: Annely Juda Fine Art, London.

In the 1930s Kenneth Martin painted landscapes in a naturalistic mode; during the 1940s his forms became increasingly abstract. His first completely abstract paintings date from 1948 to 1949. Martin began in 1951 to produce geometrically abstract sculptures, built mainly in metal 'from a nucleus outwards'. He also continued to produce two-dimensional works. With Mary Martin, Anthony Hill, Victor Pasmore and Adrian Heath, Kenneth Martin led a new post-War Constructivist movement in British art. MB-D

Kenneth and Mary Martin, Annely Juda Fine Art Catalogue, London, 1987.

43 After Rubens: *The Judgement of Paris*, 1929 [p.104]
Oil on canvas, 65.2 × 76 cm
John and Paul Martin

44 *Chance Order Change 13*, ' *Milton Park A*', 1980 [p.105]
Oil on canvas, 91.5 × 91.5 cm
Annely Juda Fine Art, London

Mary Martin 1907–1969
Student 1929–32

Goldsmiths' College, 1925–29; RCA, 1929–32. Married Kenneth Martin, 1930. Major exhibitions: Institute of Contemporary Arts, London, 1960; Tate Gallery, 1984; Arts Council touring exhibition (with Kenneth Martin), Annely Juda Fine Art, 1987. Gallery: Annely Juda Fine Art, London.

Mary Martin's pre-War work consisted of boldly-coloured landscapes and still lifes. During the 1940s, however, she moved towards geometric abstraction, and in 1950 created her first abstract paintings. In 1951 she started producing the metal, wood and perspex reliefs based on square, rectangular, cubic and wedge-shaped component parts, indebted to an international Constructivist tradition, for which she remains best known. MB-D

Kenneth and Mary Martin, Annely Juda Fine Art Catalogue, London, 1987.

45 After Watteau: *The Scale of Love*, c.1929
Oil on canvas, 50.4 × 56.6 cm
John and Paul Martin

46 *Perspex Group on Dark Blue (c)*, 1968 [p. 69]
Perspex on wood, 61 × 61 × 20.3 cm
Annely Juda Fine Art, London

Evelyn Dunbar 1906–60
Student 1929–33

Rochester School of Art and Chelsea; Kent Scholarship, RCA, 1929–33. Official War Artist, 1940–45. Illustrated *Gardener's Choice* with Cyril Mahoney, 1937.

Evelyn Dunbar painted the murals at Brockley School, Kent, between 1933 and 1936 and was a member of the Society of Mural Painters. She was one of the first women to be made an Official War Artist, and concentrated particularly on the activities of the Land Army and the 'Land Girls', who took over farming work while men were overseas. Between 1958 and 1960 she was commissioned to do a mural at Bletchley Training College, Buckinghamshire. RMcD

47 *Study for mural at Brockley School, Kent*, 1933–36
Oil on paper, 36.2 × 26.3 cm
Carlisle Museums and Art Gallery

48 *Landgirls going to bed*, 1943
Oil on canvas, 50.7 × 76.2
The Trustees of the Imperial War Museum

49 *A 1944 Pastoral: Landgirls Pruning at East Malling*, 1944
Oil on canvas, 91.3 × 121.8 cm
Manchester City Art Galleries

Merlyn Evans 1910–1973
Student 1931–33 Tutor 1965–73

Glasgow School of Art, 1927–31; RCA, 1931–33. Exhibited in *International Surrealist* exhibition, 1936. Lived in Durban, South Africa, 1938–42; South African Army, 1942; British Army, 1943–45; transferred to Rome, 1945. Retrospectives: Whitechapel Art Gallery, London, 1956; *Merlyn Evans 1910–73*, Welsh Arts Council exhibition, 1974; *The Political Paintings of Merlyn Evans 1930–50*, Tate Gallery, London, 1985. Gallery: Mayor, London.

Contacts with Mondrian, Kandinsky, Moholy Nagy and other artists in Paris, 1934–36, confirmed Evans's commitment to abstraction, manifest in his student work. He later became a member of the Surrealist Group. His paintings, which often link natural and mechanical forms, are essentially Celtic and Romantic in spirit. They reveal in a most powerful manner the musings and speculations of a mind entirely absorbed by the twentieth-century world and capable of relating it on occasion to other periods in history and other societies. RMcD

The Political Paintings of Merlyn Evans 1930–50, Tate Gallery Catalogue, London, 1985.

50 *Day and Evening*, 1932 [p.28]
Tempera on canvas, 176.5 × 127 cm
Estate of the Artist/Mayor Gallery, London

51 *Polynesian Fantasy*, 1938 [p. 23]
Tempera on panel, 19.5 × 24.5 cm
Leeds City Art Galleries

52 *Composition No. 3*, 1962 [p. 68]
Oil on canvas, 199 × 110 cm
Estate of the Artist/Mayor Gallery, London

45

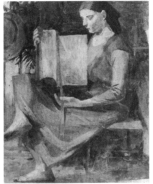

47

48

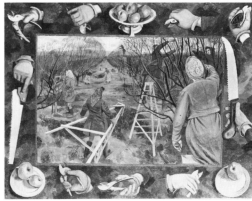

49

56

57

Sam Haile 1909–1948
Student 1931–35

Attended evening classes, Clapham School of Art; Scholarship, RCA, 1931–35 (Painting School, then Pottery School under Staite Murray). Surrealist Group and AIA, 1938. Lived in New York 1939–44. British Army, 1944. Pottery consultant to Rural Industries Bureau, 1946. Killed in car accident, 1948. Memorial exhibitions: Southampton Art Gallery and Institute of Contemporary Arts, Washington, 1948; Crafts Centre, 1951; Birch and Conran Gallery, London, 1987. Gallery: Birch and Conran, London.

Haile first achieved fame as a potter (and teacher of pottery); his pots, while sculptural in conception, related closely to the organic forms of his paintings. The latter, although much indebted to Surrealist theory and practice, remained a more private activity. Some of his images rely strongly on automatist drawing techniques, others are more considered; in all of them sexuality, suffering, violence and the threat of Fascism are major preoccupations. Haile was also a theorist of some sophistication. MB-D

Sam Haile, Birch & Conran Catalogue, London, 1987.

53 Reclining Figures, 1935 [p. 106]
Oil on canvas, 63.5 × 76.2 cm
Private Collection

54 Man and Falling Woman, 1939 [p. 107]
Oil on canvas, 63.5 × 76.2 cm
Private Collection

55 Couple on a Ladder, 1941–43 [p. 24]
Ink, watercolour and collage, 58.4 × 45.7 cm
Private Collection

Ruskin Spear b.1911
Student 1931–35 Tutor 1948–75

Scholarship, Hammersmith School of Art, 1926; scholarship, RCA, 1931–35. ARA, 1944; RA, 1954. Tutor, RCA, 1948–75. President, London Group, 1949. CBE, 1979. Retrospective: RA, London, 1980. Commissioned portraits include Sir Laurence Olivier, Sir Ralph Richardson, Harold Wilson, Lord Butler and Francis Bacon.

Describing Spear's flamboyant and colourful work, whose subject-matter has remained consistently local over the last forty years, Mervyn Levy commented on the '. . . thread of narrative satire which, through Sickert, Ruskin Spear is most closely allied with and in sympathy.' Spear's reputation as a challenging personality dates from 1948 when he joined Carel Weight as tutor in the RCA Painting School. RMcD

Mervyn Levy, Ruskin Spear, Weidenfeld and Nicolson, London, 1985.

56 Self Portrait, 1932
Pen, ink and pastel, 24.2 × 14.7 cm
Carlisle Museums and Art Gallery

57 Portrait of Francis Bacon, 1984
Oil on board, 76.2 × 63.2 cm
National Portrait Gallery

Leslie Cole 1910–1976
Student 1934–37

Swindon Art School and RCA, 1934–37. War Artists Advisory Committee (WAAC) commission in Malta, 1942. Royal Marine Commandos, 1944. WAAC commissions abroad, 1944–6. Included in exhibition, To the Front Line, Imperial War Museum, London, 1985.

Cole's first attempts at being accepted as a War artist failed, but eventually he gained several commissions. His skills as a documentary artist and strong sense of adventure won him a considerable reputation as a War Artist. Angela Weight said of Cole in 1985: 'He felt abandoned and forgotten in the post-War art world . . . the War had been a significant experience in his life and nothing afterwards could match its freedom and variety.' RMcD

58 Shaping the Heelplate of a Corvette, 1942
Oil on canvas, 50.5 × 63.7 cm
Laing Art Gallery, Newcastle-upon-Tyne, Tyne and Wear Museums Service

58

Harry Thubron 1915–85
Student 1938–40

Sunderland School of Art, 1933–38;
RCA, 1938–40. Head of Fine Art,
Sunderland College of Art, 1950–55;
Leeds College of Art, 1955–64;
Lancaster College of Art, 1964–66;
Leicester College of Art, 1966–68.
One-man exhibitions: Serpentine
Gallery, London, 1976; Jordan
Gallery, London, 1978. OBE, 1978.
Retrospectives: St Paul's Gallery,
Leeds, 1985; Goldsmiths' College
Gallery, London, 1986; Gray City Art
Gallery, Hartlepool, 1987.

Thubron's career as an ardent
educationalist has for the most part
overshadowed his reputation as an
artist. Prior to 1965, he created reliefs
out of wood, spun copper, brass and
resins; he then made collages out of
fragments of humble materials culled
from the everyday environment.
Although abstract, they refer
constantly to human activity and
human geography. The textures of
Mexico and southern Spain were of
particular importance to him. MB-D

Harry Thubron, Arts Council Catalogue,
London, 1976.

59 *Portrait of Diane Thubron*, 1940
Pencil drawing, 18 × 17 cm
Private Collection

60 *Setenil*, 1976
Corrugated paper collage on wood,
112 × 127 × 12 cm
The British Council

Albert Richards 1919–45
Student 1940

Wallasey School of Art, 1935–39;
RCA, 1940. Royal Engineers,
1940–43; 591 (Antrim) Parachute
Squadron, 1943. Official War Artist,
1944. Killed crossing minefield, 1945.

Richards seems at first to have
regarded himself primarily as a
designer. After 1938 his work
combined Surrealist content with a
precision and brilliance of colour
inspired by the Indian and Persian
miniature tradition. The work of
Christopher Wood also proved an
important influence. In the brief three
months he spent at the RCA, his
ability as a draughtsman attracted the
attention of Paul Nash. As a sapper,
he chose to depict the still, uneventful
moments of the War with a strongly
architectonic sense of structure.
However, when he became a
paratrooper and participated in the
invasion of N.W. Europe, his work
acquired a new drama, immediacy
and intensity. Like Nash, he tended to
express the effects of war through the
natural world. MB-D

*The Rose of Death: Paintings & Drawings of
Captain Albert Richards (1919–1945)*, Imperial
War Museum, London, 1978.

61 *Building a Hutted Camp in Essex*, 1942
Oil on cardboard, 60.4 × 76.3 cm
The British Council

Rodrigo Moynihan b.1910
Professor 1948–57

Studied art, Florence and Rome,
1928. Slade, 1928–31. Royal Artillery,
1940–43; Official War Artist,
1943–44. Professor of Painting, RCA,
1948–57. CBE, 1953; Hon PhD,
RCA, 1969. Retrospective: RA,
London, 1978. Lives in London and
France. Gallery: Fischer Fine Art,
London.

Moynihan's early abstract work of the
1930s shows a concern with texture,
while his figurative work of the late
1930s reflects French modernism.
During the 1940s his skills as a
portraitist developed; his interest in
still life painting dates from the War
period, and these ideas culminated in
the objective naturalism seen in the
portrait of the RCA staff, 1951. In
1956 he returned to abstraction,
attempting to define spatial areas with
ruled lines and divisions of colour, and
from 1970 painted objects seen in the
studio. HCC

Rodrigo Moynihan: A Retrospective Exhibition,
Royal Academy Catalogue, London, 1978.

62 *Portrait Group (The Teaching Staff of the
Painting School at the Royal College of Art,
1949–50)*, 1951 [p. 30]
Oil on canvas, 213.3 × 334.6 cm
The Trustees of the Tate Gallery

Robin Darwin 1910–1974
Principal 1948–71

Cambridge University; Slade, 1929.
Ministry of Home Security, 1939–44.
Council of Industrial Design,
1945–46. Principal, RCA, 1948–71.
Knighted, 1964.

While working at the Council of
Industrial Design, 1945–46, Darwin
produced a report, *The Training of the
Industrial Designer*, proposing
curriculum changes at the RCA,
which led to his appointment as RCA
Principal. He radically changed the
RCA to independent university status.
Each school became responsible for its
achievements, the staff becoming a
team, uniting, on occasions, against
Darwin. Unusually for a Principal of
the RCA, Darwin was a talented
painter, landscape being his favourite
subject-matter. HCC

Christopher Frayling, *The Royal College of
Art*, Barrie and Jenkins, London, 1987.

63 *Portrait of Hugh Casson*, 1957
Oil on canvas, 91.5 × 71 cm
RCA Collection

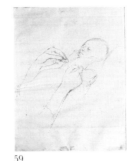
59

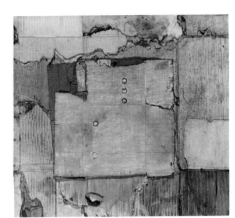
60

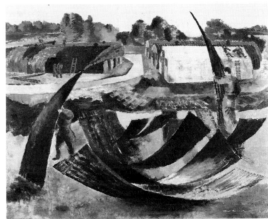
61

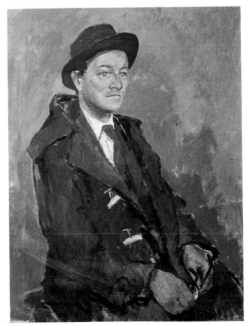
63

64

65

66

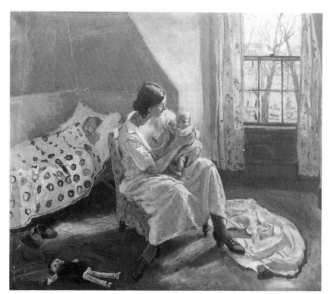

67

Charles Cyril Mahoney
1903–1968
Student 1922–26 Tutor 1948–53

Beckenham School of Art; RCA, 1922–26. Assistant, RCA, 1928–53; Tutor, 1948–53. Author of *Gardeners Choice*, 1937, illustrated by Evelyn Dunbar. RA, 1968.

A conscientious tutor and hard taskmaster at the RCA, Mahoney's concern with the academic discipline of art brought him into conflict with more modern teachers, but he flourished under the Principalship of his old Beckenham tutor, Percy Jowett. Sadly, Mahoney's mural work for Morley College, London, 1928–30, on which he collaborated with Edward Bawden and Eric Ravilious, was destroyed during the Second World War. The work led to further commissions as a mural decorator, including Brockley School, Kent (with Evelyn Dunbar), Campion Hall Chapel, Oxford, 1941–51. His oil paintings were often on a religious theme, while his landscapes and still lifes are distillations of the ordinary and everyday, in oil, watercolour, or ink and wash. HCC

Robert Woof, *The Artist as Evacuee*, The Wordsworth Trust, Grasmere, 1987.

64 *The Public Baths*, c.1926
Oil on paper, 40 × 32 cm
Elizabeth Bulkeley (*née* Mahoney)

65 *Mural of Figures in a Garden*, c.1947–53
Oil on board, 216 × 124 cm
Elizabeth Bulkeley (*née* Mahoney)

Robert Buhler b.1916
Student 1935 Tutor 1948–75

Studied art, Zurich, Basle and Bolt Court School; St Martin's; Scholarship, RCA (stayed only six weeks), 1934. ARA, 1947; RA, 1956. Tutor, RCA, 1948–75. Trustee, RA, 1975. Commissioned portraits include: Sir John Betjeman, Angus Wilson, Francis Bacon, Arthur Koestler. Lives in London. Gallery: Austin/Desmond Fine Art, Ascot.

Robert Buhler has written that painting 'should need neither explanation nor description—it should be self-evident through the language of paint.' 'He loves his subject, but mistrusts "subject-matter": he has become resolute in rejecting the literary and merely illustrative in his work . . . His "subjects" have become increasingly simplified,' wrote Colin Hayes, describing Buhler's landscapes, portraits and still lifes. RMcD

Colin Hayes, *Robert Buhler*, Weidenfeld and Nicolson, London, 1986.

66 *Dedham, Suffolk*, 1959
Oil on canvas, 50.8 × 76.2 cm
The Royal Academy of Arts

Rodney Burn 1899–1984
Tutor 1929–31, 1946, 1947–65

Slade, 1918–22; Assistant Tutor, RCA, 1929–31 and 1946; Senior Tutor, 1947–65. Director, School of Museum of Fine Arts, Boston, USA, 1931–34. Member, New English Art Club, 1926; Hon. Sec. until 1963. ARA, 1954; RA, 1962. Member, Royal West of England Academy, 1963. Hon. Fellow, RCA, 1964.

Highly esteemed by his fellow artists as a very fine draughtsman, Rodney Burn began his painting career equally at home with landscapes, portraits or figure painting, working largely in oils. Over the years he turned increasingly to seascapes as sources of inspiration; in later years, Venice and the Channel Islands were also to feature as subject-matter. MR

67 *Mother and Child*, 1962
Oil on canvas, 76 × 86.5 cm
The Royal Academy of Arts

John Minton 1917–57
Tutor 1948–57

St John's Wood School of Art, London, 1935–38. Lived in France, 1938–39. Conscientious objector, Second World War. Tutor, RCA, 1948–57. Committed suicide, 1957. Arts Council memorial exhibition, 1958; retrospective, Reading Museum & Art Gallery, 1974. Gallery: Gillian Jason, London.

Minton's *oeuvre*, which was much discussed and emulated in the post-War period under the banner of British Neo-Romanticism, tends to focus on the young male in landscape, be it the East End after the Blitz, the countryside of Surrey and Wales, London's docklands or the Mediterranean. His art is essentially linear; his pen and ink book illustrations, such as those for Alain-Fournier's *The Wanderer* (1947), are among his most characteristic and distinctive achievements. Minton was one of the most influential and popular teachers, whose lectures (according to Carel Weight) were 'almost like a musical turn'. MB-D

Rigby Graham, *John Minton*, Cog Press, Aylestone, 1967.

68 *The Death of Nelson: after Daniel Maclise*, 1952 [p. 32]
Oil on canvas, 183 × 244 cm
RCA Collection

Kenneth Rowntree b.1915
Tutor 1949–58

Ruskin School of Drawing, Oxford, and Slade. Tutor, RCA, 1949–58. Professor of Fine Art, University of Newcastle-upon-Tyne, 1959. Retrospectives: Newcastle University, 1980; Hexham Abbey Festival, 1987. Lives in Northumberland.

According to Dr John Milner, Rowntree's working method as an artist is a process of discovery: 'Once a work is begun, its forms comprise a proposition, often itself a visual ambiguity (of the kind provided by perspective depth on a flat surface), a pun on rhyming shapes, or an analogy. His work grows until a completeness is attained in which the loose ends and provocations initiated by his propositions are resolved. It is small wonder that he has such admiration for Pythagoras' theorem. Its economy and completeness provide an example in the geometrical world of pictorial events.' RMcD

Paintings and Drawings by Kenneth Rowntree, Hexham Abbey Festival Catalogue, 1987.

69 *Putney Bridge Night-piece 1*, c.1958
Oil and enamel on panel, 64 × 76 cm
The Artist

Colin Hayes b.1919
Tutor 1949–84

Christ Church, Oxford, 1938–40. War service with Royal Engineers Field Survey, Iceland, Libya, S.E. Command. Ruskin School of Drawing, Oxford, 1945–47. Tutor, RCA 1949–84. First exhibition, Marlborough Fine Art, London, 1949. ARA, 1963; RA, 1970. Lives in London. Gallery: New Grafton, London.

As a landscape painter, Colin Hayes's work has lightened in key in recent years. He spends as much time as possible painting in Greece. It was through Rodrigo Moynihan that he came to the RCA in 1949, his work having caught Moynihan's eye at Ruskin. He was one of the tutors pictured in Moynihan's famous 1949–50 painting of the RCA Painting School's staff. RMcD

70 *Landscape near Kimi, Evvia, Greece*, c.1984
Oil on canvas, 71 × 91.5 cm
The Artist

Roger de Grey b.1918
Senior Tutor and Reader 1954–73

Chelsea, 1937–39 and 1946–47. Army, 1939–45; US Bronze Star, 1945. Senior Tutor and Reader, 1954–73; Hon Associate, RCA, 1959. Major exhibition: Nottingham University Gallery, jointly with Carel Weight, 1966. Prize winner, RA Summer Exhibition, 1979. President, RA, since 1984. Lives in Kent.

De Grey's paintings are inspired by working out of doors, defining and expressing space with a concentrated palette. His work reflects a similar feeling of energy to that of Soutine, whose landscapes he admires. Another influential theme is geological form and how this affects the overlying texture of landscape. HCC

Roger de Grey and Carel Weight, Nottingham University Gallery Catalogue, 1966.

71 *La Gorge Du Loup*, date unknown
Oil on canvas, 99 × 101.6 cm
Sir Hugh Wontner GBE, CVO

Malcolm Hughes b.1920
Student 1946–50

Regional College of Art, Manchester, and RCA, 1946–50. One-man exhibition, Institute of Contemporary Arts, London, 1965. Co-founded Systems Group, 1969. Lives in London.

In Hughes's paintings, wrote Peter Brades, 'the patterns forming the image sometimes rotate, sometimes oscillate, flipping back and forth in layers. This seems only fully to be comprehended by assuming the patterns to begin behind one, coming forward as an invisible, spiralling unbroken mass until caught and illuminated at a set point. Where that point occurs has of course been predetermined by the artist according to his system, but for the observer the viewing distance is important, too. For such a critical moment, the taut surface is entirely appropriate.' RMcD

Irving Sandler, *Concepts in Construction 1910–1980*, Independent Curators Inc., New York, 1983–84.

72 *The Performers*, 1950
Oil on canvas, 40.6 × 51 cm
Manchester City Art Galleries

73 *Six Unit Relief/painting*, 1973–74 [p. 69]
Wood, hardboard, pva and oil, 167 × 111 cm
The British Council

69

70

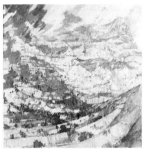

71

72

74

75

76

77

78

79

Derek Hirst b.1930
Student 1948–51

Doncaster School of Art, 1946–48; RCA, 1948–51 Artist-in-Residence, Sussex University, 1966, Head of Painting, Kingston Polytechnic, 1975–87. Retrospective: Angela Flowers Gallery, London, 1979. Lives in Chichester. Gallery: Angela Flowers Gallery, London.

Regular visits to Spain provided source material for Hirst's earlier work. Describing his retrospective, Vaughan Winter saw '. . . a strong continuity of purpose.' A visit to Japan in 1985 had a profound effect on Hirst and resulted in an exhibition, *Memories of Japan—Images of Sussex* at Angela Flowers in 1987: 'It deepened my feelings and made me able to describe an attitude to "Nature" and to Art more adequately than previously.' RMcD

Contemporary British Artists, Bergstrom and Boyle Books, London, 1979.

74 *Self Portrait*, 1950–51
Oil on canvas, 51 × 40 cm
Natalie and Christopher Sharpe

75 *Interior of a Kind*, 1965–66
Cryla on canvas, 182.9 × 152.4 cm
Angela Flowers Gallery, London

Norman Adams b.1927
Student 1948–51

Harrow School of Art, 1940–46; RCA, 1949–51. ARA, 1967. Retrospectives: RCA, 1969; RA, 1972; Whitechapel Art Gallery, London, 1973. Keeper of the Royal Academy Schools since 1986. Lives in London and Yorkshire.

Soon after leaving the RCA, Adams produced stage and costume designs for *A Mirror of Witches* for the Royal Ballet at Covent Garden, 1951, and *Saudades* at Sadlers Wells, 1953. He produced murals for Broad Lane Comprehensive School, Coventry. His range of work includes ceramic reliefs for Our Lady of Lourdes, Milton Keynes, 1975–76. His watercolours are painted out of doors, while his oils are based on studio compositions. He considers that his work should contain a message, painting and religion being integrally related. HCC

Norman Adams, A Decade of Painting 1971–81, Third Eye Centre Catalogue, Glasgow, 1981.

76 *Temptation of St Anthony*, 1951
Oil on canvas, 76.2 × 63.9 cm
RCA Collection

77 *Earth Mother and the Stars*, 1987
Oil on canvas, 180.3 × 182.9 cm
The Artist

Alistair Grant b.1925
Student 1947–50 Tutor 1955-Present

Birmingham School of Art, 1941–43. RAF, 1943–47. RCA, 1947–50; continuation scholarship, 1950–51. Tutor, Printmaking, RCA, 1955; Head of Printmaking, 1970; Chair of Printmaking, 1984. Cracow Print Biennale, 1972 (prizewinner); Royal Society of British Artists; Fellow, RCA. Lives in London. Gallery: Redfern, London.

Although now an abstract artist, he once had a reputation for his dexterity as an illustrative draughtsman. The Toulouse Lautrec drawings in John Huston's film *Moulin Rouge* were done by Grant, on camera. A keen colourist and observer of local shape and detail, both of which Grant assimilated into his work as a painter and print-maker. 'Alistair Grant paints, draws and makes collages intuitively,' wrote Mary Rose Beaumont, 'and it is only when it is finished that he titles a work after its most dominant feature.' One of the longest serving members of staff. RMcD

78 *Self Portrait, Blanes*, 1954
Oil on canvas, 167.7 × 122 cm
The Artist

79 *Claire de Lune*, 1983–84
Oil on canvas, 122 × 152.5 cm
The Artist

Derrick Greaves b.1927
Student 1948–52

Worked as signwriter, 1943–48. Scholarship, RCA, 1948–52. Studied and exhibited in Italy on Abbey Major Scholarship, 1952–54. First one-man exhibition Beaux-Arts Gallery, London, 1953; represented Britain at 1956 Venice Biennale; Travelling exhibition: *Forty From Ten, 1976–86*, Loughborough College of Art, 1986. Lives in Norwich.

Greaves himself said that his five-year apprenticeship as a signwriter probably taught him more in practical terms than did his student days at the RCA. He was delighted, however, to be able to paint 'what I wanted— every day!', and values the 'friendships that were made and have lasted'. His work of the 1950s, painted from life and depicting 'what was at your very elbow' was seen as belonging to the Kitchen Sink school. Since the 1960s, Greaves's work has become more allusive and linear, using collage techniques and layering of glazes. MB-D

Forty From Ten, 1976–86, Loughborough College of Art Catalogue, 1986.

80 *Portrait of George Pascoe Steward*, 1952
Oil on canvas, 73.6 × 49.5 cm
RCA Collection

81 *Sheffield*, c.1953 [p. 34]
Oil on canvas, 86.2 × 203.3 cm
Sheffield City Art Galleries

82 *Entering a Room with Difficulty*, 1979
Acrylic on canvas, 137.2 × 181.2 cm
Norfolk Museums Service (Norwich Castle Museum)

Edward Middleditch 1923–1987
Student 1949–52

British Army, 1942–47 (awarded the Military Cross). First one-man exhibition, Beaux-Arts Gallery, London, 1954. Represented Britain at 1956 Venice Biennale. ARA, 1968; RA, 1973. Keeper of RA Schools, 1984–86. Head of Fine Art, Norwich School of Art, 1964–84. Retrospective: Arts Council touring exhibition, Castle Museum, Norwich/Serpentine Gallery, London, 1987–88.

Middleditch was about five years older than the three fellow students at the RCA (Bratby, Greaves and Smith) with whom his name was linked under the banner of the Kitchen Sink school. Experience of War lent him extra maturity and a dark undercurrent to his work. His teachers, Ruskin Spear and John Minton, introduced him to the tradition of Sickert and the Mediterranean world of Picasso and Matisse, respectively. Figure compositions, however, occurred only in the early 1950s; thereafter he was inspired exclusively by the natural world. Described by Helen Lessore as 'a poet, a lyrical poet, of appearances', Middleditch was always notable for his strongly calligraphic sense of design. MB-D

Edward Middleditch, Arts Council Catalogue, London, 1987.

83 *Meat Porter Carrying a Carcass*, 1952 [p. 33]
Oil on canvas, 39.8 × 49.8 cm
Private Collection

84 *Snow and Bird*, c.1955
Oil on canvas, 101 × 127 cm
Private Collection

85 *Still Life*, c.1977
Oil on canvas, 92 × 125 cm
Private Collection

Jack Smith b.1928
Student 1950–53

Sheffield College of Art, 1944–46; St Martin's, 1948–50; RCA, 1950–53. First one-man exhibition at Beaux Arts Gallery, London, 1952. First Prize at first John Moore's Liverpool Exhibition, 1957. Retrospective: Whitechapel Art Gallery, London, 1959. Major exhibition, Serpentine Gallery, 1978. Designed sets and costumes for the Ballets Rambert's *Carmen Arcadiae*, 1986. Lives in Sussex.

A prominent member of the Kitchen Sink school, Smith's own paintings of a baby being washed at a sink probably gave this 1950s movement its popular name. Smith broke completely with his early beginnings, moving towards musically rhythmic abstract shapes. He has written: 'More and more do I find that activity of different kinds is essential in the painting—I want it to be as complex as a symphony; to keep the surface as flat as possible, letting it have visual space or eye dance, but no impressionist, cubist or continued space. I would like the surface to be as remote as Vermeer.' RMcD

Jack Smith, Fischer Fine Art Gallery Catalogue, London, 1981.

86 *Interior with Child*, 1953 [p. 108]
Oil on hardboard, 122 × 122 cm
RCA Collection

87 *Still Life with Cherries*, 1954–55 [p. 37]
Oil on board, 152.4 × 122 cm
Mayor Gallery, London

88 *Celebration Sounds and Silences*, 1984 [p. 109]
Oil on canvas, 91.5 × 91.5 cm
The Artist

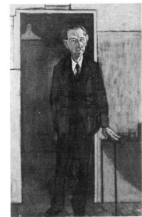

80

82

84

85

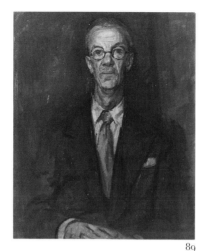

89

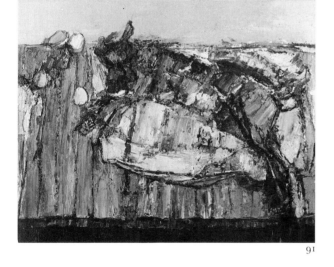

91

Peter Coker b.1926
Student 1950–54

St Martin's, 1947–50; RCA, 1950–54.
ARA, 1965; RA, 1972. Touring
retrospective: 1972; *Paintings and
Drawings of the Butcher's Shop*, RA,
1979. Lives in London. Gallery:
Gallery 10, London.

After leaving the College, Coker
became associated with the Kitchen
Sink school of English social realists.
He had an exhibition of paintings and
drawings made in an East End
butcher's shop, a show that many
found shocking. Coker had begun
painting enclosed spaces after leaving
the RCA, and a Leytonstone butcher
gave him the freedom to paint the
interior of his shop and its contents.
He could ask for specific carcasses to
be left out for him to sketch, and used
thick paint, sometimes mixed with
sand, to capture the texture of meat,
butcher's table, pre-occupied
workmen and equipment. Coker's
'butcher's shop' series attracted great
interest, but in late 1956 his attention
turned from carcasses to landscape
painting, an enthusiasm that has
remained. RM

Peter Coker, *Paintings and Drawings of the
Butcher's Shop*, Royal Academy Catalogue,
London, 1979.

89 *Portrait of Percy Jowett*, (Principal) 1954
Oil on canvas, 76.2 × 63.5 cm
RCA Collection

90 *Butcher's Shop No 1*, 1955 [p. 35]
Oil on board, 182.8 × 121.9 cm
Sheffield City Art Galleries

91 *Still Life with Hare*, 1959
Oil on board, raised in plaster and net,
91.7 × 120.6 cm
Carlisle Museums and Art Gallery

John Bratby b.1928
Student 1951 54 Tutor 1957–58

Kingston School of Art, late 1940s;
RCA, 1951–54. Married Jean Cooke,
1953 (divorced 1973). Won Abbey
Minor, Italian Government and RCA
Minor Travelling Scholarships, 1954.
First one-man show (while still at
RCA), Beaux Arts Gallery, London,
1954. Represented Britain at 1956
Venice Biennale. Painted canvases for
film *The Horse's Mouth*, based on novel
by Joyce Carey, 1957–58. ARA, 1959;
RA, 1971. First novel *Breakdown*,
1960; others followed in 1961/2/3.
Lives in Hastings. Gallery:
Thackeray, London.

The work for which Bratby was to
become celebrated after the success of
his first one-man show (Beaux-Arts
Gallery, London, 1954), was
described by Sir John Rothenstein as
expressive of 'his tough, larger-and
uglier-than-life view of his intimate
environment' and by critics as
Kitchen Sink school. His obsession
with painting his wife Jean and their
domestic surroundings lasted until the
late 1960s. The Expressionist, Van
Gogh-inspired tension of his early
paintings has gradually been replaced
by a more decorative approach to
everyday subject-matter. MB-D

Alan Clutton-Brooks, *John Bratby*, Studio
Books, London, 1961.

92 *Jean and Tabletop (girl in a yellow jumper)*,
1953–54
Oil on canvas, 122 × 101.3 cm
Sheffield City Art Galleries

93 *Jean and Still Life in front of a Window*,
1954 [p. 36]
Oil on hardboard, 122 × 108.8 cm
Southampton City Art Gallery

94 *Jean and Dayan*, 1968
Oil on canvas, 151.8 × 114.3 cm
The Royal Academy of Arts

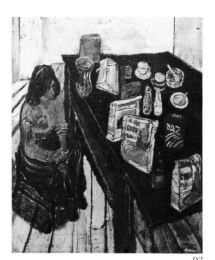

92

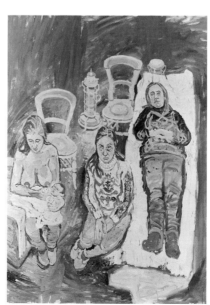

94

Bruce Lacey b.1927
Student 1951–54

Hornsey School of Art, 1949–51; RCA, 1951–54 (First Class Diploma, Silver Medal). Knapping Prize, 1951; Abbey Minor Travelling Scholarship, 1954. Film on artist, Ken Russell, *Preservation Man*, 1961. Exhibition, *Ten Sitting Rooms*, Institute of Contemporary Arts, London, 1971. Retrospective: Whitechapel Art Gallery, London, 1975. Won the 'Alternative Miss World' with a robot, 'Rosa Blossom', 1985. Elected member of British Astronomical Association, 1977. Lives in Norfolk.

At the RCA he was active chiefly as a performance artist (including cabaret) and creator of 'happenings' and environments. In the 1960s he was best known as the creator of animated robots; during the 1970s he worked in collaboration with his wife, Jill Bruce, performing rituals in homage to the elemental, mystical forces of the cosmos. Recent paintings also depict these themes. MB-D

Bruce Lacey, Whitechapel Art Gallery Catalogue, London, 1975.

95 *Vultures*, 1954
Oil on canvas, 122 × 91.4 cm
RCA Collection

96 *Giving in to the Pool*, 1983
Acrylic on sacking, wood and string, 167.7 × 183 cm
The Artist

Joe Tilson b.1928
Student 1952–55

Worked as carpenter and joiner, 1944–46. RAF, 1946–49. St Martin's, 1949–52; RCA, 1952–55. Rome Scholarship, worked in Italy and Spain, 1955–57. Represented Britain, Venice Biennale, 1964. Retrospective: Boymans-van Beuningen Museum, Rotterdam, 1973. Grand Prix, Biennale Internationale de la Gravure V, Crakow, Poland, 1974. ARA, 1985. Lives in Wiltshire and Italy. Gallery: Waddington, London.

Tilson drew on his travels in Italy and Spain for source material for his early paintings. He was later associated with the first Pop-orientated generation from the College. He works often in wooden relief, experimenting widely with different media, including ceramics and prints. Recent work has been inspired by his reading of Mircea Eliade and Jung, and by his travels to Greece. RMcD

Michael Compton, *Joe Tilson: Contemporary Artist*, Milan, 1982.

97 *Matador*, 1954 [p. 48]
Oil on board, 77.5 × 64 cm
Private Collection

98 *A–Z Box of Friends and Family*, 1963 [p. 42]
Mixed media, 223 × 152.4 cm
The Artist/Waddington Galleries, London

99 *Liknon 3*, 1987
Oil on canvas on wood relief, 197 × 197 cm
Waddington Galleries, London

Alan Reynolds b.1926
Student 1952–53

Army overseas, 1939–45. Woolwich Polytechnic School of Art, 1948–52; scholarship, RCA, 1952–53; painting medal, 1952. Lives in London. Gallery: Annely Juda Fine Art, London.

Reynolds was highly acclaimed for his landscapes while at the RCA, but from 1958 moved into abstraction. 'The forms and colours I now employ are not consciously derived from, or related to Nature,' he said in 1960, 'but are dictated by an inner need to construct an equilibrium in accord with this feeling or sensation.' His recent relief constructions relate to the work of the European Construction and Concrete schools. RMcD

Masterpieces of the Avant-Garde: Three Decades of Contemporary Art, Annely Juda Fine Art Catalogue, London, 1985.

100 *The Village, Winter*, 1952
Oil on board, 61 × 91.8 cm
Arts Council of Great Britain

101 *Structures—Group II (Z) 2*, 1983
Prepared card on a wood base, 117 × 117 × 1 cm
Annely Juda Fine Art, London

Bridget Riley b.1931
Student 1952–55

Goldsmiths' College, 1949–52; RCA, 1952–55. Exhibited in *The New Generation*, Whitechapel Art Gallery, London, 1964; *Documenta 4*, Kassel, Venice Biennale, 1968. CBE, 1972. Arts Council touring exhibitions, 1973 and 1984. Sets and costumes for Ballets Rambert's, *Colour Moves*, 1983. Lives in London and France. Gallery: Mayor Rowan, London.

After concentrating on drawing at Goldsmiths' College, Riley mastered painting techniques at the RCA. Pointillism, Futurism and post-War American art were important formative influences. She started producing the abstract 'Op Art' images, for which she remains best known, in the early 1960s; her first one-woman shows in 1962 and 1963 rapidly won her international acclaim. Essentially, her paintings, often executed by assistants working from Riley's precise preparatory drawings, comprise abstract patterns which create an illusion of movement and induce optical vibration. Until c.1965 she worked entirely in black and white; her work since then explores a full colour range. MB-D

Bridget Riley, Works 1959–78, British Council Catalogue, London, 1978.

102 *Little Nude*, c.1955 [p. 110]
Oil on canvas, 90 × 70 cm
Private Collection

103 *Crest*, 1964 [p. 64]
Emulsion paint on board, 166 × 166 cm
The British Council

104 *Bloom* 1987 [p. 111]
Oil on canvas, 164.8 × 159.4 cm
Mayor Rowan Gallery, London

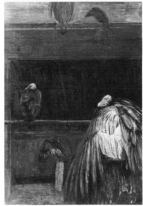

95

96

99

100

101

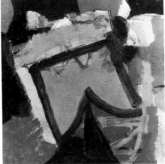

108

109

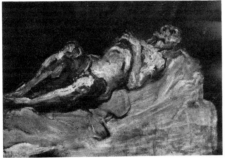

110

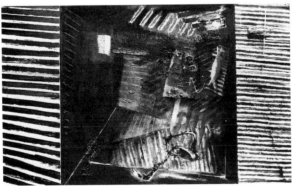

111

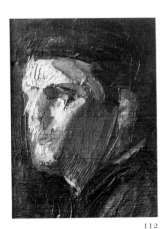

112

113

Frank Auerbach b.1931
Student 1952–55

Sent to England from Berlin, 1939; acquired British nationality, 1947. Art classes at Hampstead Garden Suburb Institute, then Borough Polytechnic, where taught by David Bomberg. St Martin's, 1948–52; RCA, 1952–55. Retrospective: Hayward Gallery, London, 1978. Represented Britain, Venice Biennale, 1986 (Golden Lion prizewinner). Lives in London. Gallery: Marlborough Fine Art, London.

Auerbach has worked in the same Camden Town studio since 1954. The deliberately narrow repertory of subject-matter (building sites, views of Primrose Hill and portraits of close friends) and richly impastoed handling of paint characteristic of his mature work were established while Auerbach was still a somewhat solitary student at the RCA. His palette, which initially he limited to earth colours and black and white, has broadened and brightened of recent years, while his unwavering humanism and strong awareness of the tradition and craft of painting have only fairly recently brought him into the British artistic mainstream. MB-D

Frank Auerbach, Arts Council Catalogue, London, 1978.

105 *Primrose Hill*, 1954–55 [p. 112]
Oil on board, 86.3 × 117 cm
Saatchi Collection, London

106 *Railway Arches, Bethnal Green II*, 1958–59 [p. 39]
Oil on board, 122.5 × 150.5 cm
Saatchi Collection, London

107 *Looking Towards Mornington Crescent Station, Night*, 1972–73 [p. 113]
Oil on board, 127 × 127 cm
Saatchi Collection, London

John Barnicoat b.1924
Student 1952–55 Senior Tutor 1976–80

Wartime Service as Naval Officer in Combined Operations. Studied History, Oxford University; RCA, 1952–55. First one-man exhibition, Galerie Colette Allendy, Paris, 1959. Senior Tutor, RCA Painting School, 1976–80. Lives in London.

A gifted painter and highly esteemed teacher and administrator, Barnicoat is widely regarded as one of the most thoughtful and influential voices in art education. MP

108 *Objects with Fragments of Mirror*, 1955
Oil on canvas, 50.8 × 60.9 cm
The Artist

109 *Painting*, 1985–86
Oil on board, 40 × 40 cm
The Artist

Anthony Whishaw b.1930
Student 1952 55

Chelsea, 1948–52; RCA, 1952–55; Travelling Scholarship, Drawing Prize, Abbey Minor Scholarship and Spanish Government Scholarship. Arts Council of Great Britain Award 1978. ARA, 1980. Abbey Premier Scholarship, 1982; Lorne Scholarship, 1982–83; John Moores Minor Painting Prize, 1982. Lives in London.

The work Whishaw produced at the RCA was much influenced by Picasso, Soutine, Sutherland and Bacon; sombre in colour and tending to Expressionistic angst, skulls were a favourite motif. His earliest exhibited work comprised Spanish landscapes and monumental figures dancing or in repose. In the late 1960s, his forms became more abstracted and spatially ambiguous; his work of the 1970s contained lyrical and allusive landscape references, while the 1980s have seen his return (via Velazquez) to the human figure. MB-D

Anthony Whishaw, *Reflections after Las Meninas*, Royal Academy Catalogue, London, 1987.

110 *Study of an old man*, 1955
Oil on canvas, 111.8 × 160 cm
The Artist

111 *Interior Triptych II*, 1983–87
Acrylic and collage on canvas, 152.4 × 254 cm
The Artist

Keith Critchlow b.1933
Student 1954–57 Tutor 1973–Present

St Martin's, RCA, 1954–57. Tutor, RCA, 1973–present; Director Visual Islamic Arts. Fellow, RCA, 1984. Lives in London. Architectural Consultancy: Keith Critchlow Associates.

An early disciple of F. Buckminster Fuller, whose first London exhibition he organized, Critchlow is a unique example in the art world—a painter, geometer and architect who moves effortlessly between aesthetics and higher mathematics. For over twenty years Critchlow has studied geometry and form, sacred patterns and order in space, and he is an acknowledged authority on sacred architecture. Committed to a holistic approach to the environment, Critchlow eschews the personality cults of modern architecture in favour of designs which acknowledge both the spiritual and physical needs of the client. He has written extensively on the role of pattern. MP

112 *Head (Self-portrait)*, 1957
Oil on wood, 28.6 × 22.8 cm
The Artist

113 *Homage to the Bearers*, 1987
Watercolour and gouache, 22.9 × 22.3 cm
The Artist

Leon Kossoff b.1926
Student 1953–56

British Army, 1945–48. St Martin's, 1949–53; Borough Polytechnic, 1950–52 (David Bomberg's evening class); RCA, 1953–56. Major exhibitions: *Recent Paintings*, Whitechapel Art Gallery, London, 1972; MOMA, Oxford, 1981. Lives in London. Gallery: Anthony d'Offay, London.

Like Frank Auerbach, Kossoff was a somewhat lone figure at the RCA. Since the 1950s, his work has been characterized by a heavily impastoed surface, painting and drawing being virtually indistinguishable. Of late, however, his colours have become lighter and brighter, the paint softer, chalkier and less thickly applied. Subject-matter remains extremely limited: people close to him in domestic interiors or anonymous figures in London's public spaces. Although seemingly isolated or alienated from each other, his protagonists retain a certain inner dignity. Commentators on Kossoff's work have seen it as an amalgam of a Jewish tendency to melancholy Expressionism and a British urban realist tradition. MB-D

Leon Kossoff, Fischer Fine Art Catalogue, London, 1984.

114 *City Building Site*, 1953 [p. 114]
Oil on canvas, 76.2 × 67.5 cm
RCA Collection

115 *Seated Woman II*, 1961 [p. 38]
Oil on board, 134.6 × 88.9 cm
The Artist

116 *Inside Kilburn Underground, Summer 1983*, 1983 [p. 115]
Oil on board, 137.8 × 168.3 cm
Saatchi Collection, London

Jean Cooke b.1927
Student 1953–55 Tutor 1964–74

Central School of Art and Design, London, 1943–45; RCA Sculpture/Painting Schools, 1953–55; Tutor, RCA, 1964–74. Member of Council, RA, 1983–85. Major portrait commissions include: Dr E. Wellesz and Dr W. Oakshott, Lincoln College, Oxford and Principal, St Hilda's College, Oxford, 1976. Lives in London.

Cooke is regarded, together with her ex-husband, John Bratby, as a Kitchen Sink realist, a 'passionate illustrator' of everyday life. Although her paintings reflect a perhaps obsessive involvement with an eccentric domestic environment, Cooke is also a portraitist with many official commissions to her credit. In recent years she has turned increasingly to land and seascapes. MP

117 *Early portrait of John Bratby*, 1955
Oil on canvas, 122 × 91.4 cm
The Royal Academy of Arts

118 *Portrait of John Bratby*, c.1968
Oil on canvas, 129.5 × 61 cm
RCA Collection

Carel Weight b.1908
Tutor 1947–57 Professor 1957–72

Hammersmith School of Art, c.1928–30; Goldsmiths' College (part time), c.1930–33. Official War Artist, 1945–46. Tutor, RCA, 1947–57 and Professor, 1957–72. ARA, 1955; RA, 1965. CBE, 1962. Major retrospective: RA, 1982. Lives in London.

On arrival, Weight found the RCA 'in a terrible mess' after the disruption of the War years. With the arrival of Robin Darwin, however, the College became a 'very forward looking premier school'. On becoming Professor, Weight made few staff changes, but took the pioneering step of employing several women tutors. Although Weight remained an advocate of working from life, his years at the RCA witnessed a general trend away from collective life studies towards a more individualistic, imaginative approach. In his own work he has consistently sought to portray the extraordinary taking place in the most ordinary of settings. MB-D

Mervyn Levy, *Carel Weight*, Weidenfeld and Nicholson, London, 1986.

119 *Escape of the Zebra from the Zoo during an air raid*, c.1943
Oil on panel, 4 panels, each 22 × 34.6 cm
Manchester City Art Galleries

120 *The Day of Doom*, c.1955–65 [p. 54]
Oil on canvas, 152.5 × 143 cm
Private Collection

Leonard Rosoman b.1913
Tutor 1956–76

King Edward VII School of Art, Durham University; RA Schools, London; Central School of Art and Design, London. Appointed Official War Artist to the Admiralty, 1943. Tutor, RCA, 1956–76. ARA, 1960; RA, 1970; Winston Churchill Fellow, 1966–67. Retrospective: Fine Art Society, London, 1974. OBE, 1981. Lives in London. Gallery: Fine Art Society, London.

Rosoman is known particularly for his mural paintings; commissions have included work for The Brussels World Fair in 1958, and, recently, Lambeth College Chapel, London. Michael Middleton wrote in 1983: 'He is the recorder of the subliminal image, of unexpected frames from the unrolling film of day-to-day existence—images which for most of us are quickly blunted and overlaid by the recurrently familiar. There are nearly always ambiguities and oddities in a Rosoman painting.' RMcD

Leonard Rosoman, Fine Art Society Catalogue, London, 1974.

121 *Portrait of Lord Esher in a Studio at the RCA*, 1978
Acrylic on canvas, 122 × 152 cm
RCA Collection

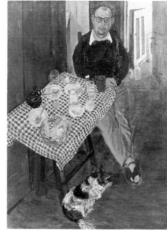

117

118

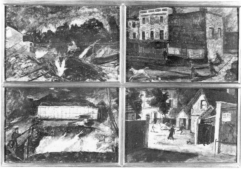

119

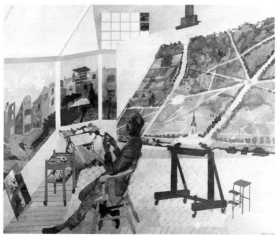

121

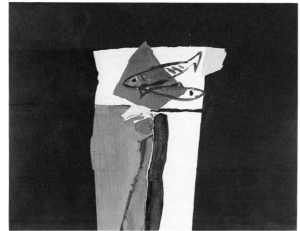

122

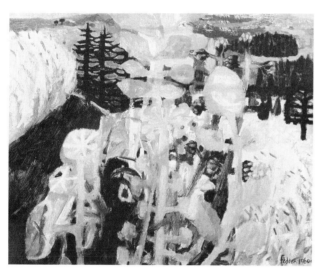

123

124

Donald Hamilton-Fraser
b.1929
Tutor 1957–83

St Martin's, 1949–50; Paris (French Government Scholarship), 1953–54. Art critic and author. Tutor, RCA, 1957–83; Fellow, RCA, 1970; Hon Fellow, RCA, 1984. RA, 1985; member, Royal Fine Art Commission, 1986. Lives in London. Gallery: Gimpel Fils, London.

Dance and ballet are important themes for Hamilton Fraser, who admits his fascination by the way in which 'the language of ballet confers sheer physical beauty on a person'. Another major theme in his work has been brilliantly coloured seascapes from the Mediterranean. 'With their expressive flow and virtuoso command, Fraser's drawings [of ballet subjects] will come as a surprise to anyone expecting the semi-abstract planes of brilliant colour that characterize his landscape paintings,' wrote Nicholas Underwood. The Mediterranean warmth of his paintings carries over into his screenprints, in which dancers, seascapes and still lifes of brilliantly coloured toys are all featured. RMcD

Donald Hamilton Fraser, Christie's Contemporary Art Catalogue, London, 1986.

122 *Still Life with Fish*, 1975
Oil on canvas, 91.5 × 122 cm
Private Collection

Mary Fedden b.1915
Tutor 1958–64

Scholar, Slade 1932–36. Tutor, RCA, 1958–64 (first woman tutor). President of the Royal West of England Academy, 1984–present. Selected mural commissions: Festival of Britain, 1951; P and O Liner Canberra, 1961; Charing Cross Hospital (with J Trevelyan), 1980; Colindale Hospital, 1985. Lives in London. Gallery: Beaux Arts, Bath.

Quintessentially English and domestic, modest in scale and subject-matter, Fedden's work imaginatively transforms the experiences of everyday life: a bowl of fruit or vase of flowers, the view through a window, the cats and birds of a suburban garden. Drenched in luminous colour and dramatically lit, the symbolic nature of her still life subject-matter is emphasized by the deliberate use of flattened space. This suggests a rhythmical unifying pattern, an intimate introversion as opposed to the expansive vistas of perspective. MP

123 *Austrian Landscape*, 1960
Oil on canvas, 60.7 × 76.2 cm
Carlisle Museums and Art Gallery

Sandra Blow b.1925
Tutor 1961–75

St Martin's, 1941–46; Royal Academy Schools, 1946–47; L'Accademia di Belle Arta, Rome, 1947–48. Tutor, RCA, 1961–75. John Moore's Second Prize Winner, 1961. ARA, 1971; RA, 1978; Honorary Fellow, RCA, 1983. Lives in London.

'My work comes from a year in Italy in my student days,' writes Sandra Blow. 'Nicholas Carone, who worked with Hans Hofmann, and Alberto Burri became close friends and mentors. The high combustion of early American Abstract Expressionism, a living experience of the Renaissance, and its transmutation into modern material by Burri, threw sparks of potential work into my mind that have remained and been the cornerstone of all developments since. Another formative source was the full tide of Abstract Expressionism in its breathtaking expansiveness and simplicity. Then English experiences and friends—a year in Zennor in 1958, painting in the fields on the cliffs, teaching at the RCA the year Hockney and Kitaj and Philip Bolshier were there—were influential.' RMcD

Hayward Annual, Arts Council Catalogue, London, 1978.

124 *Black, White and Brown, Concrete and Sawdust*, 1961
Oil and mixed media on board, 121.4 × 114 cm
Norfolk Museums Service (Norwich Castle Museum)

Bateson Mason 1910–77
Student 1932–35

Bradford College of Art, 1927–32; RCA, 1932–35. Painter in oils, watercolour and gouache; exhibited with New English Art Club and London Group; at Leicester and Redfern Galleries and in provinces. ATD, 1932; Associate, RCA, 1934.

Always inspired by his environment, but particularly by local architecture, Mason drew largely on his travels to France, Spain and Venice for source material. His later work, done during his long teaching association with Ravensbourne College of Art, became more landscape orientated, though an interest in building remained. MB-D

125 *Back Lane to the Village*, c.1974
Oil on board, 81 × 104 cm
Jo Barry

Peter Blake b.1932
Student 1953–56 Tutor 1964–76

Gravesend School of Art, 1946–51;
RCA, 1953–56 (First Class Diploma).
National Service 1951–53. Tutor,
RCA, 1964–76. ARA, 1974; RA,
1981. Founder-member, Brotherhood
of Ruralists, 1975. Retrospective:
Tate Gallery, London, 1983. Lives in
London. Gallery: Waddington,
London.

Often referred to as the father of
British Pop Art, Blake's work is
characterized by a photo-realist
manner and the use of collage and
assemblages of collected mementoes.
These techniques, and the subject-
matter drawn from popular culture,
were to a large extent pioneered by
him in the remarkably original
paintings he produced while still a
student at the College. His love of
fairground decoration, circus
characters, children's toys and teenage
pop idols won him his ideal
commission when he designed the
famous record sleeve for the Beatles'
Sgt. Pepper Album, 1967. MR

Peter Blake, Tate Gallery Catalogue,
London, 1983.

126 *The Preparation for the Entry into
Jerusalem*, 1955–56 [p. 116]
Oil on hardboard, 127 × 101.6 cm
RCA Collection

127 *Girlie Door*, 1959 [p. 40]
Collage and objects on wood, 122 × 59 cm
Private Collection

128 *The Meeting, or Have a Nice Day
Mr Hockney*, 1981–83 [p. 117]
Oil on canvas, 99.2 × 124.4 cm
The Trustees of the Tate Gallery

Brian Fielding 1933–87
Student 1954–57

Sheffield College of Art, 1950–54;
RCA, 1954–57. Abbey Minor
Travelling Scholarship to Italy and
France, 1958. Touring retrospective:
Mappin Art Gallery, Sheffield, 1986.

Fielding enjoyed a considerable
reputation as an influential teacher at
Ravensbourne College of Art. His
painting was characterized by an
allegiance to spiritual values and Zen
Buddhism. His friend John Hoyland
wrote that Fielding's reputation was
always secure amongst painters and
students, but that he was largely
neglected by dealers and the art
establishment. One writer observed
that as a student at the RCA,
Fielding's 'serious but also quietly
funny temperament won him much
lasting affection.' RMcD

Brian Fielding, New Paintings 1960–1983,
Mappin Art Gallery Catalogue, Sheffield,
1986.

129 *Antique Room*, 1957 [p. 118]
Oil on canvas, 129.5 × 91.5 cm
RCA Collection

130 *Chapel Cake*, 1984 [p. 119]
Oil on canvas, 152.4 × 152.4 cm
Estate of the Artist

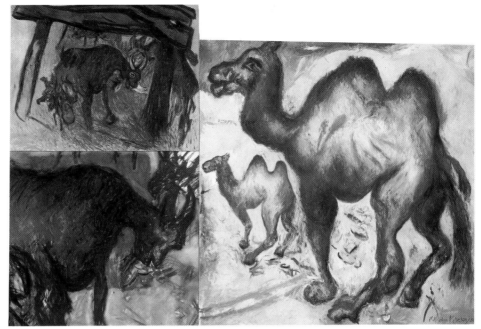

¹33

Malcolm Morley b.1931
Student 1954–57

Worked on transatlantic and North
Sea barges. Took correspondence
course in art. Camberwell, 1952–53;
RCA, 1954–57. Moved to New York,
1958. Major Retrospective: Europe,
USA and Whitechapel Art Gallery,
London, 1983. Turner Prize, 1984.
Lives in New York. Gallery: Pace,
New York.

Morley's earliest works were
landscapes, with strong tonal
emphasis derived from the tradition of
Sickert. At the RCA he continued to
produce landscapes and cityscapes, as
well as the occasional Rouault-
influenced figure composition.
Exposure in 1956 to American
Abstract Expressionism led him to
become an abstract painter. In the
mid-1960s, Morley returned to
figuration, gaining a reputation for his
Super-Realist (Morley's own term)
renderings of passenger ships. Since
1970 his work has become increasingly
painterly, and wittily exotic and
allusive in subject-matter. MB-D

Malcolm Morley: Paintings 1965–82,
Whitechapel Art Gallery Catalogue,
London, 1983.

131 *The Richmond Hill below the Wick*, 1954
[p. 120]
Oil on canvas, 68 × 90 cm
Private Collection

132 *SS France*, 1974 [p. 121]
Oil and mixed media on canvas with
objects, 182.9 × 162.6 cm
Saatchi Collection, London

133 *Camels and Goats*, 1980
Oil on canvas, 167.7 × 254 cm
Saatchi Collection, London

134

136

137

138

Richard Smith b.1931
Student 1954–57

Luton School of Art, 1948–50. RAF 1950–52. St Alban's School of Art, 1952–54; RCA, 1954–57. Lived in New York, 1963–65. Represented Britain, Venice Biennale, 1966. Grand Prix, Sao Paulo Bienal, 1967. CBE, 1972. Retrospectives: Whitechapel Art Gallery, London, 1966; Tate Gallery, London, 1975. Lives in New York. Gallery: Knoedler, London.

Smith's RCA work revealed his early gifts as a colourist. Preoccupation with the textures and shapes of commercial packaging brought him briefly into the orbit of Pop Art, but since the mid-1960s his work has been consistently abstract and formalist. At first he used shaped canvases which blurred the distinction between paintings and reliefs, and in the early 1970s used unstretched canvas and made a feature of the string and metal rods acting as its support. In recent years the high colour and decorative quality of his kite-like structures have won him many corporate commissions. MB-D

Richard Smith: Seven Exhibitions 1961–75, Tate Gallery Catalogue, London, 1975.

134 *Standing Figure*, 1956
Oil on board, 91.5 × 61 cm
RCA Collection

135 *First Fifth*, 1962 [p. 67]
Oil on canvas, 172.7 × 182.9 cm
Knoedler Kasmin, Ltd./Mayor Gallery, London

136 *Disc 7—Shahibag*, 1977
Acrylic on canvas with string, 100 × 100 cm
The British Council

Alan Green b.1932
Student 1955–58

National Service, 1953–55. RCA, 1955–58. Travelling Scholarship, 1958. Retrospective: Kunsthalle, Bielefeld, and MOMA, Oxford, 1970. Print Biennale prizes: Bradford, 1974, 1984; Norway, 1978; Tokyo, 1979. Lives in Wales. Gallery: Annely Juda Fine Art, London.

Green's move towards abstraction came about while at the RCA. For the following ten years he was involved with construction and collage, 'the act of building and organizing a painting', as well as continuing to make prints. His mature work is characterized by simple rectacular formats and the frequent use of an enclosing band. The sombre colour is built up through several layers of pigment, with great attention paid to density, weight and thickness. MP

Alan Green, Recent Paintings and Drawings, Annely Juda Fine Art Catalogue, London, 1985.

137 *Flower Pots*, 1958
Oil on canvas, 122 × 91.5 cm
RCA Collection

138 *Cerulean*, 1986
Oil on canvas, 161 × 145 cm
Annely Juda Fine Art, London

Robyn Denny b.1930
Student 1954–57

St Martin's, 1951–54; RCA, 1954–57. Exhibited in *Young Contemporaries*, 1953. One-man exhibition: Gallery One/Gimpel Fils, 1958. Critic for *Art International*, 1963–64. Represented Britain at Venice Biennale, 1966. Retrospective: Tate Gallery, London, 1973. Lives in London and USA. Gallery: Waddington, London.

Denny was a prominent figure among the so-called British 'Colour Painters', who exhibited together as the *Situation* group in 1960 (others included Bernard and Harold Cohen, John Hoyland and Richard Smith). Influenced by the American colour-field painters, he produced large, disciplined abstract paintings, generally in strong, unmodulated colours, which were divided in a rectilinear or otherwise geometric fashion, corresponding to the scale and reach of the human figure. In the artist's own words: 'I was experimenting with what new sensations of colour can be achieved with the most limited means—what great diversity of formal experience I could make with very limited means.' Recent work has seen the development of colour-fields, expanding from a more Expressionist core. MB-D

Robyn Denny, Tate Gallery Catalogue, London, 1973.

139 *Eden Come Home*, 1957 [p. 122]
Oil and gold size on board-burnt, 120 × 240 cm
The Artist

140 *Into Light*, 1964–65
Oil on canvas, 213.3 × 182.9 cm
Leeds City Art Galleries

141 *Sunset Blue*, 1985–87 [p. 123]
Acrylic on canvas, 243.8 × 199.4 cm
The Artist

Sonia Lawson b.1934
Student 1955–59

RCA, 1955–59. Travelling
scholarship to France, 1961. Major
retrospective: 1982–83. Associate
RWS, 1984. Lorne Award, London
University, 1986. Lives in Essex.

Lawson emerged as a formidable
figurative painter from an RCA
generation of Abstract and Pop
painters. Thoroughly committed to
finding authentic expression for a
profoundly held set of ideas and
beliefs, Lawson has worked largely in
isolation, only receiving critical
acclaim in the last five years. Her rich
mythological world has always drawn
deeply on her Yorkshire background
and her preoccupation with war and
man's inhumanity to man. Utilizing
her extensive knowledge of literature,
history and art history, her recent
work is more complex in its source
material, ranging from artists such as
Watteau and Courbet to the writer
Molière and the poet John Clare. MP

142 *Still Life*, 1958 [p. 124]
Oil on board, 122 × 76.2 cm
RCA Collection

143 *Homage to Molière and Watteau*, 1981
[p. 125]
Chalk on canvas, 126.6 × 101.5 cm
Arts Council of Great Britain

Stuart Brisley b.1933
Student 1956–59

Guildford School of Art, 1949–54;
RCA, 1956–59 (Abbey Minor
Scholarship 1959); Akademie der
Bildenden Künste, Munich, 1959–60;
Florida State University, Tallahassee,
1960–62. Reader in charge of Media-
Fine Art, Slade, since 1985. DAAD
Berlin Artists Programme Award,
1973–74. Retrospectives: Institute of
Contemporary Arts, London, 1981;
Serpentine Gallery, London, 1986.
Lives in London.

In the mid-1960s Brisley was
producing fairly formalist structures in
perspex and similar materials; the
incorporation into these of movement
and light led him in 1968 to become a
performance artist. His performances
can be divided into two main types:
the purification ritual, in which
endurance is a key element; and, more
recently, the contest ritual.
Apparently masochistic, their purpose
is to address issues of consumption,
power and authority: their message is
thus a political and social one. Since
c.1981, Brisley has returned to object-
making; he also creates 'imaginary
performances' (sound tapes often
accompanied by slides) and filmed
performances. MB-D

Stuart Brisley: Georgiana Collection, Arts
Council Catalogue, London, 1986.

144 *Head*, 1957
Oil on canvas, 51 × 64 cm
The Artist

145 *It can be done*, 1986
Coloured photographs, 91.5 × 213.4 cm
The Artist

Bill Culbert b.1935
Student 1957–60

Canterbury University School of Art
(NZ), 1953–56. Travelling
Scholarship, 1957. RCA, 1957–60
(Silver Medal for Painting). First
Prize, Open Painting Competition,
Arts Council of Northern Ireland,
1964 (also prizewinner, 1968).
Artist in residence, Museum of
Holography, New York, 1985.
Retrospective: Institute of
Contemporary Arts, London, 1986.
Lives in London. Gallery: Victoria
Miro, London.

In the mid-1960s, Culbert moved
from painting on canvas to
explorations of light featuring
electrical installations. William
Feaver commented in 1977: 'The
light bulb is to Bill Culbert what a
candle was to Georges de La Tour.
Not just an illumination but the
heart of the mysteries . . . a lit bulb
reflected as a dead one, for example
. . . He takes an ordinary
cheesegrater and produces
planetarium effects.' RMcD

Bill Culbert, Selected Works 1968–86,
Institute of Contemporary Arts
Catalogue, London, 1986.

146 *Kensington Gore*, 1960
Oil on ply, 100 × 146 cm
RCA Collection

147 *Green Jug*, 1980
Free-standing object, 26 × 15 cm (jug),
66 × 46 × 69 cm (table)
The Artist

Norman Stevens b.1937
Student 1957–60

Bradford Regional College of Art,
1952–57; RCA, 1957–60 (Lloyd
Landscape Scholarship, Abbey
Minor Travelling Scholarship).
Prizes: Chichester Arts Festival,
1975; John Moores, Liverpool,
1983; British International Print
Biennale, 1979. ARA, 1983. Lives in
London. Gallery: Redfern, London.

Stevens is both a painter and a
printmaker. William Packer
referred to his prints as 'some of the
most distinguished . . . of recent
years'. In 1981 he also wrote:
'Stevens has long been drawn to
formal gardens with their simple
sculptured trees and hedges,
overhung paths and alleys, and their
sense of deeply-shaded enclosure . . .
the heavy somewhat threatening
mass of the trees poised delicately on
their stilty legs, through which the
eye dodges to the blank hedges
beyond.' RMcD

148 *Abstract*, 1960
Oil on canvas, 76 × 63.5 cm
RCA Collection

149 *Collapsing Structure in the Art Historian's
English Garden*, 1975
Oil on canvas, 153.5 × 153.5 cm
Leeds City Art Galleries

144

145

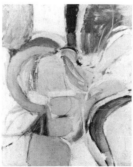

146

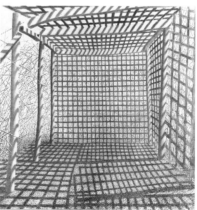

147

148

149

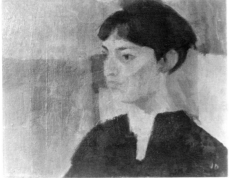

152

153

156

Adrian Berg b.1929
Student 1958–61 Senior Tutor 1987–88

Caius College, Cambridge; Trinity College, Dublin; St Martin's; Chelsea; RCA, 1958–61. Abbey Minor scholarship and French government scholarship, 1961; John Moores prizewinner, 1980; and 3rd prizewinner, 1982–83; Lorne Scholarship, 1979–80. Retrospective: *Paintings 1955–80*, Rochdale Art Gallery, 1980; *Paintings 1977–86*, Arts Council, 1986. Senior Tutor, RCA, 1987–88. Lives in London. Gallery: Piccadilly, London.

In the catalogue of Adrian Berg's Arts Council show, Peter Fuller wrote that in an era of widespread reductionism and false 'internationalism', Berg's stance of 'informed parochialism' had served him well. 'It is possible that back in the 1960s, Berg, like Constable before him, believed that through his "natural", or scientific, painting he was driving a nail to secure realism, i.e. "a more truthful account of the external world" . . . I believe that Berg's best landscapes are among the most significant works of art which deal with the natural world made in Britain in the last quarter century.' RMcD

Adrian Berg, Paintings 1977–86, Arts Council Catalogue, London, 1986.

150 *The Flight of Icarus*, 1960 [p. 126]
Oil on hardboard, 101.6 × 122 cm
RCA Collection

151 *Gloucester Gate, Regent's Park, June*, 1982 [p. 127]
Oil on canvas, 177.8 × 177.8 cm
The Arts Council of Great Britain

John Dougill b.1934
Student 1957–60 Tutor 1977

West Sussex College of Art, 1950–55; RCA, 1957–60; Tutor, RCA, 1977. Exhibited in *Thirty London Painters*, RA, London, 1985. Lives in London.

Dougill was an artist who moved away from picture-making in the early 1970s to take an active role in environmental and community issues, helping organize students in the use of films, photography and silk-screened posters. A committed teacher, and once again a practising painter, he says, 'Teaching shows me that the continuity of talent, commitment, passion and need amongst students and young artists is as great as it ever was.' RMcD

152 *Sonja*, 1960
Oil on canvas, 33.1 × 43.2 cm
The Artist

153 *Open Ending*, 1987
Acrylic on canvas, 122 × 152.5 cm
The Artist

Allen Jones b.1937
Student 1959–60

Hornsey College of Art, 1955–59; RCA, 1959–60 (expelled for 'excessive independence'); teacher training, Hornsey School of Art, 1960–61. Exhibited in *Young Contemporaries*, 1960–61. Has Lived in New York, Florida, California, Alberta and West Berlin. Prize, Paris Biennale, 1963. European touring retrospective: Walker Art Gallery, Liverpool, 1979. ARA, 1981. Lives in London. Gallery: Waddington, London.

Jones's work of the early 1960s reveals his interest in adapting the automatist elements of Abstract Expressionism to figurative painting and in fusing male and female elements (the writings of Nietzsche, Freud and Jung were an important influence). In New York in the mid-1960s his 'discovery' of the glossy, fetishist imagery of commercial art led him to adopt a more illusionist mode of painting and a more explicitly erotic approach to his subject-matter. In addition to paintings, prints and sculptures he has produced stage sets and costumes. MB-D

Allen Jones, Retrospective of Paintings 1957–1978, Walker Art Gallery Catalogue, Liverpool, 1979.

154 *You'll have to run to catch this bus*, 1961 [p. 51]
Oil on canvas, 152.4 × 152.4 cm
Private Collection

155 *Thinking about Women*, c.1965 [p. 43]
Oil on canvas, 152 × 151.8 cm
Norfolk Contemporary Art Society

156 *Untitled (diptych)*, 1986
Oil on canvas, 182.9 × 213.4 cm
Waddington Galleries, London

R. B. Kitaj b.1932
Student 1959–61

Cooper Union, New York and Akademie der Bildenden Künste, Vienna, 1950–52; Ruskin School of Drawing, Oxford, 1958–59; RCA, 1959–61. Selected *The Human Clay* exhibition, Hayward Gallery, London, 1976. Retrospective: Hirshhorn Museum and Sculpture Garden, Washington DC, 1981. ARA, 1984. Lives in London. Gallery: Marlborough Fine Art, London.

Kitaj's age and wider experience made him an important influence on his fellow students at the RCA (above all, Hockney). His own preference for figuration provided a viable modernist alternative to abstraction. Although initially labelled a Pop artist, Kitaj has always been immensely complex, wide-ranging and allusive in his cultural and political references; his intellectualism, however, is always balanced by a sensuous appreciation of his materials. Since the mid-1970s he has shown an increasing preoccupation with the question of Jewish identity in a post-Holocaust world. MB-D

Marco Livingstone, *R. B. Kitaj*, Phaidon Press, Oxford, 1985.

157 *Homage to H. Melville*, c.1960 [p. 128]
Oil on canvas, 137.2 × 90.8 cm
RCA Collection

158 *Kennst du Das Land*, 1962 [p. 45]
Oil on canvas, 122 × 122 cm
The Artist/Marlborough Fine Art (London) Ltd.

159 *The Neo-Cubist*, 1976–87 [p. 129]
Oil on canvas, 177.8 × 132.1 cm
Saatchi Collection, London

David Hockney b.1937
Student 1959–62

Bradford School of Art, 1953–57; RCA, 1959–62 (Gold Medal). Moved to Los Angeles, 1963. Retrospectives: Whitechapel Art Gallery, London, 1970. Touring retrospective: Los Angeles County Museum of Art and Tate Gallery, London, 1988. Film: *A Bigger Splash*, 1974. Theatre sets include *The Rake's Progress*, Glyndebourne, 1974–75. ARA, 1985. Lives in USA. Gallery: Knoedler, London.

By the time Hockney left the RCA, his art and his persona were already famous. His work of the early 1960s, inspired by Dubuffet and Walt Whitman, is deliberately, and ironically, naïve in its technique and imagery. From the mid to late 1960s, under the influence of Californian art and life, he adopted acrylic instead of oil paint and evolved a flatter, more hard-edged, almost photo-realist painting style. In his paintings of the late 1970s and 1980s, he used a more painterly and decorative approach. Hockney is also a consummate draughtsman, print-maker and stage designer; recently, he has experimented with photo collages and home-made prints. MB-D

Marco Livingstone, *David Hockney*, Thames and Hudson, London, 1981.

160 *I'm in the Mood for Love*, 1961 [p. 44]
Oil on board, 122 × 91.5 cm
RCA Collection

161 *Man Taking Shower in Beverly Hills*, 1964 [p. 46]
Acrylic on canvas, 167 × 167 cm
The Trustees of the Tate Gallery

162 *Paper Pool—Steps with Shadow*, 1978
Coloured and pressed paper pulp, 128 × 85 cm
Jacqueline and Gilbert de Botton, Switzerland

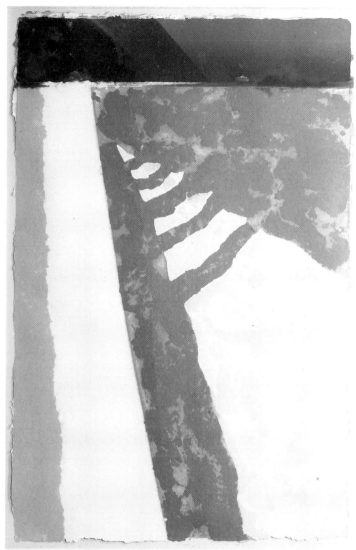

162

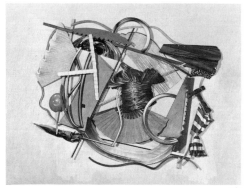

168

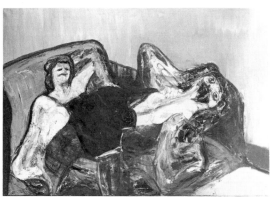

169

170

Derek Boshier b.1937
Student 1959–62

Yeovil School of Art, 1953–57; RCA, 1959–62. Exhibited in *The New Generation*, Whitechapel Art Gallery, London, 1964. Exhibitions: Whitechapel Art Gallery, London, 1973; ICA, London, 1983. Lives in Houston, Texas. Gallery: Edward Totah, London.

On leaving the RCA, Boshier was already well known for his Pop Art images of the 'Americanization' of British post-War society. In the mid-1960s, however, he rejected figuration in favour of a hard-edge 'Op' abstraction, although references to street and traffic signs persist. In 1966 he started making minimalist sculptures out of perspex and neon; until the late 1970s he worked in a politically radical conceptual mode, using photographs, ready-made material and texts to unmask the sinister effects of advertising, after which he reverted to figurative painting. MB-D

Derek Boshier, Texas Works, ICA Catalogue, London, 1982–83.

163 *Drinka Pinta Milka*, 1962 [p. 130]
Oil on canvas, 155 × 124.5 cm
RCA Collection

164 *Swan*, 1962 [p. 52]
Oil on canvas, 183 × 69 cm
Edward Totah Gallery, London

165 *The Culture of Narcissism*, 1979 [p. 131]
Oil on canvas, 171 × 125 cm
Angela Flowers Gallery, London

Peter Phillips b.1939
Student 1959–62

Birmingham College of Art, 1955–59; RCA, 1959–62. Harkness Fellowship, New York, 1964–66. Touring retrospective: Walker Art Gallery, Liverpool, 1982. Lives in Zürich. Gallery: Neuendorf, Hamburg and New York; Bischofberger, Zürich.

Although he did receive his painting diploma, friction between Phillips and his tutors in the Painting School caused him to transfer to the Television School in 1961. His early 1960s work took the form of mixed media collage, in which images culled from advertising, slot machines and juke boxes were used to create bold, flat patterns. Since the late 1970s, his work has become more abstracted. MB-D

Peter Phillips retroVISION, Walker Art Gallery Catalogue, Liverpool, 1982.

166 *Motorpsycho/Club Tiger*, 1962 [p. 49]
Oil on canvas, 127 × 76.2 cm
Private Collection

167 *Kewpie Doll*, 1963–64 [p. 47]
Oil on canvas, 132 × 107 cm
Private Collection

168 *Entanglement Series; Perpetual Flux*, 1981–82
Oil, acrylic and wax on wood, 200 × 267 × 23 cm
Arts Council of Great Britain

Frank Bowling b.1936
Student 1959–62

Slade; RCA, 1959–62 (Silver Medal, 1962). Exhibitions: Whitney Museum, New York, 1971; Serpentine Gallery, London, 1986. Lives London and New York. Gallery: Angela Flowers, London.

Vivien Raynor wrote: 'He was at one time an expressionist, influenced by Francis Bacon but possessed of a social conscience.' Of recent paintings, Raynor said: 'The lacquered surfaces seethe with ridges and lumps produced by scraps of polyurethane, small deposits of crumpled fabric and other unidentified objects buried under the paint. Sometimes "wounds" open up in the skin. Contriving to look rich and at the same time slightly repulsive, Bowling's is strange, impressive painting that—no mean feat—strikes a balance between the African fetish and the dribbled images of Jackson Pollock.' RMcD

Frank Bowling: Paintings 1983–86, Arts Council Catalogue, London, 1986.

169 *Two Figures on a Bed*, 1962
Oil on canvas, 122 × 183 cm
RCA Collection

170 *Centurion*, 1986
Acrylic on canvas with strips of plastic foam, 182.9 × 76.2 cm
The Artist

Patrick Caulfield b.1936
Student 1960–63

Chelsea, 1956–59; RCA, 1960–63. Exhibited in *The New Generation*, Whitechapel Art Gallery, London, 1964. Retrospective: Walker Art Gallery, Liverpool, and Tate Gallery, London, 1981. Lives in London. Gallery: Waddington, London.

Caulfield's first mature works—black and white paintings based on a grid pattern and depicting familiar objects were produced in his last year at the RCA. Léger and Gris were important early influences. Caulfield is frequently seen as one of the third generation of Pop painters: his ironic references to popular culture take the form of a deliberate, commercialized banality of surface texture and subject-matter (still lifes and interiors). Colours are bright and unmodulated; forms are defined by precise black lines. More recently he has introduced areas of painterly illusionism into his compositions. MB-D

Patrick Caulfield: Painting 1963–1981, Tate Gallery Catalogue, London, 1981.

171 *Christ at Emmaus*, 1963 [p. 132]
Oil on board, 101.1 × 127 cm
RCA Collection

172 *Stained Glass Window*, 1967 [p. 53]
Oil on canvas, 213.4 × 122 cm
Waddington Galleries, London

173 *Fish and Sandwich*, 1984 [p. 133]
Acrylic on canvas, 76.2 × 111.8 cm
Saatchi Collection, London

John Loker b.1938
Student 1960–63

Graphic design at Bradford Regional College of Art, 1954–58; RCA, 1960–63. Awarded Abbey Minor Travelling Scholarship, 1963. Touring exhibition *Ten Years' Work*, Arnolfini, Bristol, 1981. Lives in London. Gallery: Angela Flowers, London.

After the abstract character of his student work, environmental considerations have been an underlying feature—from the constructions of the 1970s, through photographic pieces, to painting with distinct references to landscape. In 1983 Loker created a work based on elements of an almost aerial view of the Bradford district. Recently he has explored a new range of concrete imagery which has the same lyricism that he previously brought to motives in landscape. RMcD

John Loker, Monograph, Arnolfini Gallery, Bristol, 1981.

174 *(Composition)*, 1963
Acrylic on canvas, 122 × 122 cm
RCA Collection

175 *Spin Off Sunset*, 1986
Oil on canvas, 153 × 122 cm
Angela Flowers Gallery, London

Michael Moon b.1937
Student 1962–63

National Service, Germany, 1956–58. Chelsea, 1958–62; RCA, 1962–63. John Moores Liverpool Exhibition, First Prize winner, 1980. One-man exhibition, Tate Gallery, London, 1976. Major Arts Council Award, 1980. Lives in London. Gallery: Waddington, London.

Michael Moon's colour 'strip' paintings, with their muted and graduated colour, won him critical notice in the 1960s. He turned away from these in 1973. In recent years he has travelled backwards and forwards across the boundary dividing painting from print-making, creating large 'monoprints' which involve the collaging of printed materials. 'I'm never quite certain with any one piece whether the image in my mind will promote the sort of material I print or the other way round,' he says. 'The process is so closely intertwined that this question might be considered part of their content.' RMcD

Judy Marle, *Michael Moon*, Tate Gallery Catalogue, London, 1976.

176 *Life Study*, 1963
Oil on canvas, 20.3 × 25 cm
The Artist

177 *Charred Orange*, 1984
Lithographic monotype, 125 × 91.4 cm
Waddington Graphics, London

Victor Burgin b.1941
Student 1962–65

RCA, 1962–65; Yale University, 1965–67. DAAD Fellowship (West Berlin), 1978–79. Author and publisher of theoretical articles, *Artforum*, *Studio International*, *20th Century Studies* and *Screen*. Retrospective: MOMA, Oxford, 1978. Lives in London.

Although some of his student works show a debt to hard-edge abstraction, Burgin soon came to reject Modernist notions of the pre-eminence and 'purity' of the art object. Taking an essentially pedagogic approach to art as a form of political education, he makes no distinction between his activities as writer, photographer, manipulator of verbal and visual texts, and teacher. Issues of power and sexuality are of particular concern. MB-D

Between, Institute of Contemporary Arts Catalogue, London, 1986.

178 *Abstract (AKA Gatsby)*, 1965
Acrylic on canvas, 182.9 × 101.6 cm
RCA Collection

179 *Possession*, 1976
Photo lithographic print, 120 × 84 cm
Arts Council of Great Britain

Bill Jacklin b.1943
Student 1964–67

Walthamstow School of Art, 1960–61, 1962–64. Worked as graphic designer, 1961–62. RCA Print School, transferred to Painting School, 1964–67. Has lived in New York and London since 1985. Gallery: Marlborough Fine Art, London.

An artist who responds to the times, Jacklin's work has shifted dramatically in both style and subject-matter over the last twenty years. Initially he worked environmentally, incorporating fixtures such as fire extinguishers and fire buckets, moving in the early 'seventies through a distinctive Pop Art period, towards a cool abstract Minimalism. The move into figurative imagery was marked by a strong sense of pattern, concentrating on intimate interiors, figures and still lifes. Since moving to New York, Jacklin has taken, literally, to the streets, with broad vistas of buildings, crowds and factory workers. An excellent draughtsman and technician, his exploitation of rich colour and dramatic effects of light has made his work particularly individual in terms of contemporary figuration. MP

Bill Jacklin, Marlborough Fine Art Catalogue, London, 1987.

180 *The Invitation Card*, 1962–64 [p. 134]
Mixed media, 128.3 × 95.3 × 25.4 cm
The Artist/Marlborough Fine Art (London) Ltd.

181 *Washington Square at Night*, 1986 [p. 135]
Oil on canvas, 198.1 × 198.1 cm
Marlborough Fine Art (London) Ltd.

174

175

176

177

178

179

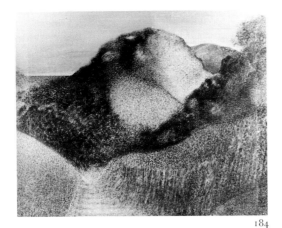

184

185

187 186

188

189

John Bellany b.1942
Student 1965–68 Tutor 1969–73

Edinburgh College of Art, 1960–65; RCA (Burston Award), 1965–68; Tutor, RCA, 1969–73. Film, *John Bellany*, BBC TV (Scotland), 1975. Artist in Residence, Victoria College of Arts, Melbourne, Australia, 1983. Retrospective: *Paintings, Watercolours and Drawings*, Scottish National Gallery of Modern Art, Edinburgh and Serpentine Gallery, London, 1986. Lives in London.

At the RCA Bellany, who described himself as being 'surrounded by aesthetic scribbles', was something of an outsider. Carel Weight and Peter de Francia, however, lent him their wholehearted support. His work is powerfully expressionistic, a distinctive blend of autobiography and allusive symbolism (raw meat, dead fish and seabirds, often in a state of metamorphosis, are recurring motifs). A visit to East Germany in 1967, which included Buchenwald concentration camp, proved a crucial experience. Van Gogh, Ensor and Beckmann have been important influences. MB-D

John Bellany: Paintings, Watercolours and Drawings 1964–86, Scottish National Gallery of Modern Art Catalogue, Edinburgh, 1986.

182 *Bethel*, 1967 [p. 136]
Oil on hardboard, 248 × 319.7 cm
Southampton City Art Gallery

183 *Celtic Feast*, 1974 [p. 137]
Oil on hardboard, 193.5 × 343.7 cm
Sheffield City Art Galleries

Graham Ovenden b.1943
Student 1965–68

Southampton School of Art, 1960–64; RCA, 1965–68. One-man exhibitions: *Lolita Drawings and Prints 1972–75*, Waddington Galleries, London, 1975; *Ovenden Prints and Drawings*, Asard Gallery, Stockholm, 1977; photographs at Plymouth Arts Centre, 1981, and Olympus Gallery, London, 1984. Author of several books. Lives in Cornwall. Gallery: Piccadilly, London.

Ovenden has been one of the driving forces behind the 'Brotherhood of Ruralists', a group of painters founded in 1975. He has been described as 'a talented pupil of Peter Blake from the Royal College of Art', who did much to prompt Blake himself towards new interests. Nicholas Usherwood writes that Ovenden's landscapes 'in their lushness and suggestion of growth remain metaphors for the same, though more overt, eroticism of his figure compositions.' RMcD

Graham Ovenden, *Graham Ovenden*, Academy Editions, London, 1987.

184 *The Tor? Looking towards the Downs*, 1965
Oil on panel, 10 × 12.5 cm
James Sellars

185 *Peter and Juliette Blake*, 1976
Oil on canvas, 122 × 91.5 cm
Piccadilly Gallery, London

Brendan Neiland b.1941
Student 1966–69

Birmingham College of Art, 1962–66; RCA (Silver Medal), 1966–69. Arthur Tooth Prize, *Young Contemporaries* exhibition, 1969. John Moores Exhibition prize-winner, 1978. One-man exhibition, *Facades*, Fischer Fine Art, London, 1987. Lives in London. Gallery: Fischer Fine Art, London.

'Brendan Neiland is a painter of cityscapes with a difference,' wrote Marina Vaizey. 'He conveys the feeling of a city with true originality and insight. His city scenes are pure, they are unpeopled: social implications are indirect. His handling of continual reflections and refractions of light, always his primary subject, gives a sense of physical substance to these haunting and beautiful paintings.' Marina Vaizey said of Neiland's RCA work: 'It was clear that his paintings, which looked abstract at first glance, were not only representational . . . but also adopted certain preoccupations of Impressionism.' RMcD

Christine Lindsay, *Super Realist Painting and Sculpture*, Orbis Books, London, 1981.

186 *Blue Base*, 1969
Acrylic on canvas, 73.5 × 122 cm
Collection Robert Heller

187 *Towering Pillar*, 1987
Acrylic on canvas, 53.3 × 61 cm
Collection Banque Arab et Internationale d'Investissement, Paris.

Keith Milow b.1945
Student 1967–68

Camberwell, 1962–67; RCA, 1967–68. Experimental work, Royal Court Theatre, 1968. Artist in Residence, Leeds University (Gregory Fellowship), 1970. Harkness Fellowship, New York, 1972–74. Calouste Gulbenkian Foundation Visual Arts Award, 1976; First (equal) prize, Tolly Cobbold Eastern Arts, 1979; Arts Council Major Award, 1979. Lives in New York. Gallery: Nigel Greenwood, London.

Keith Milow uses two important symbols in his work—the cross and the cenotaph. Jasper Johns writes of Milow: 'His approach takes a certain distance, and at the same time that he is looking back to the past he is also telescoping that history into the present with references in his work. But these cenotaphs must not be read in a literal way as representing this or that. They are meant to be contemplated and felt through their subtlety and subtle references.' RMcD

Diane Waldman, *British Art Now*, Guggenheim Museum, New York, 1980.

188 *Siltschenko Grid*, 1967
Acrylic and oil on canvas, 172.7 × 213.4 cm
Nigel Greenwood Gallery, London

189 *For Friends*, 1986
Lead over wood, 84 × 35 × 31 cm
Nigel Greenwood Gallery, London

David Tindle b.1932

Tutor 1972–83

Coventry School of Art, 1945–47. Retrospective: Coventry City Art Gallery, 1957. Winner Johnson Wax Award, RA, 1983. Tutor, RCA, 1972–83. ARA, 1973; RA, 1979; Fellow, RCA, 1981. Featured in film, *A Feeling for Paint*, BBC TV, 1983. Ruskin Master, Ruskin School of Art, 1983. Lives in Leamington Spa. Gallery: Fischer Fine Art, London.

Marina Vaizey has written: 'David Tindle uses the most painstaking of techniques: egg tempera on canvas or board . . . Seemingly a realist, Tindle's realism is firmly located in the immediacy of his own surroundings, irradiated by personal emotion. Still life, interiors and landscape are his subjects: portraits, when they do appear, are dazzlingly immediate and full of feeling.' Tindle enjoyed working with Professor Peter de Francia at the RCA: 'I thought he was a fantastic teacher. The whole time I was there I felt I was learning as much as anybody else.' RMcD

Marina Vaizey, *David Tindle*, Fischer Fine Art, London, 1985.

190 *The Moth*, c.1980
Egg Tempera, 61 × 81.3 cm
Private Collection

Peter de Francia b.1921

Professor 1972–86

Academy of Brussels and Slade, 1938–40. Tutor, RCA (General Studies), 1961–69. Published *Fernand Léger—the Great Parade*, Cassell, 1969; *Fernand Léger*, Yale University Press, 1983. Principal of Fine Art Dept., Goldsmiths' College, 1970–72. Professor of Painting, RCA, 1972–86. Retrospectives: Camden Arts Centre, London, 1977 and 1987. Lives in London and France.

As a painter, de Francia is best known for his politically committed images of the 1950s (notably the monumental *Bombing of Sakiet* series). He has been more prolific as a draughtsman than as a painter: inspired above all by Picasso, Beckmann and Guttuso, his drawings comprise a powerful, often satirical, sometimes horrific, mythic human comedy. Described by Kitaj as 'a great and born teacher', he made strong intellectual demands on his students and proved a sometimes savage, but always constructive, critic. He was always especially generous to foreign students and was determined to avoid an over-elaborate bureaucracy. MB-D

Peter de Francia: Painter and Professor, Camden Arts Centre Catalogue, London, 1987.

191 *Monsieur et Madame Beylac*, 1974 [p. 56]
Oil on canvas, 170 × 152 cm
Arts Council of Great Britain

192 *Family in an Interior*, 1978
Oil on canvas, 136 × 152 cm
The Artist

Bernard Cohen b.1933

Tutor 1975–77

S.W. Essex School of Art, 1949–50; St Martin's, 1950–51; Slade, 1951–54. French Government Scholarship, 1954; Boise Scholarship for Travel (Madrid and Rome), 1956–57. Retrospective: Hayward Gallery, London, 1972. Tutor, RCA, 1975–77. Head of Painting, Wimbledon School of Art, 1980–87. Lives in London. Gallery: Waddington, London.

Allied with, but never fully part of, the British 'Pop' movement, Cohen's early work was influenced by Abstract Expressionism, and its simplified non-illusionistic forms. A fascination with pattern and ornament, both organic and man-made, was emphasized by the formal and systemized use of materials, particularly spray paint, in increasingly structured compositions. Recent painting has become even more complex, with immense attention to surface. Canvases are packed with imagery, bright colour and texture, detail upon detail brought together to suggest certain themes, often in the area of domesticity and the Jewish home. An influential and committed teacher. MP

Bernard Cohen, Arts Council Catalogue, London, 1972.

193 *Mask*, 1975–76
Acrylic on canvas, 91.5 × 91.5 cm
Arts Council of Great Britain

Alan Miller b.1941

Tutor 1974–Present

Bath Academy of Art, 1959–63; Slade, 1963–65. First one-man show, Serpentine Gallery, 1973. Tutor, RCA, 1974–present. Fellow, RCA, 1982. John Moores prizes, 1974, 1976. Retrospective: Ikon Gallery, Birmingham, Arts Council, 1984. Athena Art Awards Prizewinner, 1987. Lives in London.

Initially an abstract painter, Miller's large architectonic works have shifted over the last fifteen years from formal allusions to interior space to more personalized figurative imagery. Complex in composition and manipulation of space, monumental in scale, Miller's move into representation reveals a fertile, somewhat macabre imagination, with contorted organic forms battling against a threatening natural world. MP

Alan Miller, Ikon Gallery Catalogue, Birmingham, 1984.

194 *Gifts (for Ruby)*, 2nd version, 1985 [p. 58]
Oil on canvas, 182.9 × 152.4 cm
The Artist

190

193

197

198

John Golding b.1929
Tutor 1971–86

Educated in Mexico and Canada (University of Toronto); postgraduate, Courtauld Institute of Art, London, 1951–57. Doctoral thesis published as *Cubism 1907–14*, 1959. Taught at Courtauld Institute of Art, 1959–81; Tutor, RCA, 1971–86. One-man exhibitions: MOMA, Oxford, 1973; National Gallery of Modern Art, Edinburgh, 1977. Senior Tutor, RCA, 1981–86. Lives in London. Gallery: Mayor Rowan, London.

Golding's early work retained traces of figuration. Since the 1960s, however, his paintings, large but intimate, have belonged to the tradition of colour-field abstraction, his handling of paint and use of colour becoming increasingly lyrical. Golding described his work as 'basically reflective or contemplative'. As someone who has achieved equal distinction as a writer, lecturer and exhibition organizer, painter and teacher of painting, he is an unusual figure in the British art world. MB-D

John Golding, Paintings and Drawings, Kettle's Yard Catalogue, Cambridge, 1975.

195 *Splintered Light—Toledo Blue*, 1985 [p. 73]
Acrylic and mixed media on canvas, 152 × 208 cm
Mayor Rowan Gallery, London

John Walker b.1939
Tutor 1974–78

Birmingham College of Art, 1956–60; Academie de la Grande Chaumière, Paris, 1961–63. Represented Britain, Venice Biennale, 1972. Tutor, RCA, 1974–78. Moved to Australia, 1979; Dean, Victoria College of Arts, Melbourne, 1982. Major exhibition, Hayward Gallery, London, 1985. Lives in New York and Melbourne. Gallery: Nigel Greenwood, London.

From the mid-1960s until the late 1970s, Walker produced canvases that were abstract but spatially ambiguous, experimental in shape and in their manipulation of surface texture. Since then his work, while staying, in his own words, 'just this side of abstraction', has become increasingly illusionistic, allusive, and figurative in its references. These are often to his own earlier work, as well as to that of the Old Masters, notably Goya. His juxtapositions of forms and handling of paint are increasingly dramatic. Since living in Australia, his paintings have developed an obsession with primitive ritual in confrontation with Western culture. MB-D

John Walker, Paintings from the Alba and the Oceania Series, 1979–84, Arts Council Catalogue, London, 1985.

196 *The Shape and the Disgruntled Oxford Philosopher*, 1979–80 [p. 72]
Oil and acrylic on canvas, 211 × 184 cm
Whitworth Art Gallery, University of Manchester

Michael Thorpe b.1937
Tutor 1976–Present

St Martin's, 1957–61; RA Schools, 1961–64. Abbey Minor Scholarship, 1963; Leverhulme Prize, 1964; Boise Travelling Scholarship, 1964; Italian Government scholarship, 1965; Winston Churchill Fellowship (USA), 1967–86. Tutor, RCA, 1976–present. Fellow, RCA, 1980. Governor of London Institute of Art and Design. Lives in London.

Thorpe began teaching at the RCA at the start of Peter de Francia's time as painting Professor. 'There was a vital change of direction during that time,' he says, 'and it was exciting to be part of it throughout the time of Peter's involvement. There was a new emphasis on intelligent questioning— on examining young artists' motivations so that they were enabled to progress by becoming more self-aware.' Of his recent works, he says: 'Though still predominantly conceptual and formalist, they mark the re-emergence of figuration and "subject-matter" in my work after fifteen years of other concerns.' RMcD

197 *Modern Times I*, 1982–83
Acrylic and oil on canvas, 76 × 38 cm
The Artist

Howard Hodgkin b.1932
Tutor 1975–76

Camberwell, 1949–50; Bath Academy of Art, Corsham, 1950–54. Tutor, RCA, 1975–76. CBE, 1977. Represented Britain, Venice Biennale, 1984. Retrospective: Whitechapel Art Gallery, London, 1985. Turner Prize, 1985; first prize, Bradford Print Biennale, 1986. Trustee of Tate Gallery, 1970–76; Trustee of National Gallery. Lives in London and Bath.

Since the 1950s, Hodgkin has evolved a style of painting and print-making which may at first seem abstract, but which is in fact inspired by real-life events—most often an encounter between the artist and people close to him, frequently in an interior containing works of art. The lushness and jewel-like brilliance of his colours and his strong emphasis on pattern-making reveal his long-standing admiration for Indian miniatures and the paintings of Matisse. MB-D

Howard Hodgkin, Whitechapel Art Gallery Catalogue, London, 1985.

198 *A Henry Moore at the Bottom of the Garden*, 1975–77
Oil on canvas, 102.9 × 102.9 cm
Saatchi Collection, London

Wynn Jones b.1939
Tutor 1985–86

Cardiff College of Art, 1957–62.
Jubilee Fellow, Byam Shaw School,
1963. First one-man exhibition,
University of Wales, 1974. Tutor,
RCA, 1985–86. Lives in London.

In a world dogged by catastrophe,
Wynn Jones depicts the fragile human
condition, sparing the spectator none
of its horrors or absurdities. Culling
from sources as diverse as comic strips,
Beckett and Kabuki, the artists
Beckmann, Picasso and Guston,
Jones's densely constructed images
offer layer upon layer of meaning.
Heavily painted, often veiled in a grey
Celtic mist, the fragmented, distorted,
sometimes shrouded figures, assorted
consumer detritus and shallow space
suggest the nightmare vision of a post-
nuclear age. A committed and
influential teacher, Jones has taught at
the Byam Shaw School for the last
twenty-five years, as Senior Tutor
since 1980.　MP

Artspace, Catalogue, Aberdeen, 1983.

199 *The Hunting Party*, 1986–87
Oil on canvas, 165 × 190.5 cm
The Artist

Mario Dubsky 1939–85
Tutor 1981–85

Slade, 1956–61; Abbey Major
Scholarship to British School, Rome,
1963–65; Harkness Fellowship, New
York, 1969–71; Artist in residence,
British School, Rome, 1982.
Retrospective: South London Art
Gallery, 1984. Tutor, RCA, 1981–85.

Dubsky's earliest works were
figurative, and unashamedly
emotional, reflecting an obsession with
the Holocaust. His work of the 1960s
and early 1970s, although apparently
abstract, retained an underlying
figurative concern, increasingly bound
up with an acknowledgement of the
artist's homosexuality. Although he is
probably best known for the
powerfully disturbing drawings of
male nudes he started producing in
the later 1970s, he also created
paintings of great intensity and
complexity, linking past and present,
paganism and Christianity, myth and
reality in what was essentially a tragic
vision of the world.　MB-D

*Mario Dubsky: Paintings & Drawings
1973–84*, South London Art Gallery
Catalogue, 1984.

200 *In the Circle of Smoke and Fire*, 1984
Oil on canvas, 203.2 × 203.2 cm
Estate of the Artist

Chris Fisher b.1950
Student 1971–74 Tutor 1976 Present

Winchester School of Art, 1967; St
Martin's, 1967–70; RCA, 1971–74.
Abbey Major Travelling Scholarship,
John Minton Award, Anstruther
Award, 1973. Tutor, RCA,
1976–present. Lives in London.

Fisher now teaches both painting and
tapestry students, and works
unconventionally in tapestry. He
writes: 'A work of art is not made by
increasing skill and virtuosity, and
there can be little personal satisfaction
in repeating oneself. Changes are
inevitable, and because the work is
always in advance of its
understanding, disappointment and
uncertainty are inescapable parts of its
true making.'　RMcD

201 *Mixed Media Composition*, 1974
Wood and paint, 122 × 122 cm
RCA Collection

202 *Jonathan and Anna playing Blind Man*,
1987
Tempera and oil on canvas, 71.1 × 60.9 cm
The Artist

Stephen Farthing b.1950
Student 1973–76 Tutor 1978–85

St Martin's, 1968–73; RCA, 1973–76;
British School at Rome, 1976–77;
Visiting Lecturer, RCA, 1978–85;
Head of Painting, West Surrey
College of Art and Design, Farnham,
1985. Touring retrospective: MOMA,
Oxford, 1987. Lives in Surrey.
Gallery: Edward Totah, London.

In their appropriation both of Old
Master images and everyday objects,
Farthing's student works reveal a debt
to Pop Art. Although his work
matured in the mid-1970s, at a time
when painting itself was distinctly
unfashionable, he has remained a
figurative painter throughout.
Virtually all his paintings are a direct
response to the different environments
in which he has lived: in some,
architectural motifs predominate; in
others, items of furniture take on a
slightly sinister, anthropomorphic life
of their own. His most recent canvases
depict a rural environment threatened
by militarism. Apparently naturalistic
in style, his paintings are in fact full of
spatial, and psychological,
ambiguities.　MB-D

Stephen Farthing: Mute Accomplices, Museum
of Modern Art Catalogue, Oxford, 1987.

203 *Flat Pack, Rothmans*, 1975 [p. 138]
Screenprint and acrylic on canvas,
213.3 × 109.2 cm
RCA Collection

204 *Siberian Crows*, 1987 [p. 139]
Oil on canvas, 175 × 207 cm
Edward Totah Gallery, London

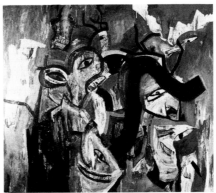

199

200

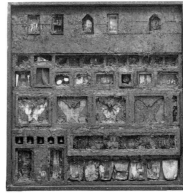

201　　　　　　　　　202

205

206

207

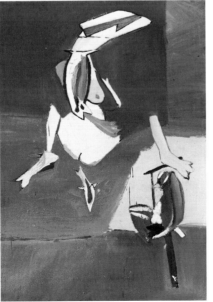

211

Lucy MacKenzie b.1952
Student 1973–76

Bristol Polytechnic, 1970–73; RCA, 1973–76. Commissioned by RCA to paint Silver Jubilee gift to H.M. The Queen, 1976. Fellowship, Gloucestershire College of Art, 1976–77. One-woman exhibitions: Fischer Fine Art, London, 1979; Coe Kerr Gallery, New York, 1986. Lives in Gloucestershire. Gallery: Fischer Fine Art, London.

Writing in *ART news* in January 1980, Maria Vaizey commented: 'Lucy MacKenzie employs meticulous, small, immaculate, hypnotically "realistic" imagery that first drew attention to her work in the final-year student show at the Royal College of Art in 1976. The objects of her attention are mundane and are transformed by the intensity and affection of her gaze. The miniature scale is very appealing, as is the unexpected, gentle, delicate, even wry, humour.' RMcD

205 *Tulips*, 1976
Oil on board, 10.1 × 12.7 cm
The Artist/Fischer Fine Art, London

206 *Decoy and Picnic Hamper*, 1985
Oil on board, 23 × 18.5 cm
Private Collection

Andrzej Jackowski b.1947
Student 1974–77 Tutor 1985-Present

Falmouth School of Art, 1957-69, 1972–73; RCA, 1974–77. *Eleven 32* magazine published with David Drain, RCA, 1976 and 1977. Abbey Minor Travelling Scholarship, 1976; Rodney Burn Award, John Minton Scholarship, 1977; Artist-in-Residence, University of Surrey, 1978–79. Prizewinner, Tolly Cobbold Eastern Arts, 1981. Major exhibition, Marlborough Fine Art, London, 1986. Lives in Brighton. Gallery: Marlborough Fine Art, London.

An artist following the legacy of Beckmann, Redon and Carra, Jackowski creates a metaphysical world of alluring beauty and haunting terror. Characterized by dark but luminous thinly-painted surfaces, the loosely-painted figurative images refer to an intensely personal and rich iconography. The internal and external worlds of the artist are inextricably linked. Memories of the wooden huts of the refugee camp or the sea of the Cornish coast are fused with cultural sources such as the films of Tarkovsky, the poetry of Rilke, the sexuality of Balthus, to create powerful and enduring images. MP

Andrzej Jackowski, Oil Paintings, Marlborough Fine Art Catalogue, London, 1986.

207 *The Marriage*, 1976
Oil on canvas, 122 × 122 cm
The Artist/Marlborough Fine Art (London) Ltd.

208 *Earth Stepper with Running Hare*, 1987 [p. 60]
Oil on canvas, 152.5 × 233.5 cm
Marlborough Fine Art (London) Ltd.

Michael Heindorff b.1949
Student 1975–77 Tutor 1980-Present

Art College and University of Braunschweig, 1970–74; RCA, 1975–77. German National Scholarsip, 1972–76; DAAD Scholarship for London, 1976–77; John Moores Liverpool 10 Award, 1976. Tutor, RCA, 1980-present. Schmidt-Rottluff Prize; Villa Massimo, Rome, Prize, 1981. Retrospective: *Works 77–87*, Northern Centre for Contemporary Arts, 1987. Lives in London. Gallery: Bernard Jacobson, London and New York.

Highly thought of in Europe and America, Heindorff is an artist of exceptional versatility, moving easily between styles and mediums, searching for imagery which reflects a strong sense of place and history. A consummate print-maker, he has experimented widely with little known carborundum etching and drypoint processes as well as with established techniques such as silkscreen. His gradual shift away from strongly figurative imagery to a form of semi-abstraction has been accompanied by increasing experimentation, including ceramics and oils on copper. MP

Michael Heindorff, Mathildenhöhe Catalogue, Darmstadt, Germany, 1983.

209 *15 Deckchairs; a Fragment Contra Repetition*, 1976 [p. 140]
Tempera on board, each 34 × 23 cm
Bernard Jacobson Gallery, London and New York

210 *Cave Dance*, 1987 [p. 140]
Oil on paper on canvas, 78.7 × 144.8 cm
Bernard Jacobson Gallery, London and New York

Eileen Cooper b.1953
Student 1974–77

Goldsmiths' College, 1971–74; RCA, 1974–77. One-woman exhibitions: Blond Fine Art, London, 1982, 83, 85; AIR Gallery, London, 1979. Lives in London. Gallery: Benjamin Rhodes, London.

Working in the mainstream of contemporary figurative painting, and strongly influenced by Gauguin, German Expressionism and British artists such as Ken Kiff and Victor Willing, Cooper deals primarily with female experience. Her bold and expressive drawings suggest both tenderness and humour, whilst the large paintings, with their loosely handled use of luscious colour, are almost primitive in their spirit of celebration. MP

Eileen Cooper, Benjamin Rhodes Gallery Catalogue, London, 1988.

211 *A State of Change*, 1976
Oil on canvas, 106.5 × 76.5 cm
The Artist

212 *Taking Root and Falling Leaves*, 1984–85 [p. 59]
Oil on canvas, 212.1 × 151.8 cm
The Artist/Benjamin Rhodes Gallery, London

James Mooney b.1955
Student 1978 81

Edinburgh College of Art, 1973–78; RCA, 1978–81. British School at Rome, 1981–83. Rome Scholarship, 1981; Escuela Campo Alegre, Caracas, Venezuela, Travel Scholarship, 1986; Oppenheim John Downs Memorial Award, 1986. First one-man exhibition, Edinburgh College of Art, 1981. Lives in Edinburgh and London.

Coming from a close mining community in Central Scotland, Mooney, a committed Socialist, consistently aims to effect a synthesis between emblematic public themes and personal narrative. His large, rather austere figurative images made at the RCA were strongly influenced by Cubism, the work of Léger and Picasso. On moving to Rome, more associational and symbolic imagery emerged, drawing heavily on sources such as Baudelaire, Benjamin and Rousseau's *Reveries of a Solitary Walker*. A period in Venezuela, and exposure to pre-Columbian Art and contemporary South American culture, led to the use of images which are increasingly expressive and non-didactic. MP

213 *Invisible Cities*, 1987 [p. 61]
Oil and wax on canvas, 213.3 × 411.3 cm
The Artist

Lucy Jones b.1955
Student 1979–82

Byam Shaw School of Art, 1975–77; Camberwell, 1977–79; RCA, 1979–82; British School at Rome, 1982–84. Exhibition, Angela Flowers Gallery, London, 1987. Lives in London. Gallery: Angela Flowers, London.

An artist who has faced particular challenges, Jones's work is characterized by immense strength and boldness, tempered in her portrait work by an acute sensitivity and insight into her subject-matter. Obsessively interested in urban landscape, particularly a specific area around Waterloo Bridge in her native London, Jones continually re-examines her subject-matter, with a highly individual use of Fauve colour and heavy expressive brushwork. The compositions, often monumental in scale, are bold and simplified, with the use of deep space and shadow exaggerated by the vivid colour. MP

214 *Three Trees South Bank*, 1987
Oil on canvas, 175 × 213 cm
Angela Flowers Gallery, London

Denzil Forrester b.1956
Student 1980–83

Central School of Art and Design, London, 1975–79; RCA, 1980–83. Rome Scholarship, 1983; British School at Rome, 1983–85; Harkness Fellowship to USA, 1986–88. One-man exhibitions: Riverside Studios, London, 1983; Commonwealth Institute, London, 1986. Lives in New York.

Brought up in Grenada until the age of eleven in a profoundly religious family, Forrester's move to London in the late 'sixties laid the foundations for his exciting synthesis of European and West Indian culture. Impressed by images of Renaissance religious art which adorned Grenadian homes, his interests in religion extended to Rastafarianism and all aspects of black spiritual and cultural life. Reminiscent of German Expressionism, particularly the work of Kirchner, Forrester's monumental paintings, with their heavy use of shadow, brilliant colour and often coarse drawing, are pervaded by an atmosphere of rhythm and ritual. MP

215 *Untitled*, 1983 [p. 63]
Oil on canvas, 240 × 195.5 cm
RCA Collection

Thérèse Oulton b.1953
Student 1980–83

St Martin's, 1976–79; RCA, 1980–83. Bose Scholarship, 1983. Exhibited in *Britain in Vienna, British Art 1986*, Kunstlerhaus, Vienna, 1986, organized by Contemporary Art Society, London, 1986; one-woman exhibition, Marlborough Fine Art, London, 1988. Lives in London. Gallery: Marlborough Fine Art, London.

Oulton's paintings first came into the public eye at the RCA Diploma Show of 1983; since then she has exhibited widely both in Britain and abroad. Her work is characterized by a lushly impastoed surface (greens, blues and gold dominate) and monumental scale; her imagery hovers tantalizingly between the figurative and the abstract. Turner, John Martin and late Monet are often cited as important influences; the Romantic landscape tradition, with strong mystical overtones, is frequently invoked in connection with her work. MB-D

Thérèse Oulton: Fool's Gold: New Paintings, Gimpel Fils Gallery Catalogue, London, 1984.

216 *Pearl One*, 1987 [p. 62]
Oil on canvas, 238.8 × 213.4 cm
Marlborough Fine Art (London) Ltd.

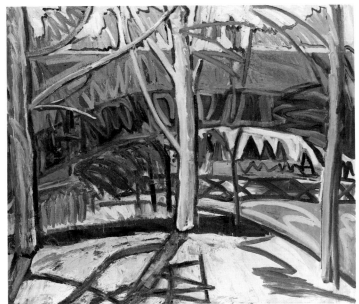
214

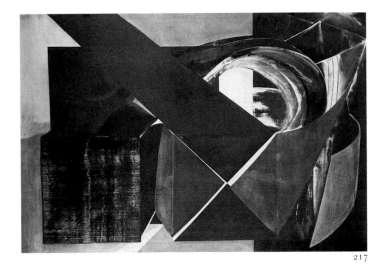

217

218

219

Chris Baker b.1944
Student 1975–78

Camberwell, 1971–75; RCA,
1975–78. Lubiam Award, Mantova,
Italy, 1977. One-man exhibition:
Warwick Arts Trust, 1982–83. Lives
in London. Gallery: Paton, London.

Baker's late apprenticeship as an art
student was preceded by a tough,
South London boyhood and ten years
as a motor mechanic—experiences
which continue to dominate his work.
The cold, harsh world of the city, the
sensations of stone, metal and glass are
imaginatively transformed by means
of reduction and abstraction into
carefully constructed images, in which
the slow process of making is crucial to
the final image. The colour is cool and
detached, the surfaces often rough and
impasto, the shapes reflective of
architectural New Brutalism, rather
than Post-Modernism. An artist out of
step with the prevailing humanistic
ethos of the eighties. MP

Chris Baker, Warwick Arts Trust Catalogue,
London, 1983.

217 *Untitled*, 1978
Acrylic on canvas, 182.9 × 274.3 cm
RCA Collection

Jake Tilson b.1958
Student 1980–83

Chelsea, 1976–79; RCA, 1980–83.
Exhibitions: Paris Biennale, 1983;
Nigel Greenwood Gallery, London,
1986; *New Forms in Visual Poetry*,
Guggenheim Museum, New York,
1988. Publisher, *Atlas* magazine. Lives
in London. Gallery: Nigel
Greenwood, London.

Inspired by the example of Kurt
Schwitters and Joe Tilson, his Pop
artist father, Jake Tilson creates
assemblages out of urban debris,
which he endows with strongly
personal narrative implications. He is
equally active, however, as a producer
of 'little magazines' and artists' books,
rendered distinctive by his inventive
use of a colour photocopier. Although
he started producing these while still
at school, the arts magazine *Cipher*,
which he edited at the RCA, marked
his real debut in this field. He also
works as a graphic designer, and
clothes designer. MB-D

218 *El Misterio de la Habitación Numero 5
1986*, 1986
Diorama, mixed media; 236 × 136 × 71 cm
Private Collection

Anthony Green b.1939
Visiting Tutor c.1965–Present

Slade, 1956–60. French Government
Scholarship to Paris, 1960. First one-
man exhibition, Rowan Gallery,
London, 1962. Fellowship to USA,
1967–69. ARA, 1971; RA, 1977.
Tutor, RCA, c.1965–present.
Retrospectives: RA, 1978; touring,
Japan, 1987–88. Lives in London.
Gallery: Mayor Rowan, London.

Green's paintings since the 1960s have
been characterized by large scale and
a wealth of detail, a flattening of
perspective, discrepancies in scale and
(more recently) the use of irregularly-
shaped supports, so as to create (in his
own words) 'a very concentrated
image . . . a total little world'. His
work is mainly inspired by his wife,
Mary, and memories of people and
places close to him; implicitly
anecdotal and confessional, wittily
exaggerated in both form and colour,
it possesses a distinctly surreal,
hallucinatory quality. MB-D

Anthony Green, *A Green Part of the World*,
Thames and Hudson, London, 1984.

219 *Young Man with Grenadier*, 1983
Oil on board, 199.5 × 171.5 cm
Mayor Rowan Gallery, London

Stephen Buckley b.1944
Visiting Tutor 1976 and 1986

University of Newcastle-upon-Tyne,
1962–67; University of Reading
(MFA), 1967–69. Visiting Tutor,
RCA, 1976 and 1986. Prizewinner,
Northern *Young Contemporaries*, 1968;
John Moores, 1974 and 1985;
Chichester National Art Exhibition,
1975; Tolly Cobbold, 1977.
Retrospective: MOMA, Oxford,
1989. Lives in London. Gallery:
Knoedler, London.

Buckley's unwavering commitment to
the physicality of the art object made
him an influential figure in a mid-
1970s British art world, dominated by
Minimalism and Conceptualism.
Influenced by Dada and Pop Art, he
has always worked with a wide variety
of unorthodox, 'non-art' materials and
techniques, the artifice of which he
openly acknowledges. Although his
forms appear abstract, they often
suggest objects or patterns (tartans,
crazy paving, etc.) from the everyday
environment; his titles, too, tend to be
allusive. MB-D

Stephen Buckley: Many Angles, Museum of
Modern Art Catalogue, Oxford, 1985.

220 *Splash 2*, 1975–77 [p. 75]
Oil on canvas, 122 × 122 cm
J. Kasmin Collection

Paul Huxley b.1938
Tutor 1976–86 Professor 1986–Present

Harrow School of Art, 1951–56; RA Schools, 1956–60. Prizewinner, *The New Generation*, Whitechapel Art Gallery, London, 1964; Harkness Fellowship, 1965; Prizewinner, Paris Biennale, 1965; Sao Paulo Biennal, 1975. Trustee, Tate Gallery, 1975–82. Tutor, RCA, 1976–86. Designed tilework for London Transport's Kings Cross Station, 1984–87. First prize, Athena Award, 1985. Professor, RCA, 1986–present. ARA, 1987. Lives in London. Gallery: Mayor Rowan, London.

In the early 1960s, Huxley's fluid, serpentine forms influenced much of the painting and sculpture of the period. Later his forms became more geometric and concerned with internal dialogues. Always a believer that abstract painting can be the vehicle for ideas and the expression of human values, he has developed this theme in his more recent divided and self-mirroring canvases. John Spurling writes: 'Huxley is a painter in the grand manner. His large paintings radiate classical calm and perform stately dances of geometrical proportion on a luminious, other-wordly ground. Although they are highly organized paintings, the richness of colour and tone always outweighs the austere shapes, so that the effect is lyrical and liberating rather than mathematically constricting.' MR

Masterpieces of the Avant-garde: Three decades of Contemporary Art, Juda Rowan Gallery Catalogue, London, 1985.

221 *The Studio II*, 1979–80
Acrylic on canvas, 213.5 × 213.5 cm
Mayor Rowan Gallery, London

222 *Surrogate*, 1982 [p. 71]
Acrylic on canvas, 195.5 × 195.5 cm
The Artist/Mayor Rowan Gallery, London

Yehuda Safran b.1944
Student 1971–73 Tutor 1976–Present

St Martin's, 1969–71; RCA, 1971–73. Tutor, RCA, 1976–present. Trustee and consultant 9H Gallery, London, 1986; regular contributor to *9H* magazine. Lives in London.

Safran's early experience was in stage design, as resident designer at Alborg in Denmark (1966–67) and then in Israel (1968–69). A period of art training was followed by several appointments as art tutor and lecturer in both Britain and his native Israel. Recently his interest has moved towards architecture, particularly that of Adolf Loos, whose touring exhibition Safran recently organized for the Arts Council of Great Britain. A highly regarded lecturer and theoretician. MR

223 *Hommage à Adolf Loos*, 1985–86
Oak, glass and silver, 99 × 241 × 241 cm
The Artist

Ken Kiff b.1935
Tutor 1979–Present

Hornsey School of Art, 1955–61; Tutor, RCA, 1979–present. Illustrated *Folk Tales of the British Isles*, ed. M. Foss, Macmillan, 1977. Retrospective: Serpentine Gallery, London, 1986. Lives in London. Gallery: Fischer Fine Art, London.

Kiff's earliest works were essays in formal abstraction. Starting to paint 'fantasy' pictures in his mid-twenties, Jungian psychotherapy enabled him to feel at ease with the world of his imagination and to avoid definitive interpretations. The lushly-painted, earthy, seemingly naïve, often frightening and occasionally lyrical images inspired by myth and fairy tales that he has produced since the mid-1960s have greatly influenced the recent generation of figurative painters. MB-D

Ken Kiff: Paintings 1965–85, Arts Council Catalogue, London, 1986.

224 *Talking to a Psychoanalyst: Night Sky no. 13*, 1973–79 [p. 57]
Acrylic on canvas, 81 × 137 cm
Private Collection

Jennifer Durrant b.1942
Tutor 1979–Present

Brighton College of Art, 1959–63; Slade, 1963–66. Rome Abbey Minor travelling scholarship, 1965. Tutor, RCA, 1979–present. Retrospective: Serpentine Gallery, London, 1987. Lives in London.

Although Durrant's paintings of the mid-1970s are clearly indebted to American colour-field painting and the ideas of Clement Greenberg, the preference for organic forms, the tendency to lyricism and intimacy in spite of their large size are Durrant's own. In 1978 her forms became more allusive, poetically suggestive of natural phenomena; the early 1980s saw the beginnings of a greater textural variety and a richer, more resonant use of colour, while her most recent canvases achieve a new spatial and iconographic complexity. Like all her mature work, they exploit the fruitful ambiguity of forms that are neither literal nor completely abstract. MB-D

Jennifer Durrant, Arts Council Catalogue, London, 1987.

225 *Little Deaths Series—Descent*, 1985 [p. 70]
Acrylic and metallic paint on canvas, 260 × 278 cm
The Artist

221

223

227

228

229

Gillian Ayres b.1930
Tutor 1986–Present

Camberwell, 1946–50. ARA, 1982. Major exhibitions: MOMA, Oxford, 1981; Serpentine Gallery, London, 1983. Tutor, RCA, 1986–present. Lives in Wales. Gallery: Knoedler, London.

Substantially influenced by the scale and energy of American Abstract Expressionism, Ayres emerged in the late 1950s as an ambitious and highly original abstract painter, sympathetic, but never allied, to either the St Ives Group or the emerging 'Hard Edge' abstractionists. Her monumental canvases, choked with layer upon layer of oil paint, are characterized by vibrant colour and pulsating rhythms. Organic shapes and groups of small marks suggest references to nature (perhaps a reflection of her recent move to Wales); more recently, an enclosing band hints at an interior space or a view through a window. A stubborn individualist and highly regarded teacher, Ayres has been a profound influence on a whole generation of abstract painters, most notably the 'Stockwell Group'. MP

Gillian Ayres, Arts Council Catalogue, London, 1983.

226 *Wells*, 1982 [p. 74]
Oil on canvas, 213.4 cm (diam.)
Knoedler Kasmin Ltd., London

Paula Rego b.1935
Tutor 1986–Present

Slade, 1952–56. One-woman exhibitions: Sociedade Nacional de Belas-Artes, Lisbon, 1965; Edward Totah Gallery, London, 1982. Married to artist Victor Willing. Tutor, RCA, 1986–present. Lives in London. Gallery: Marlborough Fine Art, London.

Rego's obsession with popular culture—folklore, fairy tales, caricature and operatic narratives—derives largely from childhood experiences. Dubuffet's work, which she first encountered in 1959, lent artistic credibility to these interests. Much of her work took the form of collage. The large, brightly coloured paintings she has produced since 1981, and which have won her considerable public acclaim, capture the often nightmarish world of the female child with wit and sophistication. MB-D

Paula Rego, Paintings 1984–1985, Edward Totah Gallery Catalogue, London, 1985.

227 *Prey*, 1986
Acrylic on paper, mounted on canvas, 150 × 150 cm
Marlborough Fine Art (London) Ltd.

Francis Bacon b.1909

Worked in London as furniture designer and interior decorator, 1925–44. No formal art training. Visiting artist, RCA, c.1950–51 and c.1968. Represented Britain, Venice Biennale, 1954. Retrospectives: Guggenheim, New York, 1963–64; Grand Palais, Paris, 1983; Tate Gallery, London, 1962 and 1985. Lives in London. Gallery: Marlborough Fine Art, London.

Bacon first came into the public eye with his 1944 triptych, 'Three Studies for *Figures at the Base of a Crucifixion*'. Shock on the part of the critics and public was followed in the mid-1950s by acceptance and acclaim. His subject is the human condition, vulnerable and alienated; his sources of inspiration include Velasquez, Van Gogh, the photographs of Muybridge and a film still from Eisenstein's *Battleship Potemkin*. Portraits of his friends and himself have been an obsession, and he says of them: 'If they were not my friends I could not do such violence to them.' MB-D

David Sylvester, *Interviews with Francis Bacon*, Thames and Hudson, London, 1975.

228 *Study for the Human Body. Man Turning on the Light*, 1973–74
Oil and acrylic on canvas, 198 × 147.4 cm
RCA Collection

Matta b.1911

Full name: Roberto Sebastian Matta Echaurren. Studied architecture, Catholic University, Santiago, 1929–31. Lived in New York 1939–48; then Italy, France and England. Major exhibition, Arts Council, London, 1977. Visiting artist, RCA, c.1975–80. Lives in Paris.

One of Surrealism's main practitioners of pictorial automatism, Matta's early 'Psychological Morphologies' or 'Inscapes' sought calligraphically and allusively to depict states of mind (despair, anguish, desire). The early 1940s, during which time he exercised a crucial influence on the emerging American Abstract Expressionists, saw an increasing concern with forces of a cosmic nature. In the later 1940s, he introduced more explicitly figurative elements, organic and mechanistic, to express the anxiety of technological Man. His work of the 1950s tends to a greater lyricism; that of the 1960s is more political in its orientation. Matta's preoccupation with the cosmic and apocalyptic continues to the present day. MB-D

Matta, A Totemic World: Paintings, Drawings, Sculpture, Andrew Crispo Gallery Catalogue, New York, 1975.

229 *Touche Cœur*, 1977
Acrylic on canvas, 72.5 × 65 cm
Private Collection

LIST OF LENDERS

Banque Arab et Internationale d'Investissement, Paris 187
Jo Barry 125
Rosalind Bliss 26, 27
Jacqueline and Gilbert de Botton 162
City of Bristol Art Gallery and Museum 2
Elizabeth Bulkeley 64, 65
Bury Art Gallery and Museum 20
Carlisle Museums and Art Gallery 9, 12, 47, 56, 91, 123
Robert Heller 186
Katharine Horton 17
J. Kasmin 220
Eva Kolouchova 34
Leeds City Art Galleries 51, 140, 149

London:
Angela Flowers Gallery 75, 165, 175, 214
Annely Juda Fine Art 44, 46, 101, 138
The Arts Council of Great Britain 21, 100, 143, 151, 168, 179, 191, 193
Benjamin Rhodes Gallery 212
Bernard Jacobson Gallery 209, 210
The British Council 5, 60, 61, 73, 103, 136
Mario Dubsky Estate 200
Courtauld Institute Galleries, London (Fry Collection) 3
Edward Totah Gallery 164, 204
Merlyn Evans Estate 50, 52
Brian Fielding Estate 130
Fischer Fine Art 205
Gillian Jason Gallery 14,16
The Trustees of the Imperial War Museum 48
James Kirkman 37
Knoedler Kasmin Ltd. 135, 226
Marlborough Fine Art (London) Ltd. 39, 158, 180, 181, 207, 208, 216, 227
Mayor Gallery 50, 52, 87, 135
Mayor Rowan Gallery 104, 195, 219, 221, 222
The National Portrait Gallery 57
Nigel Greenwood Gallery 188, 189
Peter Nahum Gallery 41
Piccadilly Gallery 185
The Royal Academy of Arts 66, 67, 94, 117
Saatchi Collection 105, 106, 107, 116, 132, 133, 159, 173, 198
The Trustees of the Tate Gallery 6, 7, 62, 128, 161
Waddington Galleries Ltd. 1, 37, 98, 99, 156, 172
Waddington Graphics Ltd. 177

Manchester City Art Galleries 4, 11, 28, 42, 49, 72, 119
University of Manchester, Whitworth Art Gallery 196
John and Paul Martin 43, 45
Newcastle-upon-Tyne, Laing Art Gallery (Tyne and Wear Museums Service) 15, 29, 58
Norfolk Contemporary Art Society 155
Norfolk Museums Service, Norwich Castle Museum 82, 124
Ceri Richards Estate 30, 31, 32
Salford Art Gallery 13
James Sellars 184
Nathalie and Christopher Sharpe 74
Sheffield City Art Galleries 8, 18, 81, 90, 92, 183
Southampton City Art Gallery 93, 182
John Tunnard Estate 14,16
Sir Hugh Wontner GBE, CVO 71

Sir Richard Attenborough
Peter Cochrane
Mr and Mrs Paul Dufrien
Mr and Mrs William Govett
Marianne Haile
Mrs D. Hainsworth
Roger Lubbock
Sir John Mills
Peggy O'Sheel
Joe Tilson
Brita and Ed Wolf

and lenders who prefer to remain anonymous

ACKNOWLEDGEMENTS

Judy Adam
Fred Allen
Peter Allen
Carol Anderson
The Arts Council of Great Britain
Charlotte Barrett
Jo Barry
Edward Bawden
Derek Birdsall
Ingrid Bleichroeder
Rosalind Bliss
The British Council
Robert Buhler
Elizabeth Bulkeley
Cavan Butler
Robert Callcut
Staff of Carlisle Art Gallery
Jacqueline Cartwright
Ginette Casey
Richard Chapman
Joyce Chivers
Kelly Clark
Peter Cochrane
Anne Compton
Jimmy Connell
The Contemporary Art Society
Veronica Copland
Robert Cumming
Roy Deller
Robyn Denny
John Earl Drax
Joanna Drew
Edinburgh College of Art
Edward Totah Gallery
Nick Edwards
Robert Epps
Julia Ernst
Marjorie Evans
Francis Farmar
Fischer Fine Art
Matthew Flowers
Nigel Frank
Stephanie Frew
Anne Geare
Sid Gill
Theresa Gleadow
Mel and Rhiannon Gooding
Harry Greenaway
Alex Gregory-Hood
Pamela Griffin
Lisa Guild
Eva Guttentag
Marianne Haile
Ron Hart
Katharine Horton
Howard Hussey
Sally Jarman
Jenny Jenkins

Isobel Johnstone
Allen Jones
Annely and David Juda
Peter Kennard
James Kirkman
Rosa Lee
The Lefevre Gallery
Doreen Lewisohn
George Liddell
Lillian Lindblom
Alan Linn
Angela McFarlane
Stan McKenzie
Nick MacRae
Tricia Margolin
Marlborough Fine Art Ltd.
Paul Martin
Rees Martin
Mayor Gallery
Mayor Rowan Gallery
Alan Miller
Sophie Miller
Jim Moyes
John Murphy
Andrew Murray
Peter Nahum
Chris Neale
Arabella Patrick
Gillian Patterson
Gail Pearce
Kate Phillips
Vivien Richmond
Lucy Ross
Staff of RCA Library
Yolande Royer
Isabel Ryan
Richard Savage
Nicola Shane
Sarah Shott
Petronilla Silver
Richard Smith
Steve Smith
Victor Solanki
Jeffrey Solomons
John Stolworthy
Tony Sutcliffe
Frank Thurston
Joe Tilson
Barbara Treganowan
James Trimble
Peter Tunnard
Marie Valsamidi
Waddington Galleries Ltd.
Muriel Walker
Steve Webber
Carel Weight
Lynne Willis
Bill Wood

PHOTOGRAPHIC ACKNOWLEDGEMENTS

Photographs have been kindly supplied by lenders or galleries as listed in the catalogue section of this book. Acknowledgements are also due as follows:

Susie Allen pp. 8, 15
Anthony d'Offay Gallery Cat. no. 19
BBC Hulton Picture Library p. 12
Beedle and Cooper Cat. no. 190
British Crown Copyright Reserved Cat. nos. 5, 60, 61, 73, 103, 136
Ronald E. Brown Cat. no. 36
Robert Buhler pp. 13, 14
A.C. Cooper Cat. nos. 166, 167
Prudence Cuming Associates Ltd. Cat. nos. 1, 37, 39, 99, 158, 162, 172, 177, 187, 207, 208, 214, 220
The Fine Art Society Cat. no. 121
David Godbold Cat. no. 226
Derrick Greaves Cat. no. 82
Clive Hicks Cat. no. 40
Dorothy Latham Cat. no. 72
Gotz Linzenmeier Cat. no. 223
Marco Livingstone Cat. nos. 98, 127, 164, 167
Nick MacRae Cat. nos. 38, 64, 65, 131
John McGregor (Edinburgh College of Art) Cat. no. 213
Charles Mahoney p. 11
The Medici Society Ltd. Cat. no. 27
James Mortimer Cat. no. 115
Anthony Oliver Cat. nos. 110, 111
Piccadilly Gallery Cat. no. 190
Tim Platt Cat. no. 70
Royal Academy of Arts Cat. no. 77
Sotheby's Contemporary Art Cat. no. 154
Phillippa Stjernsward Cat. no. 130
Frank Thurston Cat. nos. 10, 14, 16, 17, 22, 23, 24, 33, 35, 43, 45, 53, 54, 55, 56, 59, 63, 70, 71, 76, 78, 79, 80, 85, 89, 102, 112, 113, 120, 121, 122, 126, 129, 134, 137, 144, 146, 148, 157, 163, 169, 171, 174, 176, 178, 201, 203, 205, 211, 217, 222, 224, and all paintings in RCA Collection
John Webb Cat. nos. 6, 21, 150, 151, 191, 219, 221
Witt Library, Courtauld Institute of Art Cat. no. 149
The portrait of Bridget Riley (p. 85) is reproduced from *Vogue*, © Condé Nast Publications Ltd.
The portraits of Peter Blake (p. 87) and R. B. Kitaj (p. 91) are reproduced courtesy of Lord Snowdon
The portraits of Cecil Collins (p. 79), Ruskin Spear (p. 81), Jack Smith (p. 83), Adrian Berg (p. 89), John Bellany (p. 93), and Lucy Jones (p. 95) are reproduced courtesy of *The Sunday Times* and Lord Snowdon
The photograph of Robyn Denny and Richard Smith (p. 14) is taken from *Ark* magazine no. 20, 1957.

SELECT BIBLIOGRAPHY
relating to the College

Andrew Brighton and Lynda Morris (eds.), *Towards Another Picture : an Anthology of Writings by Artists Working in Britain, 1945–77*, Midland Group, Nottingham, 1977.
Christopher Frayling, *The Royal College of Art—One hundred and fifty years of Art and Design*, Barrie and Jenkins, London, 1987.
William Rothenstein, *Men and Memories, 1900–22*, London, 1939.
William Rothenstein, *Since Fifty—Men and Memories, 1922–38*, London, 1939.
Gilbert Spencer, *Memoirs of a Painter*, Chatto and Windus, London, 1974.
Robert Woof, *The Artist as Evacuee, The Royal College of Art in the Lake District, 1940–1945*, The Wordsworth Trust, Grasmere, 1987.

Reference may also be made to the College magazine *Ark* (1950–1977).

INDEX OF ARTISTS